Behind the Camera

The Greatest Photojournalists
of Our Time

WHITE STAR PUBLISHERS

Project Editor
VALERIA MANFERTO DE FABIANIS

Editorial coordination
LAURA ACCOMAZZO

Captions by MARCO SANTINI
Consultant editor: ELENA CERATTI

Editorial Staff
ICEIGEO, Milan (MARGHERITA GIACOSA)

Graphic Design
MARIA CUCCHI

Behind the Camera

The Greatest Photojournalists
of Our Time

Texts by
LAURA MAGNI

Contents

Introduction

by Laura Magni

Among them are those who say they were born photographers, others who came to choose this path later on. They began taking photos, some just by chance. They used their father's Rolleiflex or one they got in exchange for a 20-pound block of margarine; a Kodak with folding bellows. A little Leica that is particularly handy. A Pentax that is able to capture the sharpest of details.

There are those guided by a strong desire to represent reality and those who explore the hazy line between the image presented and its possible interpretations. Those who follow the precise thread of a theme; those who feel the ethical duty of denunciation; those who opt for an illusory world meticulously constructed in the studio and who use surreal, metaphorical language; those who prefer a realizable dream to illusion, and seek out the poetry that is to be found in everyday life.

There are those who take photographs by exploring above all the place where they were born and where they return in order to reinterpret it with the eyes of an adult; or the place where they came out of curiosity, or restlessness, or to escape a totalitarian regime, or racial laws. There are those who go exactly where they want to take photographs and those who discover a new visual language in a land they crossed by chance and which mysteriously attracted them. Those who privilege the smart set and the powerful photographed in sophisticated official frames and those who take their portraits without poses at informal moments; and those who take portraits on the street, taking the necessary time to allow the soul to emerge on a face. There are those who move easily among people, preferring chance encounters and the unconventional beauty of details that seem meaningless only to those incapable of observation. There are those who use a photographic language inscribed in a rigorous geometry; those who rely on the immediacy of an image caught from around a corner. Those who take pictures in an irreverent, provocative manner, and those who do so with empathy, suffering, and deep humanity. There are those who tell stories without judgment and those who instead judge and denounce, penetrating the most harrowing circumstances to point their finger at injustice, misery, genocide, violence, and war.

They can be fearless, eccentric, fun, rough, idealists. All of them, at any rate, are animated by a deep and abiding passion. And they are among the greats of photography. Photography corresponds to their lives – and sometimes their deaths – and is interwoven inextricably with what they are, what they will become, and what they choose to continue being and doing. It becomes a direct means with which to communicate news, information, anecdotes, delicate emotions, nonconformist ideas, oxygen, tension, fun, risk, dreams, horror, the capacity to escape horror, irony, and participation.

Thus everything that would happen in the 20th century, including the Second World War, the crises and the wars that overwhelm Europe, Asia, and Africa, would violently enter people's homes and blow the roofs off of them, and smother them with the dirt from the Dust Bowl, drying out the walls and fields, and compelling those who lived in a world constructed by propaganda and advertising to sit for a moment on rocky roadside together with those who had nothing.

These photographers' pictures would jump start the public's conscience and force them to face the harsh encounter with the Great Depression: no job opportunities, famine, lines of migrants fleeing from a land turned to desert toward a future made of nothing. They would force them to sleep on the ground under a cardboard box a few steps from an air-raid shelter; to run through a jungle burning with napalm; to be appalled in a concentration camp; to climb down into gold mines that are circles of hell. To look children in the face who are playing among the ruins of bombed out houses and Asian girls whose piercing, severe gazes contain a story that is impossible to read.

Many of these photojournalists went to the front lines of the wars they sought to document and often paid a dear price for it. Some died during military action, others escaped with serious wounds that would trouble them for years, or shocks that were impossible to get over and a remnant of lasting pain, leading to the decision to never photograph armed conflict again.

Introduction

Some would then take a different path, but always in the world of photojournalism. Photography would dig inside them and flush new interests out: ethnographic studies, the exploration of the rural Andean world, of the lands traversed by Asian nomads or African tribes. Or the nostalgia for a lost paradise and the hope for a planet Earth that can survive all the destruction and return to being an Eden.

It is the passionate engagement of one who in order to communicate emotions cannot avoid first absorbing them and working through them, and not only visually. After all, the great photojournalists are – often by choice and occasionally unknowingly – also witness to our history, to its contradictions and backstage developments, a priceless resource for our collective memory. They are the first to cross frontiers previously considered off limits; they are among the few to participate directly in events of great historical significance and to be able to approach figures of extraordinary standing to take their portraits.

Many are true explorers who have been on an incredible numbers of expeditions across an incredible number of countries and have travelled an incredible number of miles, at times even on foot, in forests and jungles and deserts and along mountain paths carved out millennia before.

They all have also worked constantly to refine their own personal technique. Light years separate today's digital cameras from the ones the masters of the last century had in their hands: flexible, maneuverable, in close contact with the feelings they wanted to express and the order they sought to give to the overall composition. The angle, exposure, focus, shutter speed interacted quickly and effectively to emphasize features, tonal contrasts, the depth of field, the play of light, the lines of perspective. And then there were the first experiments with color, its combination with movement, dynamic force, blurring. All according to a poetics that each photographer has had firmly in mind, even those who have claimed not to follow any rules. It is the need to transcend pure reality without transforming it, to bring order to chaos by extracting that frame and not

another. To reorganize creatively what is reflected inside the viewfinder: "To react to something all others might walk by." To humanize the camera. In fact they all have instinctively recognized the importance of discipline and of a cultural background. Many got their start by enrolling in art schools, in graphic design courses, or they hoped to become writers, to open a painting studio. Some also worked as journalists, cameramen for the cinema, costume designers, directors' assistants, or unit still photographers.

They have often been friends of artists and their photography reflects the influence of the post-war cinema and contemporary art movements: cubism, futurism, constructivism, and abstractionism; or the attraction to new industrial technologies.

Nearly all of them have written: not only streams of notes taken at the front or in the street, alongside the stories their images tell, but also diaries, books, and autobiographies too, at times monumental ones. Their need to express themselves is very strong, with click of the shutter just as with a pen, "as long as their fingers don't hurt."

A key moment in the history of photography was the meeting of the Hungarian Robert Capa, the French Henri Cartier-Bresson, the Polish David "Chim" Seymour, the very English George Rodger, the American William Vandivert, from Illinois, and his wife Rita, and Maria Eisner. It was May 1947, in New York. Based on an idea of Capa, they founded what is still today the world's most prestigious photographic agency, Magnum Photos: exclusive, old school, focused on photographers' freedom of expression and their social engagement.

This book, which introduces nineteen great photojournalists, would like to provide the stimulus to get to know them by going beyond, to lose oneself in the study of what they were and what they had to say: through their pictures, their faces, their words, the rules they have articulated and the ones they have broken in composing an extraordinary story, an immense delta that creates disorientation along with that irresistible pleasure of one who follows a Pied Piper.

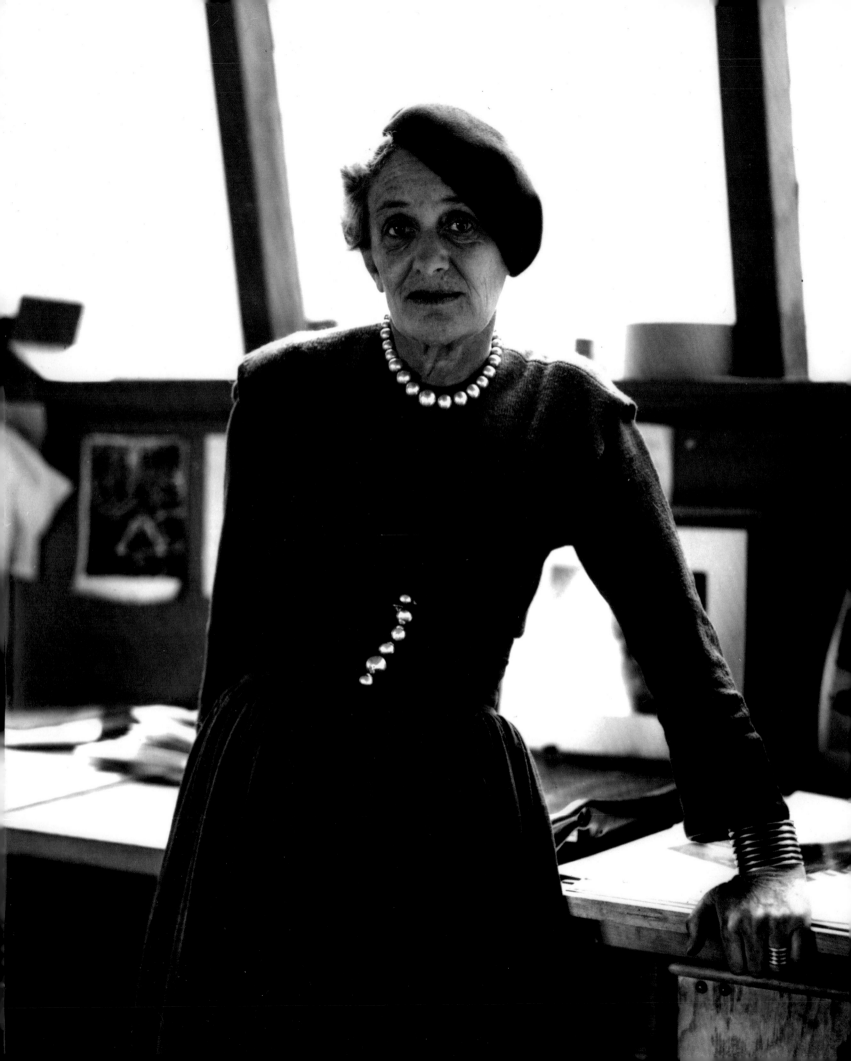

Dorothea Lange

A life of courageous challenges issued to the core of the American Dream. The Great Depression and the other face of America depicted with deep and lucid humanity.

Even before being a great photographer, Dorothea is a great woman. Sorely tried by life, she reacts promptly blow after blow. She began to face challenges early on; at age 7 polio left her limping; at 12 her father left home (along with a surname that she would give up); her health was permanently compromised when she was still quite young.

Dorothea Nutzhorn was not just important (in protest she took her mother's surname, Lange), she was also, as they say, an awkward woman, a thorn in the side of an America that promoted itself as a messenger of freedom and progress. An allegorical portrait could represent Dorothea like a muse crouched on the roof of a Dodge (both in black and white), in the color landscape of a 1940s ad: ecstatic housewives and career husbands against the background of a pink sunset. She would hold up a large mirror in which – once again in black and white – a bleak horizon would be reflected: rolling tumbleweeds, pushed by the wind under a cloudy sky. Her eyes would spring up over the mirror. Clear eyes, full of empathy, but firm not to make concessions to anyone. As if to say to America: this is who you really are.

When Lange left New York in 1918, she had already planned to travel around the world, but a lack of money forced her to stop and choose the place where she would remain for the rest of her life: Berkeley, in the San Francisco Bay. Here, from her studio as a portrait photographer, she was dragged out by the economic crisis, the strikes of the Great Depression, and the devastating Dust Bowl, with its dust storms, drought, and famine. The other view of America is a giant tumbleweed that suddenly rolls over it. Photos depicting unemployed peasants, laborers and sharecroppers in hard-panned desert soil where there is nothing to harvest.

May 26th, 1895 - Hoboken, United States • October 11th, 1965 - San Francisco, United States

In this portrait taken by Larry Colwell, Dorothea Lange looks self-effacing, with a veil of sadness over her face. The image speaks more to her sufferings than to the indomitable courage with which she faced them.

Dazed and hungry migrants accustomed to eating vegetables as frozen as the earth's crust from which they are extracted; the unemployed in line for a dish of food, such as those in the magnificent snapshot in which one of them, with his back to the others, expresses the mute despair of them all. Another photo shows the magnetic *Migrant Mother*'s painful and hopeless look with two children hiding behind her shoulders. They are the same brothers of barley and seasonal pickers from Steinbeck's books, living on the same streets and dilapidated shacks of Monterey.

California, US, 1936 Taken in Imperial Valley, California, this photo entitled *Migrant Mother* will go on to become the most iconic image of the Great Depression. The woman pictured is the mother of seven children who is struggling to survive on the outskirts of a camp along with 2,000 other pea pickers in desperate conditions. The image's publication in the *San Francisco News* will bring national attention to the living conditions of thousands of migrant day laborers living in total poverty, which will lead to people sending help, in the form of food and medicine, for the camps. The story is also a great success in the world of photojournalism (in 1998 a signed copy of *Migrant Mother* will be sold by Sotheby's for 244,500 dollars) and the young mother's face is even made into a stamp. Years later a journalist tracked the woman down. Her name was Florence Thompson and she claimed that she had asked that the photos taken of her not be published. She stated that she had gotten nothing out of the photo's fame. But in 1983, when she was sick with cancer, a fundraising campaign for her medical care would bring her family 25,000 dollars in donations.

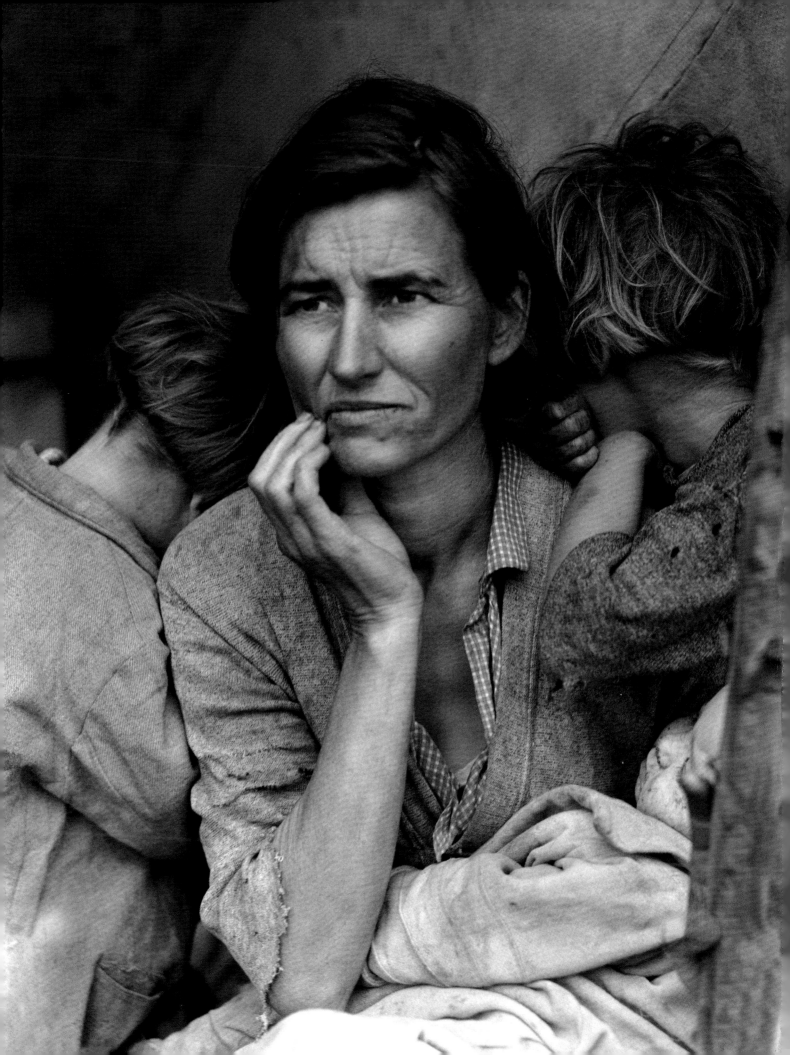

In '41 the Guggenheim Foundation awarded a prestigious fellowship to Dorothea Lange, but she later gave up the award in order to document on behalf of the government the tragedy of the Japanese-American civilians after Pearl Harbor: the deportation from the West Coast, the imprisonment of young men, who shortly before had sworn allegiance to the American flag, and their internment in permanent camps.

These photos were so critical and powerful that the army seized them, keeping them locked in their archives for over fifty years. Even a reportage commissioned by *LIFE* on the flooding of the Berryessa Valley and the death of the town of Monticello wasn't published. Lange would then devote to this topic an entire issue of *Aperture Magazine*, of which she was cofounder. In addition to her work on this unsettled and degraded America, which strove to create dreams, but was effectively unable to fight poverty, Lange produced photo essays on Ireland and Egypt. Together with her second husband she explored Pakistan, Korea, and Vietnam. He prepared reports and collected data; she took photographs, increasingly coming into direct contact with people, sitting on the floor with them, talking about herself before asking questions, without prohibiting the dirty, sticky hands of children from touching her camera.

California, US, 1936 For this homeless family hoping for a ride along Highway 99, where there is not even the shadow of a tree, there is nowhere to go. Lange composes her pictures precisely to underline just that sense of an absent future: in this case the vast empty space, beaten by the sun. The road stretches out into the distance, nearly deserted and seemingly beyond reach.

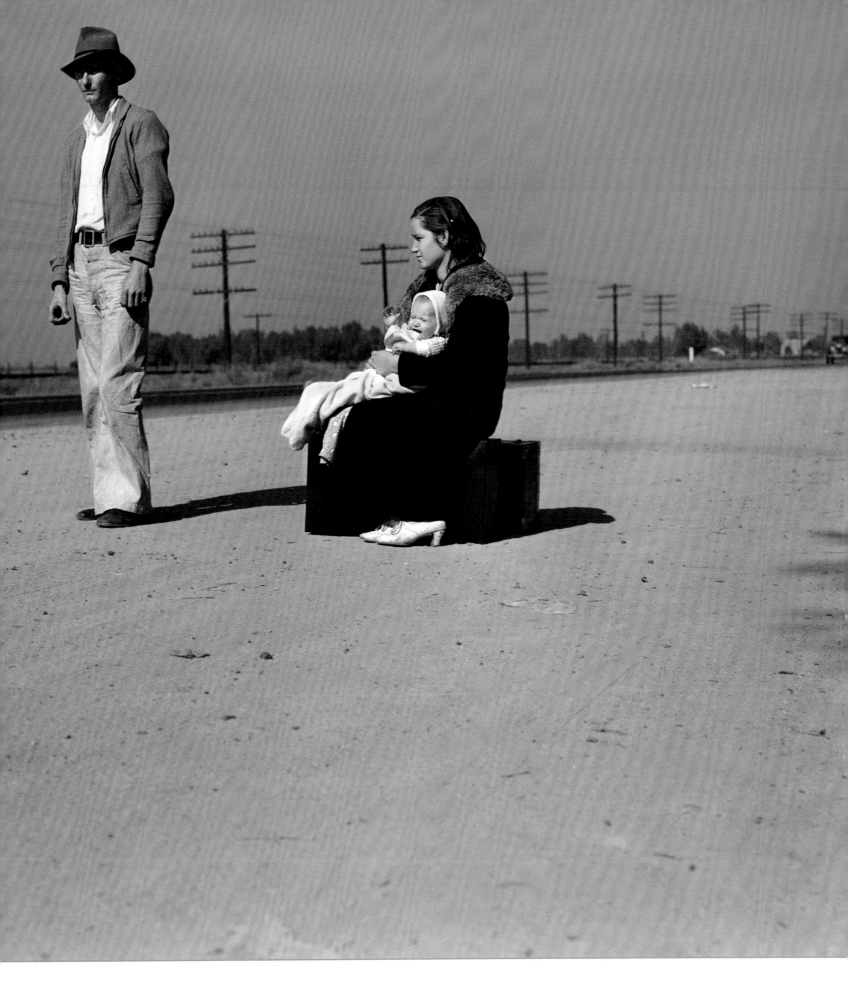

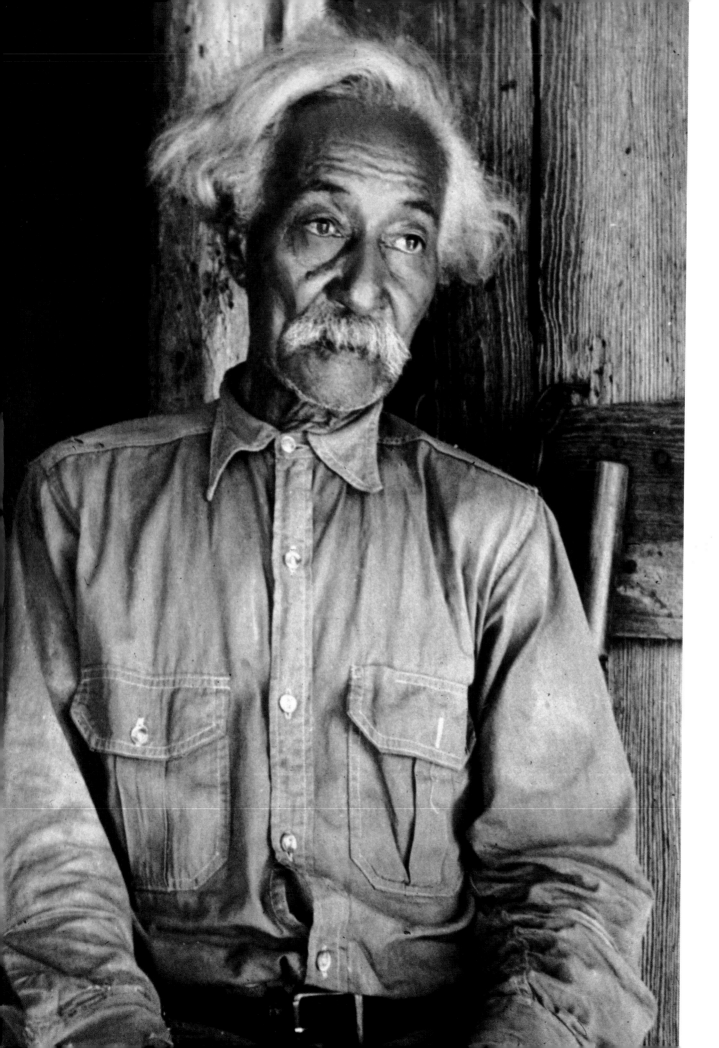

Dorothea Lange

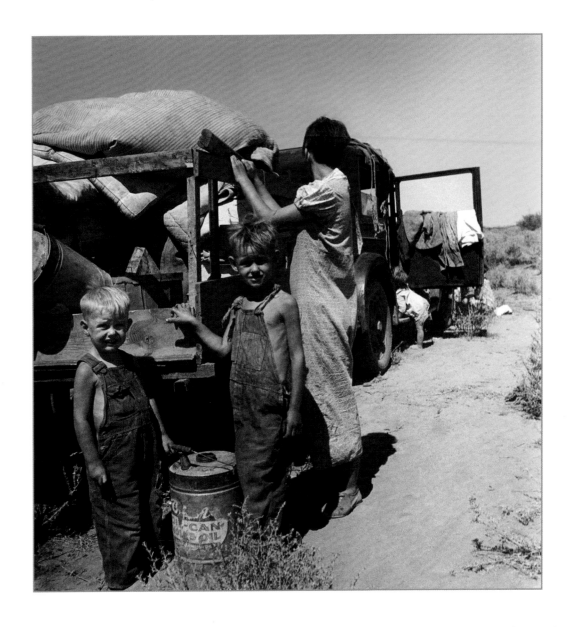

16 - Carrizo Springs, Texas, US, 1936 There is a great, unutterable tiredness in the face of Bob Lemmons, a former plantation slave. The Great Depression has struck hard, especially in these rural areas, and has wiped away the hopes and dreams of the poor, those who make their living working the earth. The image's strong contrast emphasizes the lines of his face that converse with the grain of the wood and tell the story of a life of hardship.

17 - New Mexico, US, 1936 Dorothea Lange's vision of America is unexpected and difficult to articulate. Pictured here is a family of farmers who have emigrated from Iowa to New Mexico. But the promised land has turned out to be a land of deserts and mountains, harder and harsher than the one they left behind. In order to feed themselves they have been forced to put their car and trailer up for sale. Lange worked for the Resettlement Administration and Farm Security Administration, documenting the living conditions of thousands of Americans who were forced to become refugees in their own country. The greatness of her work is on full display in this collection of photographs that tell their story with unequaled humility and humanity.

December 6th, 1898 - Dirschau (Tczew), Germany • August 23rd, 1995 - Oak Bluffs, United States

Alfred Eisenstaedt

A picture that became iconic and ninety covers for *LIFE*. A photographer-storyteller of incurable optimism and disarming simplicity, as well as a master of light.

He had predicted ironically: "On my tombstone they will write: he is the author of *V-J Day in Times Square*." But as he passed the film to the editors of *LIFE*, he could not imagine that, seventy years later, three astrophysicists would examine every millimeter of that click. He could not foresee that, by locating the source of the shadow in the frame, they would manage to establish the exact time of the click. They studied the astronomical correspondence between the hours of sunset in Manhattan that day, the hands on the clock hanging from the O of a brand of fabric, and the time when the announcement of victory had been made in Times Square with an electric signal. They calculated the height of a sign on the roof of the Astor Hotel (an unwitting sundial) over the corner of Broadway and West 45th Street. They built simulations and compared the result with the testimony of would-be protagonists of the photo. They concluded that none of the couples who had shown up at *LIFE* could be "that" couple: a sailor passionately kissing a nurse met by chance in the street in the euphoria of V-J Day, when Japan surrendered and the war was finally over.

Born in what was then the German Empire and is now Poland, Eisenstaedt made his living in Berlin selling belts and buttons until he took up photography. He captured the meeting between Hitler and Mussolini in Italy, and in Geneva he caught Goebbels glaring at the lens; yet it was in New York that his career took off, right in the newsroom of *LIFE*. From 1936 to 1972 "Eisie" would go there most days except in August, the month dedicated to his beloved Martha's Vineyard. On the island, in the blinding light of the ocean off Cape Cod, he began experimenting with filters, lenses, prisms, but never with flash.

This shot, from 1964, is by Philippe Halsman. In front of the camera Eisenstaedt playfully alludes to his art and poses as though he were a tripod, with two cameras around his neck and an eye gaping like the shutter at the moment of a camera's click. He puts his passion and determination for photography on full display.

He loved natural light, using a small and handy 35mm Leica that allowed flexibility and quick snapshots in a relaxed atmosphere that put everyone at ease, ordinary people and celebrities alike, such as Charlie Chaplin, Bernard Shaw, Marlene Dietrich, Thomas Mann, and even the Kennedys in their private lives and the Clintons on vacation.

"With this small camera nobody takes me too seriously," he said, even if he encountered some difficulties. Churchill demanded to teach Eisenstaedt how to photograph him; in a boat, during one of his tantrums, Hemingway threatened to throw him overboard.

Though his style is not considered the most sophisticated, Eisie always managed to capture "the narrative moment," concentrating the core of a story in a single image, inscribing it in a simple composition that natural light makes familiar, and conveying it with gentle humor; as in the case of the waiter skating in St. Moritz while balancing a tray of glasses, or other waiters looking out, all in a row, from the same window. Other rows compose his amusing geometries: a row of Fifth Avenue ladies sitting under a row of hair dryers; a double row of soldiers leaning out from the windows of a train kissing their women; a row of school desks and on every desk a sleepy little head. LIFE considered him an ideal artist and entrusted him with 2,500 assignments, using ninety cover shots of the "little fellow from Germany": tireless, impeccable, capable of maintaining until age 97 an almost childlike interest in the world and an unbreakable trust in chance and empathy.

"If you get the feel of photography" – writes Eisenstaedt – "you can take fifteen pictures while one of your opponents is trying out his exposure meter."

New York, US, August 14th, 1945 Eisenstaedt's most famous photo is part of a news story done in Times Square during the celebrations for the victory over Japan. Published in *LIFE*, for years there was a parade of couples who came forth claiming to be the pair featured, but in end the kiss has remained anonymous. With their spontaneous and uninhibited embrace – perfectly framed by the square behind them – the snapshot captures the joy and optimism of post-war American society. Another photographer in Times Square that day, Victor Jorgensen, captured the same scene from a different angle, framing it in a medium close shot reminiscent of American cinematic style. Published in the *New York Times* a day later, its sharply different approach only serves to emphasize the masterfulness of Eisenstaedt's iconic shot.

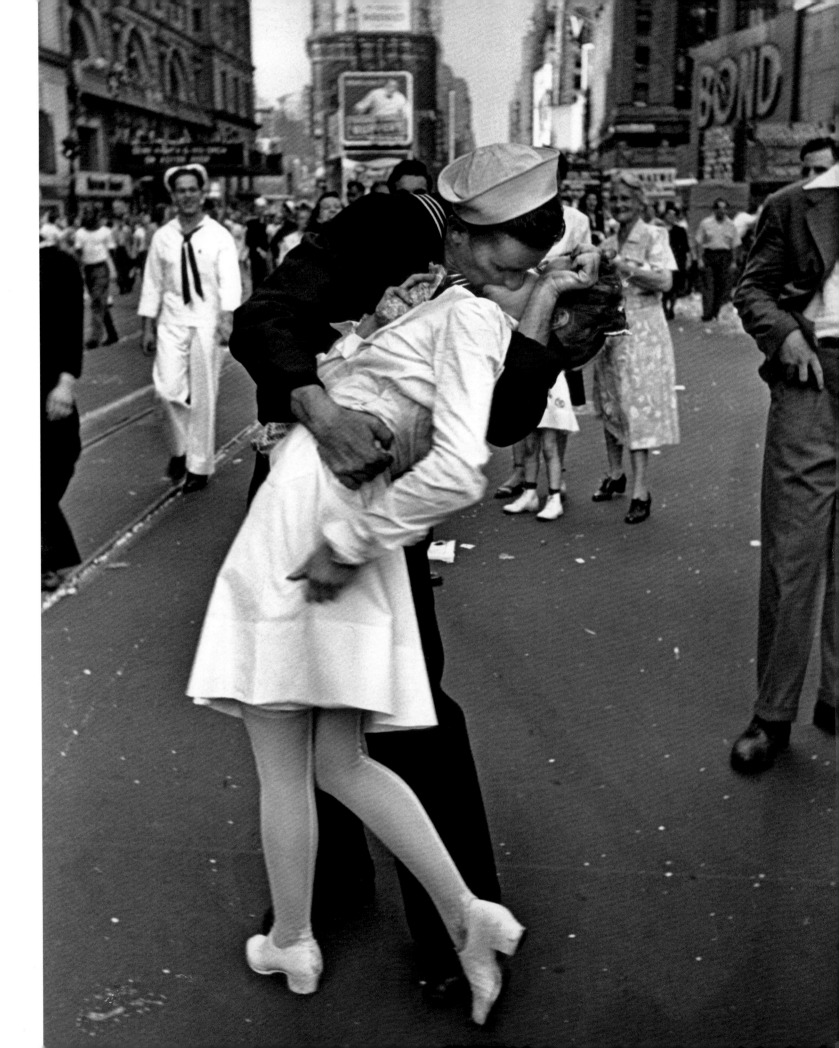

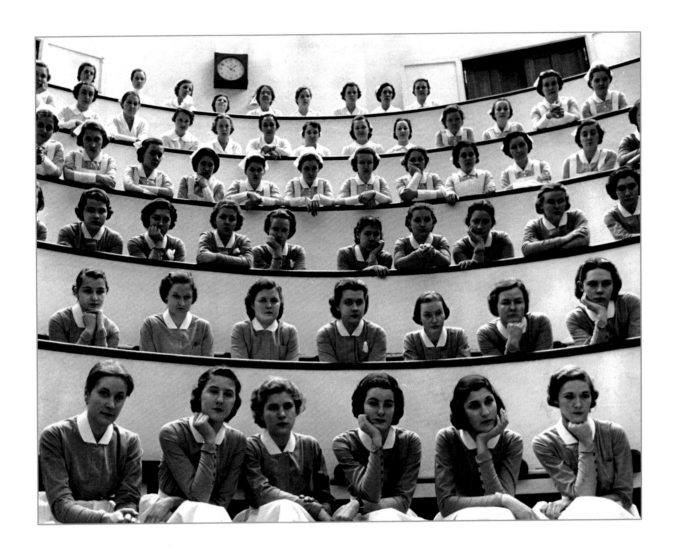

22 - Berlin, Germany, 1932 Another example of composition through the repetition of lines and shapes: a tasting of various types of tea in a store. The counterpoint of the lines of the table and trays accompanies the strong visual element of the cups to create an impactful dynamic flow. The human figures, usually of great weight from a compositional point of view, here have a secondary role. The stage transcends the actors.

23 - New York, US, 1938 An expert in the art of finding order everywhere, Eisenstaedt takes advantage of every visual opportunity he meets. In this case it is the repetition of the lines of subjects (nursing interns who are observing an appendectomy) to attract the viewer's gaze. The photographer manages to create a balance in the composition and to compensate for the distortion in perspective typical of photos taken from a low vantage point.

24-25 - Milan, Italy, 1934 Here we find ourselves at the La Scala opera house. Eisenstaedt took many photographs in dance schools, which in this case he interprets splendidly through small details. The dancing shoes, the position of the feet, which are on their tiptoes almost as though by instinct, give a precise sense to the legs of these girls, who otherwise could have been sitting in a classroom of any school. The exclusive use of natural light renders each detail with softness and delicacy.

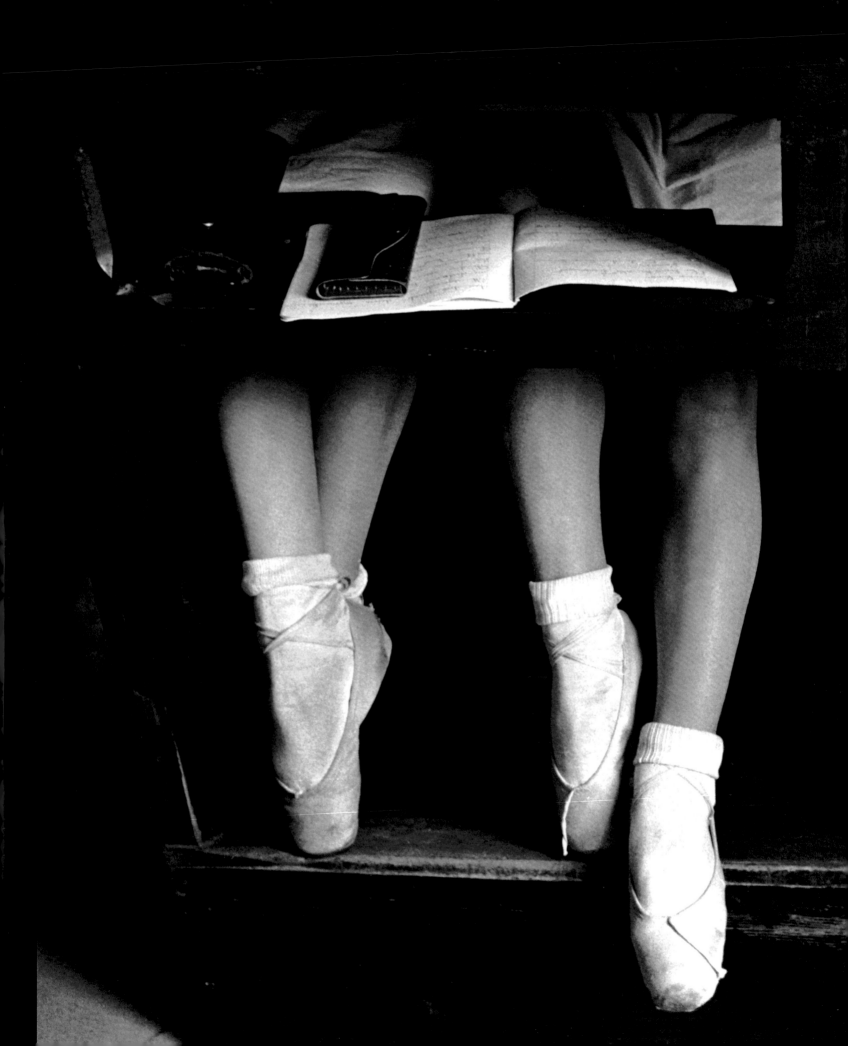

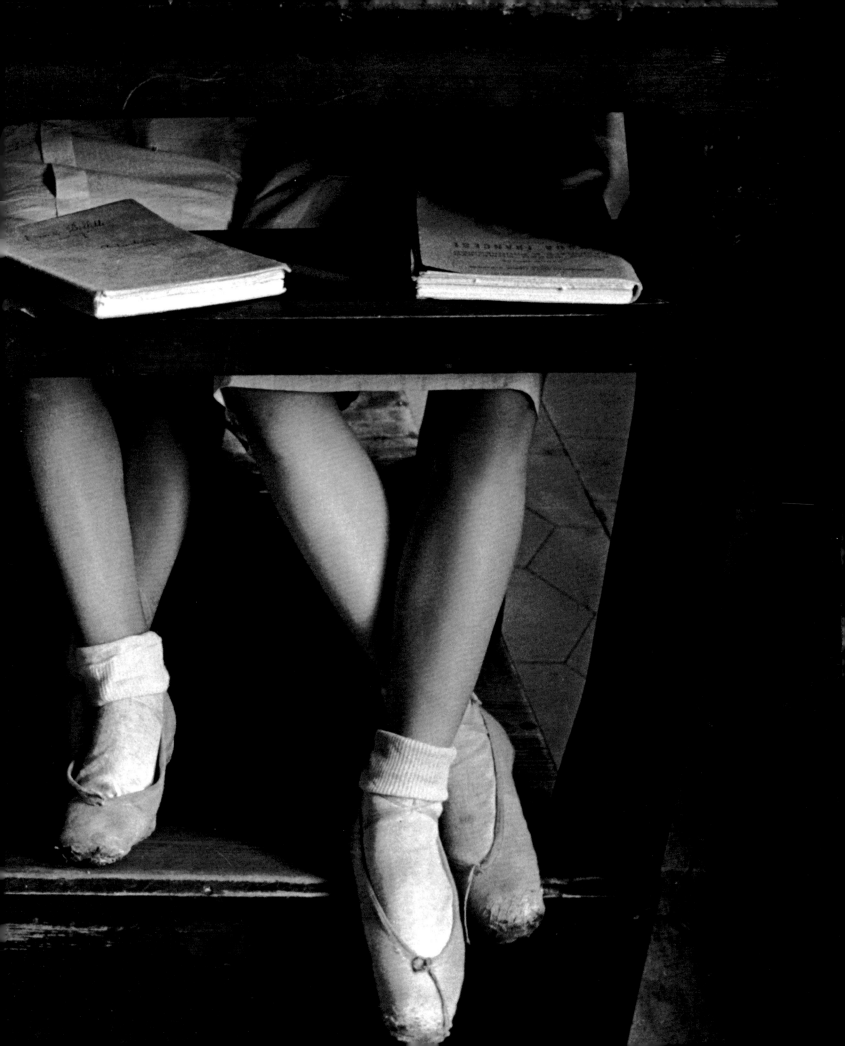

Cecil Beaton

The official portrait photographer of English nobles, celebrities, and the rich and powerful, whom he photographed everywhere from Buckingham Palace to Hollywood with masterfully decorative taste.

On June 2nd, 1953 in Westminster Abbey, Elizabeth II was crowned Queen of the United Kingdom – and not only that. On her silk dress, in addition to the Tudor rose, the Welsh leek, the Scottish thistle and the Irish shamrock, are embroidered the Canadian maple leaf, the Australian acacia, the cotton flowers reminiscent of Pakistan, two lotus blossoms of India and Ceylon, the South African Protea, and a fern of New Zealand. None of these details escaped the careful and insatiable eye for pomp of Cecil Beaton, appointed for some fifteen years as a court photographer and author of countless portraits of the royal family: that of the young queen posing under the weight of almost 2 pounds of gold, silver and platinum, 2,868 diamonds, 269 pearls, 17 sapphires, 11 emeralds and 4 rubies went around the world.

A Londoner from Hampstead, son of a timber merchant, Cecil Beaton decided early on to aim high. He left school, crossed the ocean and arrived in New York. He had ambitious dreams and wanted to live big. The world between the glitter of Hollywood and exclusive British aristocratic circles was what attracted him like a magnet and in which he was anxious to participate fully. Beaton fulfilled his goal. He portrayed the VIPs of both continents and accumulated a fortune as he turned them into icons. Stars, artists, noble and mighty individuals of the world sat at his table: even Churchill, De Gaulle, and Jackie Kennedy. Finally, thanks to a title granted to him by Her Majesty, Mr. C. W. Hardy Beaton, born Cockney, became Sir Cecil Beaton.

His luck began when, in the late 1920s, he was hired by *Vogue* as both an artist and a photographer, and stood out for elaborate sets in which he placed the celebrity portraits and golden youth of the Roaring Twenties. The setting was that of Fitzgerald, but devoid of yearning and melancholy; it was rather imbued with a keen hedonism and worldliness.

In the 1940s Cecil Beaton took this photo of himself with its extravagant setting: it could hardly have been otherwise for the man who in his photos evoked a world in which every figure is framed in a surreal atmosphere.

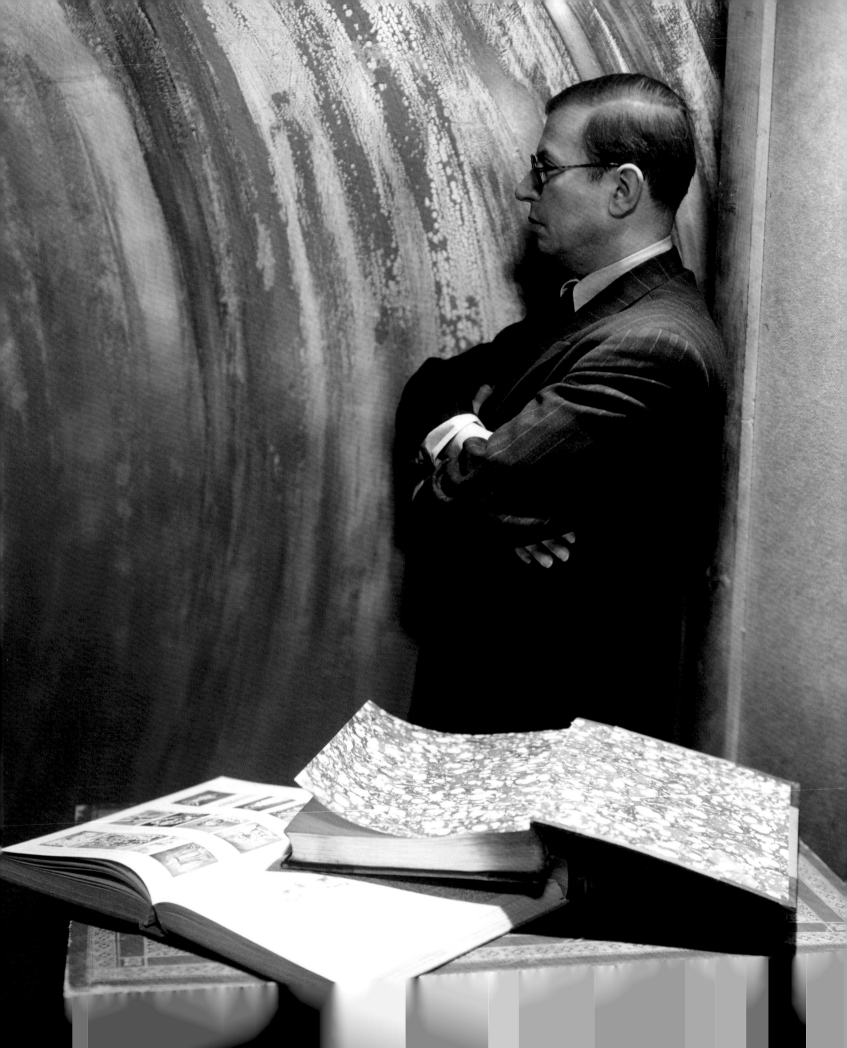

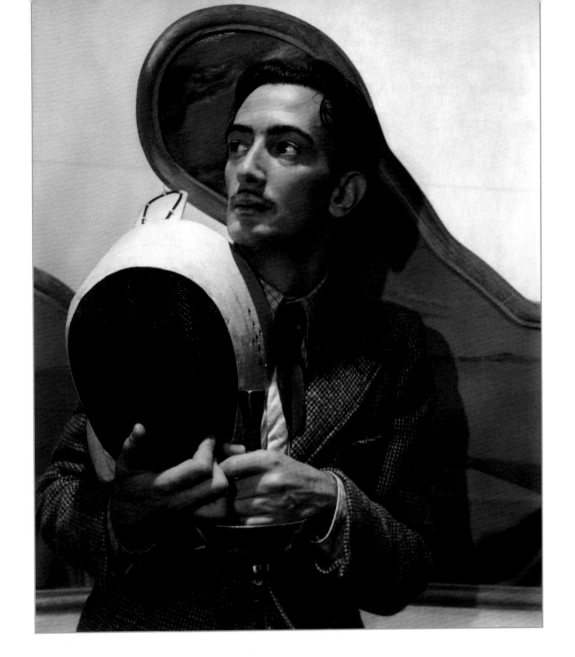

28 - 1946 One might say that Cecil Beaton was the greatest profile specialist in the history of photography; surely he is the one who was able to develop the most unusual interpretations of the profile. Here the foreground of books so masterfully lit and the abstract background, recalling optical art, captures the viewer's attention as much as the subject himself, a stern Jean-Paul Sartre who is gazing intently out of the frame.

29 - 1936 The artistic encounter between Beaton and Dalí occurs in the arena of surrealist poetics, showcasing their common love for staging and for a theatrical tradition of representing reality. In this portrait the photographer captures the disoriented gaze of the Spanish painter, who appears utterly indifferent to the fencing mask and sword he is holding.

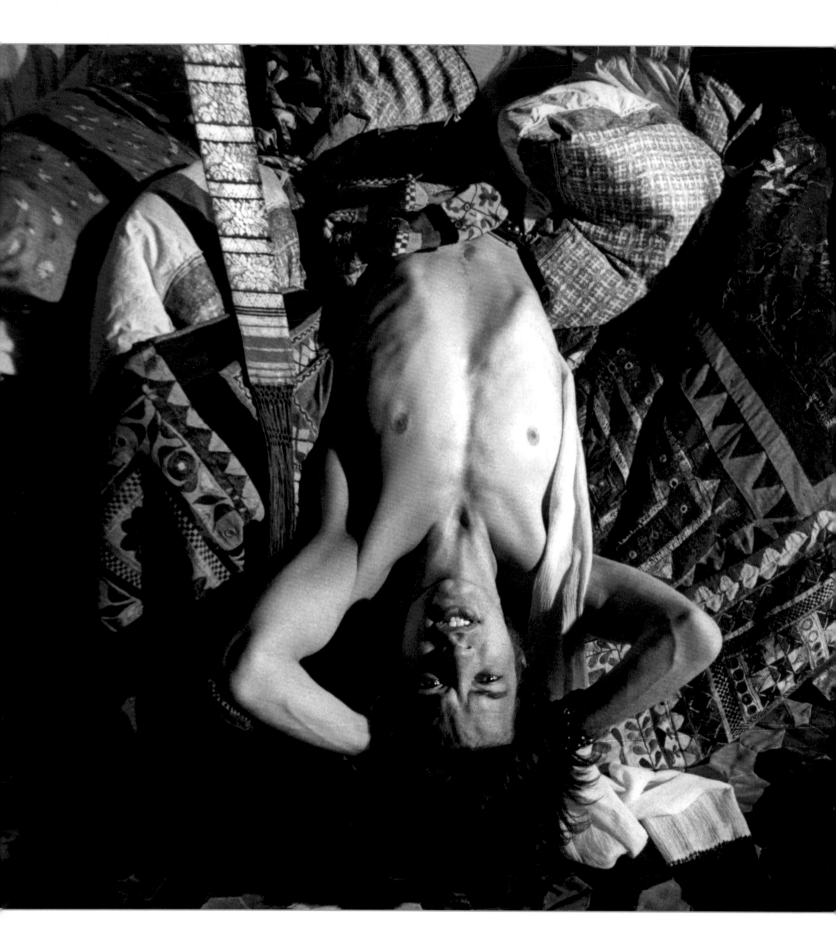

The admiration of the renowned Diana Vreeland and Coco Chanel threw open the doors of high fashion photography; the collaboration with *Vanity Fair* and *Harper's Bazaar* did the rest. Beaton's philosophy was the opposite of that of Cartier-Bresson; exactly the opposite of the poetics of the decisive moment, the spontaneous snap; that is, Beaton sought the desired snapshot, artificially constructed through a meticulous and often metaphorical staging. Rather than Cartier-Bresson's rigorous search for the real, he obsessively sought all that dazzles, decorates, and intensifies, namely an illusory world as an escape from the mediocrity and boredom of the real one. "Be daring, be different, be impractical, be anything [. . .] against the play-it-safers, the creatures of the commonplace, the slaves of the ordinary." Beaton was a dandy, an esthete, and deeply snobbish. For his characters he assembled backgrounds filled with quotes ranging from surrealist sophisticated atmospheres to frivolous backdrops that today are reminiscent of those from soap operas. He mixed medieval times, rococo, elements of orientalist painting, reflective surfaces of all kinds, and old disused backstage scenery; sometimes ironically, sometimes with a purely celebratory intention.

London, UK, 1968 In this photo, Beaton's signature is immediately evident. The background, typically redundant and excessive, could divert attention from the subject. Hence the decision to shoot, Mick Jagger, the lead singer of the Rolling Stones upside-down, in order to create a visual tension that can soften the background and bring back the gaze on the human figure.

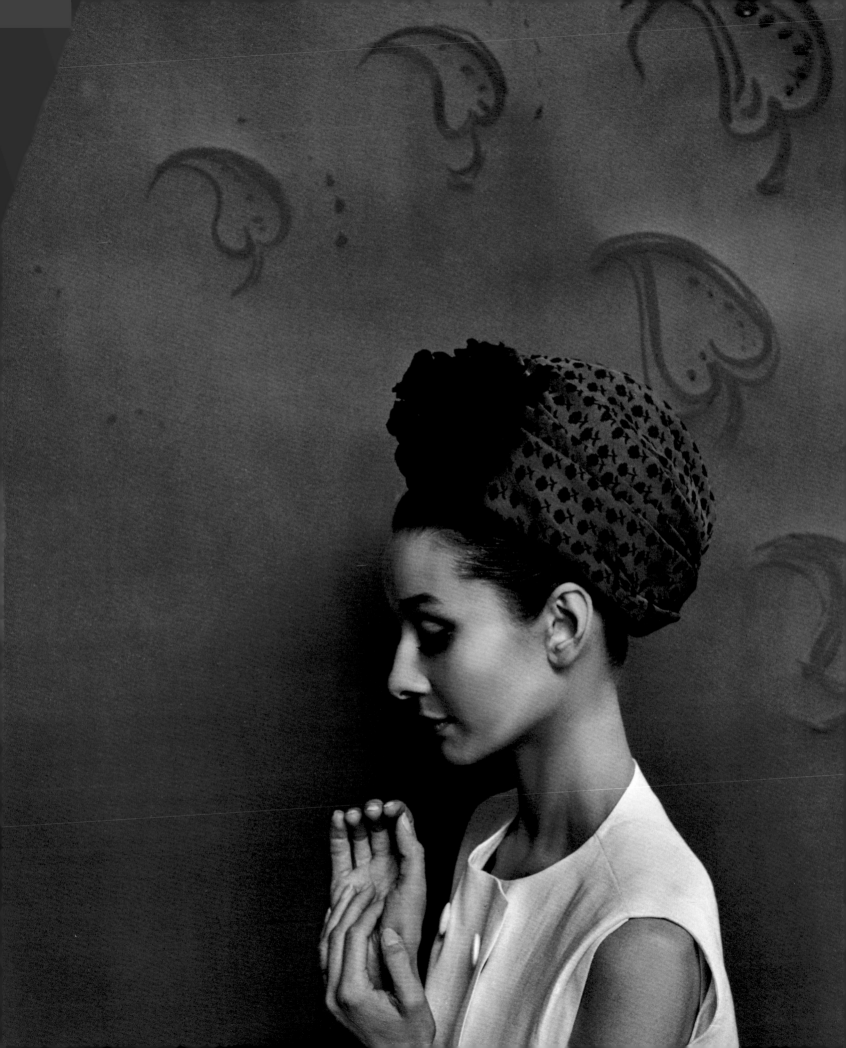

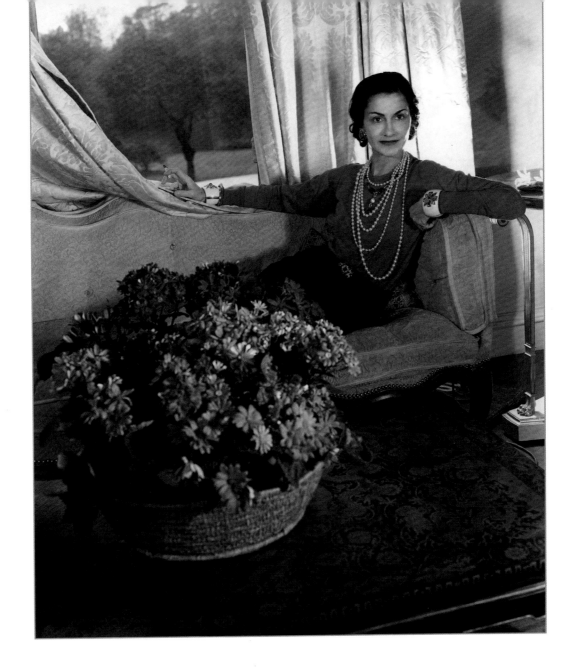

32 - 1964 The profile of one of the women deeply admired by Beaton. Here the composition largely breaks conventional rules. The subject is unusually low, the face too close to the center of the image. The hue of the turban almost confused with the background. The drawings on the wall are too invasive. Yet the result is a portrait that returns all the elegance of the actress: our attention is fixed on the gesture of the hands, wondering where that look is lost; we admire the delicacy of her features.

33 - London, UK, 1938 Elegance is the common thread that connects the women photographed by Cecil Beaton. Coco Chanel, whose figure stands out from the slight confusion of broken lines and a foreground occupied by flowers, is no exception. What might have seemed like a snapshot, finds its sense in the dialogue between the diagonal lines and the woman's pose, so relaxed as to make us feel like we are sitting in the room with her.

The two sumptuous houses he rented, renovated and decorated in the 1930s in the English countryside tell us just as much as do his photographs who Cecil Beaton was and what he meant to the world; they describe him better than do his shots made during Second World War as the official photographer for the British Ministry of Information. His leadership, his penchant for the spectacular, and his pursuit of effect converged in his successful post-war theatrical and cinematic experiences. Beaton was awarded three Oscars for costumes and set design for *My Fair Lady* (his Ascot hats on the ladies' heads are famous), and Belle Epoque costumes of *Gigi*.

Flattered by an array of rich and famous, Beaton flattered them in turn only to chill them in his journals with lapidary and very poisonous reviews, in pure Elsa Maxwell style (Grace Kelly's veal right profile, Liz Taylor's Peruvian peasant breast, Dalí's smelly breath, Katharine Hepburn's horse teeth, eunuch asexual Mick Jagger, horribly sloppy Peggy Guggenheim, and Virginia Woolf, the pig). Few came out unscathed from his contemptuous pen: Greta Garbo, an object of veneration (Beaton, although openly gay, said he was crazy about her), Marlene Dietrich, and the lovely Audrey Hepburn, of which Sir Cecil could only recognize her class and extreme grace. "Beaton? A self-invention", Truman Capote will say of him. Yet the set design of the Black & White Ball at the Plaza, set up to celebrate the publication of *In Cold Blood*, was precisely inspired by Beaton's blazing use of black and white for *My Fair Lady*.

1934 This is a splendid example of mastery of the relationship between light and shadow. It is a powerful dialogue between Katharine Hepburn's slender figure and an overlying dark and gigantic statue. Just this dialogue, wanted and sought, between strength and finesse, rough stone and almost diaphanous skin, gives surprising intimacy that is revealed in her gesture. That hand and that arm break the balance; they push Hepburn toward those who are observing the photograph. Once again, the face of the subject is nearly in an impossible position, but the superb management of the important visual elements restores it to a primary role.

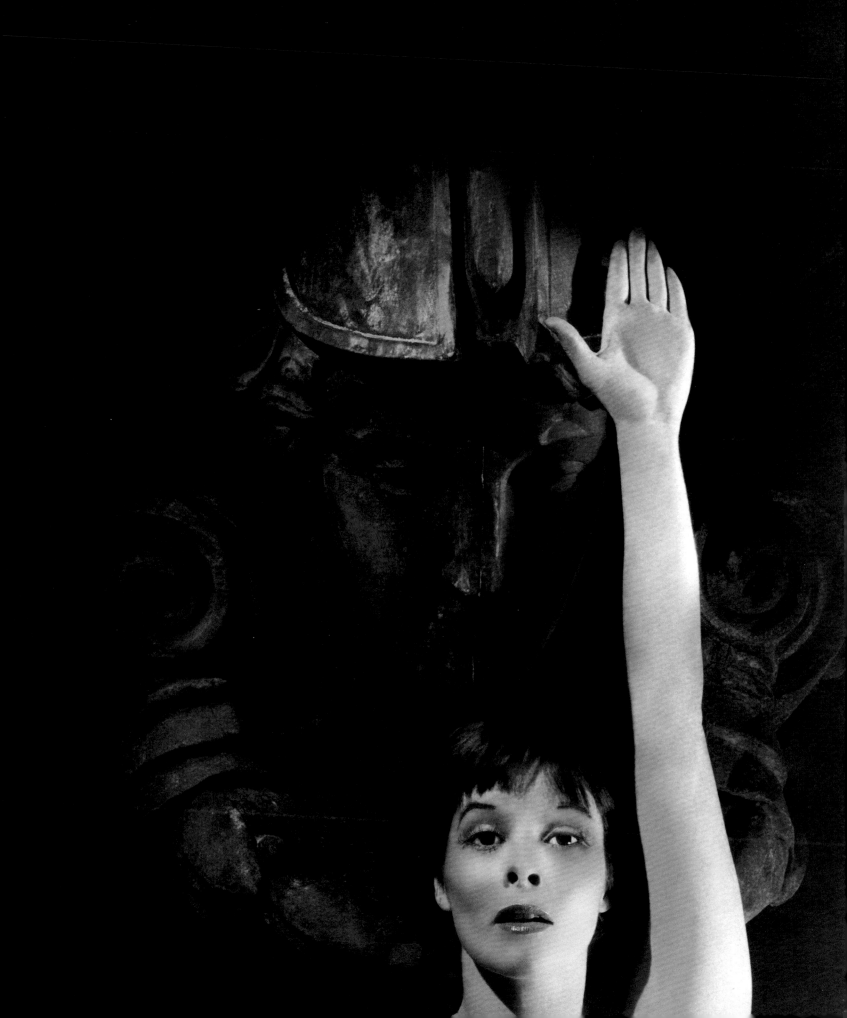

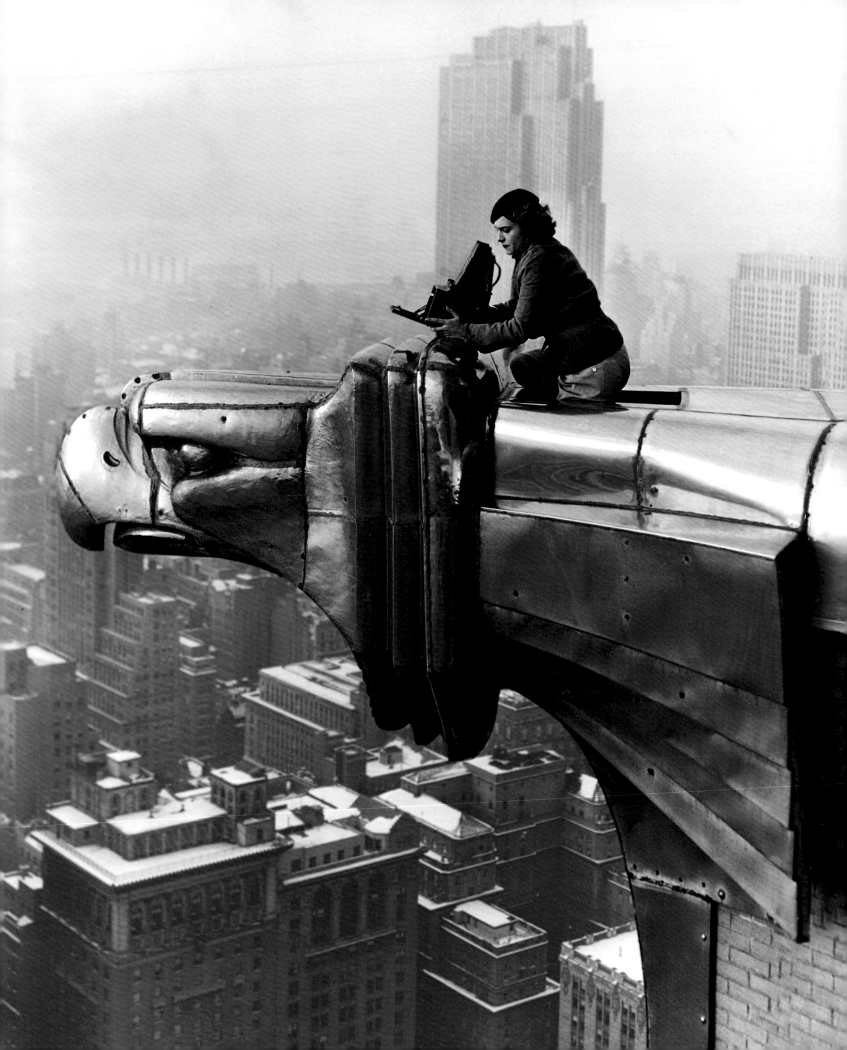

Margaret Bourke-White

An attraction for industrial technology and the influence of avant-garde art feature in the work of this intrepid woman who achieved a remarkable number of "firsts" over her trail-blazing career.

Margaret Bourke-White was born into an unusual family – her father was a mechanical engineer, naturalist and inventor; her grandfather was a shipbuilding carpenter, and her grandmother (English) was a cook. She was born in the Bronx in 1904, when the Bronx, previously a part of Westchester County, had just become one of the boroughs of New York. It was a time of growth, population explosion and hope.

Bourke-White, who often accompanied her father in the factories for which he designed printing presses, was fascinated by industrial technology. Even in Cleveland she will note in her journal that every morning just after dawn, she awaited that a dense skyline of scaffolding, cranes, and chimneys of foundries would emerge, with a sort of exaltation, from the mist. She looked at all this with young eyes. As for the forms, we notice an instinctively Cubist filter. She used light and contrast in a dramatic and expressionistic way. She had a Futuristic love for movement, such as the rattle of trains, steam engine trails, the flow of liquefied and hot metal. Margaret Bourke-White was a girl who lived her era fully and who tackled the technical challenges of photographic ground that was still little explored, pioneering the way. She produced photos that became passionate and theatrical manifestos of an epochal transformation and a celebration of heavy industry. The machines – as well as the impressive architectural structures – to her were almost cathedrals, towering over men who move blurred and confused. Miniature men like ants.

She quickly became adept, so good to begin to work soon after for *Fortune*, the *New York Times* business magazine on the rise, and for *LIFE*, which for half a century would remain a fundamental point of reference for international photojournalism. Then, as the country was struggling to breathe, in the grip of the Great Depression, Margaret Bourke-White shifted her lens from industrial architecture to human tragedy and photographed the American Dust Bowl: the devastating sandstorms that for eight years in the 1930s raged on the central plains; storms triggered by decades of misguided agricultural techniques. With the addition of a sardonically irreverent outburst, she also photographed the schizophrenia between the propaganda of the radiant American dream and the reality of black people, and others, who were struggling to stay afloat.

Oscar Graubner took this photo in 1935 in New York, when Bourke-White had climbed out onto the head of one of the eagle gargoyles atop the Chrysler Building. The photo captures the spirit of an entire generation of young American photographers.

June 14th, 1904 - New York, United States · August 27th, 1971 - Stamford, United States

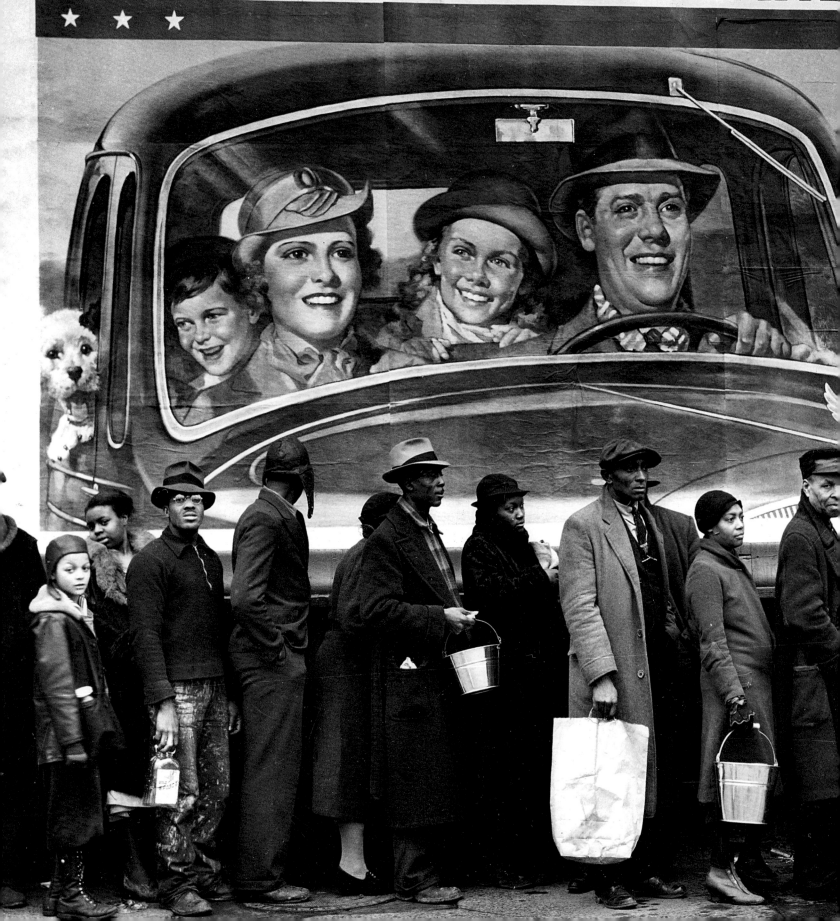

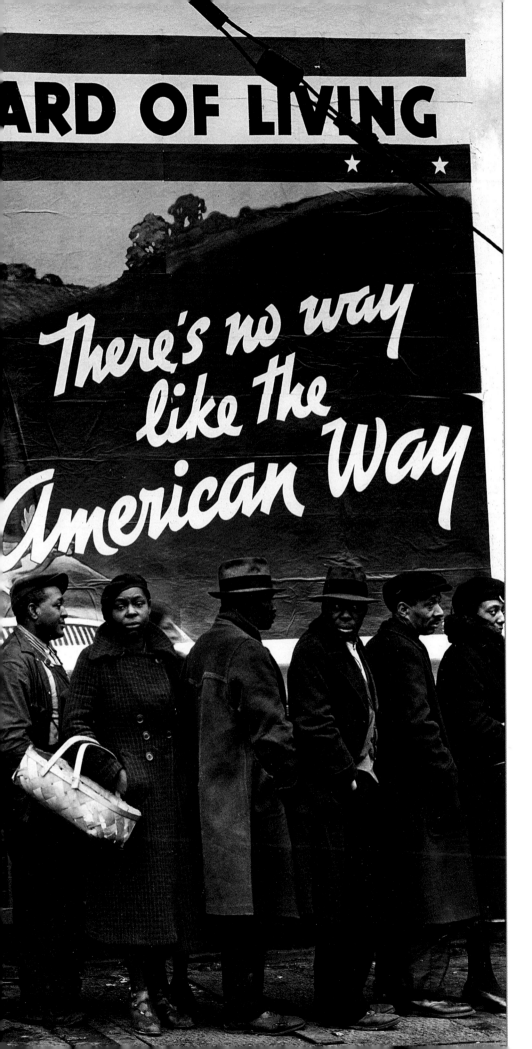

ARD OF LIVING

There's no way like the American Way

Margaret Bourke-White

Kentucky, US, 1937 In the midst of the Great Depression, after the years of the Dust Bowl, the Ohio River overflows, causing massive devastation in several states and leaving in its wake one million homeless. Margaret Bourke-White takes this shot for *LIFE*, which is a summary of the reality of those years in the United States. In a single glance she portrays the optimism of the unstoppable American dream and the harsh reality of the poor, especially blacks, in line for a piece of bread.

Over the years, Margaret Bourke-White collected an incredible, almost embarrassing number of firsts. The photo published on the cover of the first issue of *LIFE* was hers. A powerful shot, highly symbolic of the Fort Peck Dam in Montana, photographed as if it were an impregnable wall. She was the first journalist to receive a visa to enter the Soviet Union in order to document the industrial revolution on the brink of war. She was the first to obtain authorization for photographing in a combat zone. She was the first American war correspondent, and the only foreign reporter who witnessed the Nazi invasion of Moscow. She was the first woman to accompany American fighter planes during the bombing against the Germans.

Bourke-White often had the luck of being in the right place at the right time. Not only in Moscow, when Germany and the Soviet Union renounced the non-aggression pact, and where she photographed Stalin in an unusually good-natured expression. She was also in Buchenwald shortly after the arrival of the Allies, where she documented the horror through the opaque and astonished eyes of prisoners who found it hard to believe that they had survived. The photographer was in New Delhi with Gandhi, whom she had already immortalized in a famous shot next to his spinning wheel. She would interview him again shortly before his assassination (she was the only photojournalist allowed at the funeral, along with Cartier-Bresson). She was among the few photographers to attend live the bloody aftermath of the gory rift between India and Pakistan. These photos have remained the most important testimony of those facts. She was also the first to perceive the disastrous consequences of the Korean War, in which she participated until Parkinson's disease began to hinder her work.

After escaping the bombs, the torpedoes in the Mediterranean, the machine guns of the Luftwaffe, Margaret Bourke-White remained untamed and attracted to every arduous endeavor. She chased the future, grabbed it by the tail in the same impetuous and brave way when she flew hanging in the void from a helicopter to follow a Navy rescue mission; or when she took pictures of New York from above, sitting on a gargoyle on the 61st floor of the Chrysler Building as if she were at the Plaza waiting for a tea. She wore a belted pea coat as her watchful gaze focused on the lens, ready to pierce the air from under a cloth beret.

India, circa 1946 During the violence that followed the separation of Pakistan and India, Margaret Bourke-White's lens not only focuses on the political facts; it also follows the dramatic exodus with a crystalline and human vision. People on the move to opposite sides of a border that had never existed. With her photographs, the American reporter gives us back the inevitable empathy for those who document life in the Indian continent, together with the dignity of a people that has always coexisted with hunger and hardship.

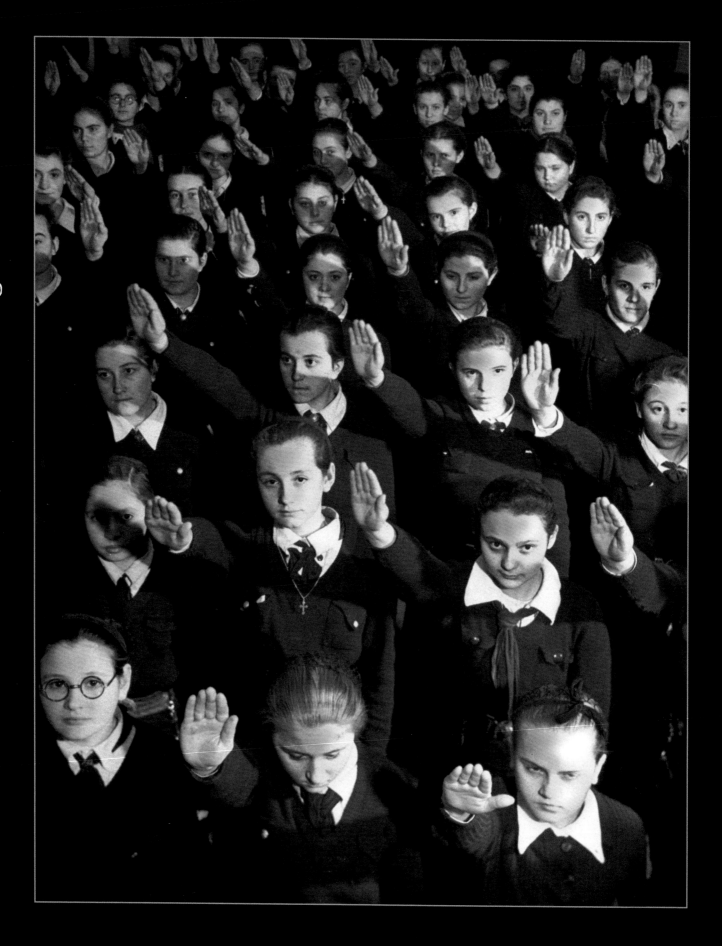

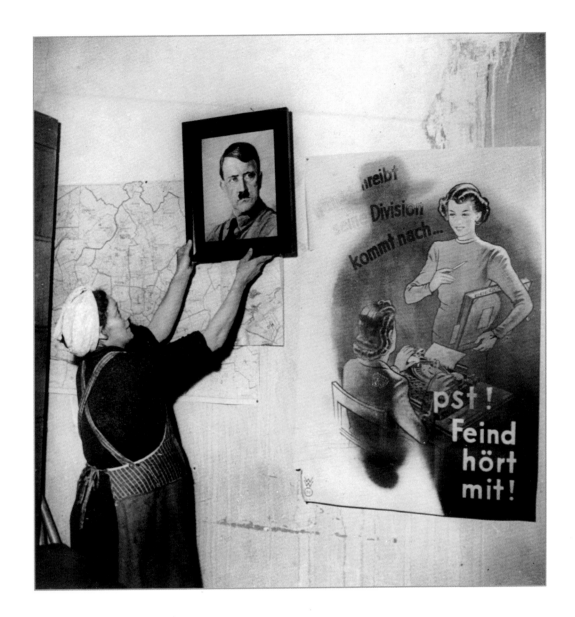

42 - Chişinău, Romania, 1940 Between the late 1930s and at the beginning of 1940 the American photographer's work aimed at showing the effect of nazism and communism on living conditions in Europe and the Soviet Union, the militarization of society and the markedly ideological teaching imparted from the first years of school. Here Bourke-White photographs the female students in a Romanian school.

43 - Frankfurt, Germany, 1945 Another example of the ability of Bourke-White to grasp contradictions: we are in 1945, a woman removes a portrait of Hitler from the wall of a Frankfurt church turned into the party headquarters. To the side, however, a poster reminds her of the dangers of even whispered dissent.

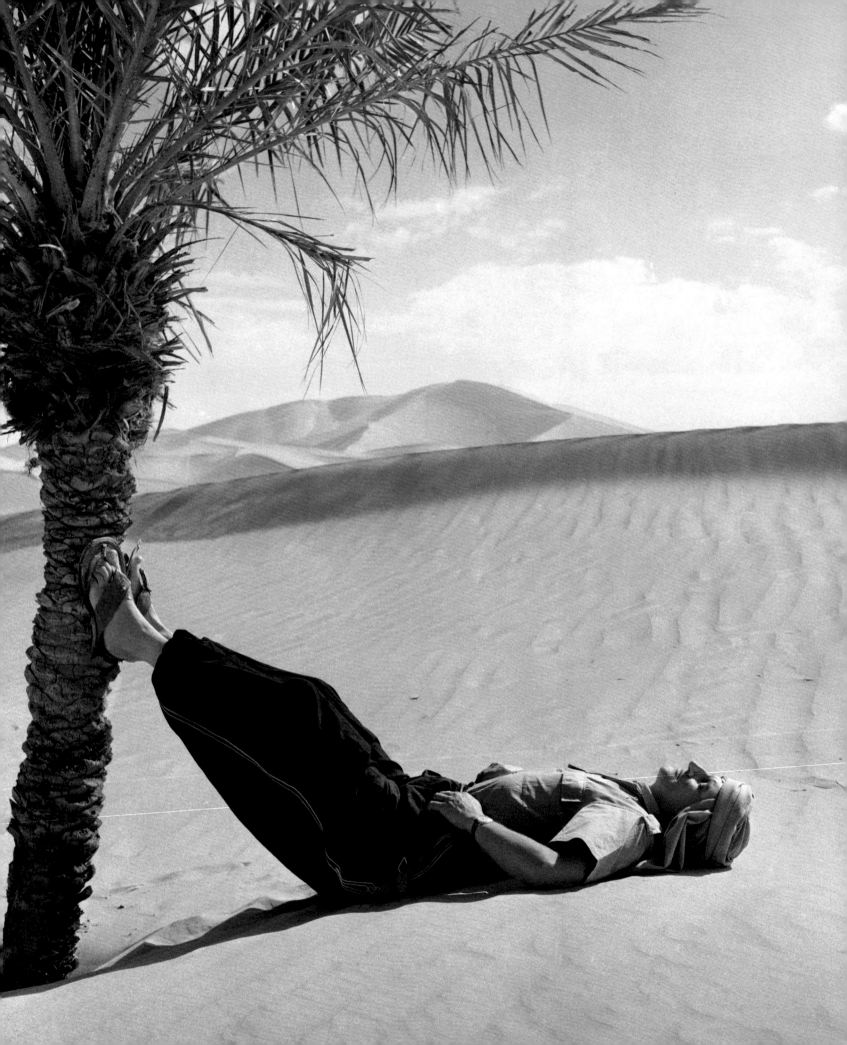

George Rodger

From his first harrowing war photography to the shock of the concentration camps, to the discovery of a great passion for ethnographic photojournalism among African tribes.

There is a moment of particularly intense emotion in the story of George Rodger: not only as regards his own experience, but also for those who read about it. As soon as the British photographer completed his reportage on the concentration camp in Bergen-Belsen, he realized he was in shock. During an interview he talked about it this way: "When I could look at the horror of Belsen – and think only of a nice photographic composition I knew something had happened to me, and it had to stop."

Of Scottish descent, born in England, quiet, shy but drawn to adventure, Rodger was 18 when he embarked on a British Merchant Navy cargo ship and traveled the world writing detailed diaries, complete with photos, that he wanted to publish. After a futile attempt to find work in the United States during the Great Depression, he returned to Europe penniless, and when the war broke out he had already decided that photography was the best way for him to document it. He bought a Leica and a Rolleiflex, and commissioned by the BBC he photographed London during the heavy German raids that transformed the city into a series of incandescent fires. No epic tone in his shots, no spectacular image; rather ordinary people who resist as best as they can, looking for a way to get by, fending off the destruction of everyday life which was becoming increasingly impossible.

After this report, he became a war photojournalist for *LIFE* and documented sixty-two fronts, including Abyssinia and Eritrea. He followed the legendary Black Bull Armoured Division during the Normandy landings and the advancing Allies in France, Belgium and Italy, from Sicily to Montecassino.

March 19th, 1908 - Hale, United Kingdom • July 24th, 1995 - Smarden, United Kingdom

Perhaps a self-portrait, set among the dunes of the Sahara in 1957, in that Great Erg that so fascinated the English photographer. Lying back in the sand, his feet propped up on the trunk of a palm tree, showing that complete relaxation that comes from the contact with nature.

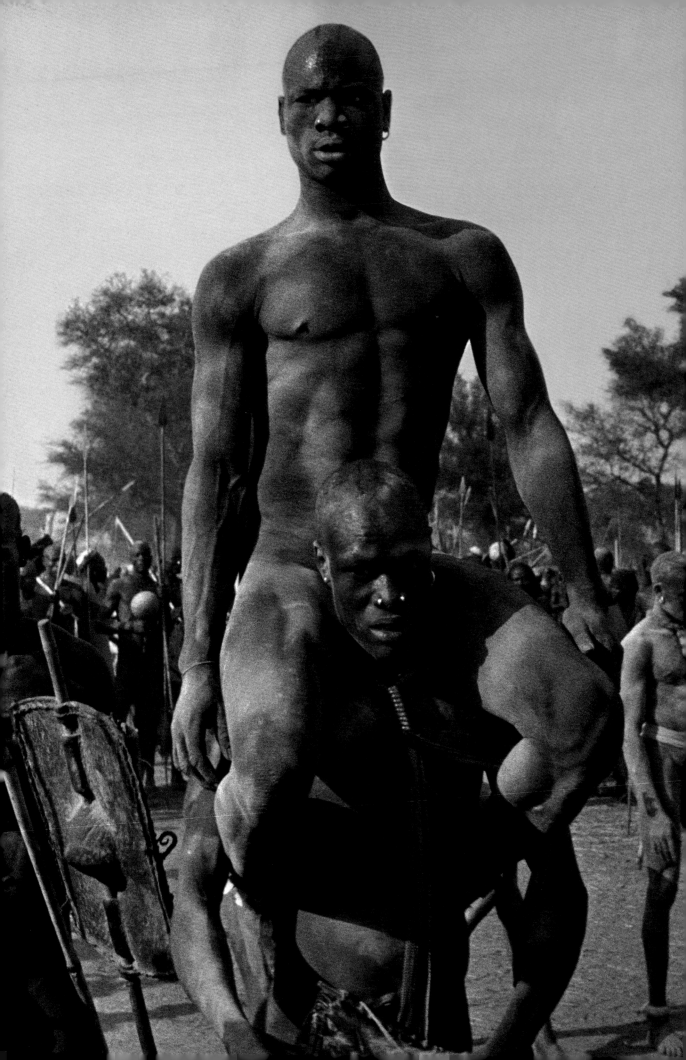

On the Asian front, he traveled 300 miles in the Burmese jungle to escape the Japanese, documenting the fall of Burma. His dry and telegraphic notes follow the rhythm of the shots: "Ukrainian women cooking a meal on a refuse dump in the camp. For fuel for their fire they used the ragged clothing torn from corpses. They are boiling pine needles and roots to form a sort of soup."

After victory came the shocking reportage in Bergen-Belsen. Rodger would not look at those images for 45 years. Marked by an indelible trauma, he swore he would never photograph a war again. Yet his separation from assignments gave him headaches and depression until he met Capa and Vandivert; an event that marked, with the founding of Magnum Photos agency, the opening of a new perspective. This was the beginning of a new life for Rodger.

In '51 he traveled to the Belgian Congo with his camera bag, canned sardines, insect repellent and a growing passion for the primitive tribes and ethnographic and naturalistic photojournalism in Afghanistan, India, and especially Africa. In the African bush his angst subsided. He was the first to photograph the tribal conflicts between the Nuba and the Latuka tribes in Sudan, as well as the courtship dances of the Pygmies of the rainforest. He does so with profound humanity, emphasizing the beauty of the colors that stand out brightly in the tribal paintings, clothes, and jewelry.

Between one African voyage and another, he explored Haiti and Bali, then returning to the Sahara for *National Geographic*. In the 1970s he covered the Tuareg and Masai tribes; the latter, after repeated denials, allowed him to attend a circumcision ceremony, an event strictly closed to foreigners.

"I may juggle the composition [. . .]. Or I may play with the light. But I never interfere with the subject. The subject has to fall into place on its own and, if I don't like it, I don't have to print it." Always looking for a balance between heightened sensitivity and the necessary detachment of the observer, Rodger says: "It must be like watching from the audience a play you already know by heart."

Kordofan, Sudan, 1949 In '47 Rodger left for Africa, and in southern Sudan he heard talk of Nuba, an unknown people living according to traditions stretching back thousands of years. He would manage to reach them only in '49 after a journey that was adventurous to say the least. He and his wife Cicely were the first Westerners to document the traditional lifestyle of these people with whom they communicated with gestures, without an interpreter. His pictures show the pantomimes of fighting, the challenges, ceremonies, and rituals. As in the powerful image shown here, which has become iconic: the victor of a competition is carried on a fellow tribesman's shoulders and receives the approbation of the tribe.

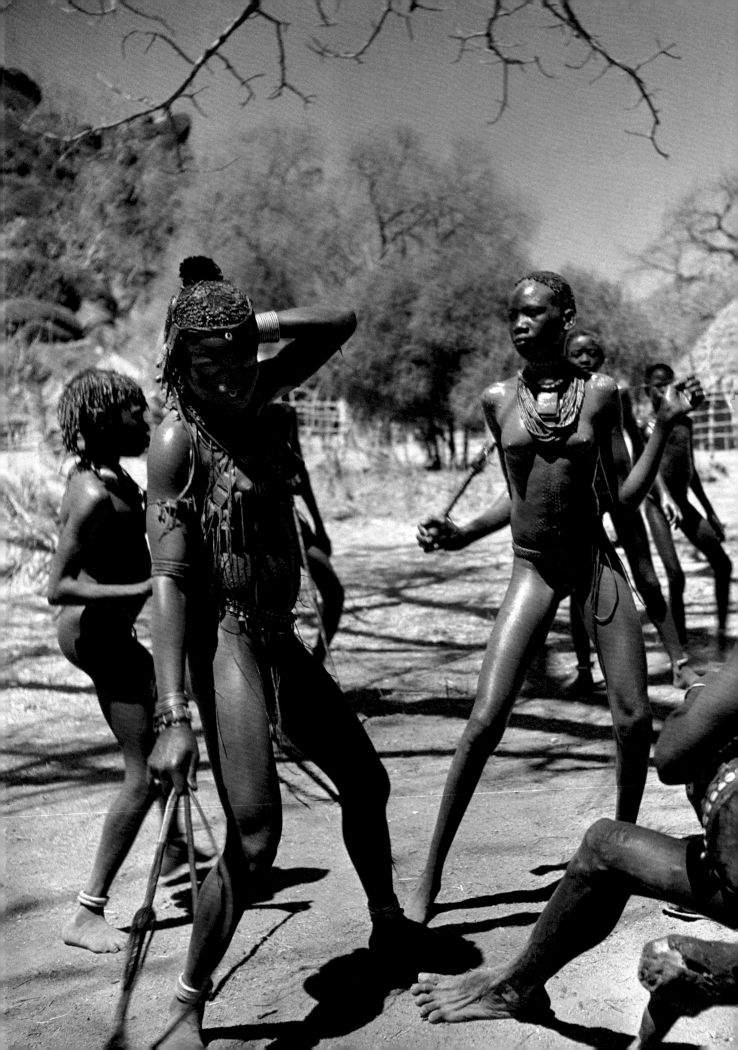

George Rodger

48-49 - Kordofan, Sudan, 1949 As is so often the case in Africa, the dances are the essential moment of every social gathering. Photos such as these of dancers in Kordofan would be seen around the world and would bring the attention of other photographers, directors, and tourist operators who did not always have Rodger's human gaze and respectfulness. The nudity was sometimes seen as a provocation and led to a reaction from the Sudanese Islamic authorities, who put pressure on the tribe. Changes began, the distance from the West got shorter and the Nuba would soon no longer be unreachable. Rodger's images remain an extraordinary record of an intact and authentic world that survived history.

50-51 - Kordofan, Sudan, 1949 Another image of the dancers of Kordofan: in the background the people of the village beat out the rhythm with their hands. Despite the fatigue from the long journey that had lasted months and the hardships of a life in primitive conditions, Rodger kept his mind alert, giving us an extraordinary photo essay. His lens captures not only the gestures of the dance and of these people's everyday life, but also their more subtle moods. The English photographer opens up a window onto a world that is substantially happy, cheerful, and unaffected, and shows it to us with exceptional transparency.

52-53 - Kuwait, 1952 Rodger traveled not only in Africa, but around the world, with his lens aimed at themes related to nature and ethnography. In 1952 he accepted a commission in Kuwait to photograph the development of the oil industry. During his time there he did a series of shots about falconry, including this one. The choice of an open aperture limits the focus and causes the eye to start from the left, to run across the soldier's cartridge belt before settling on the falcon. The background is secondary, but it captures well the space and silence of the desert.

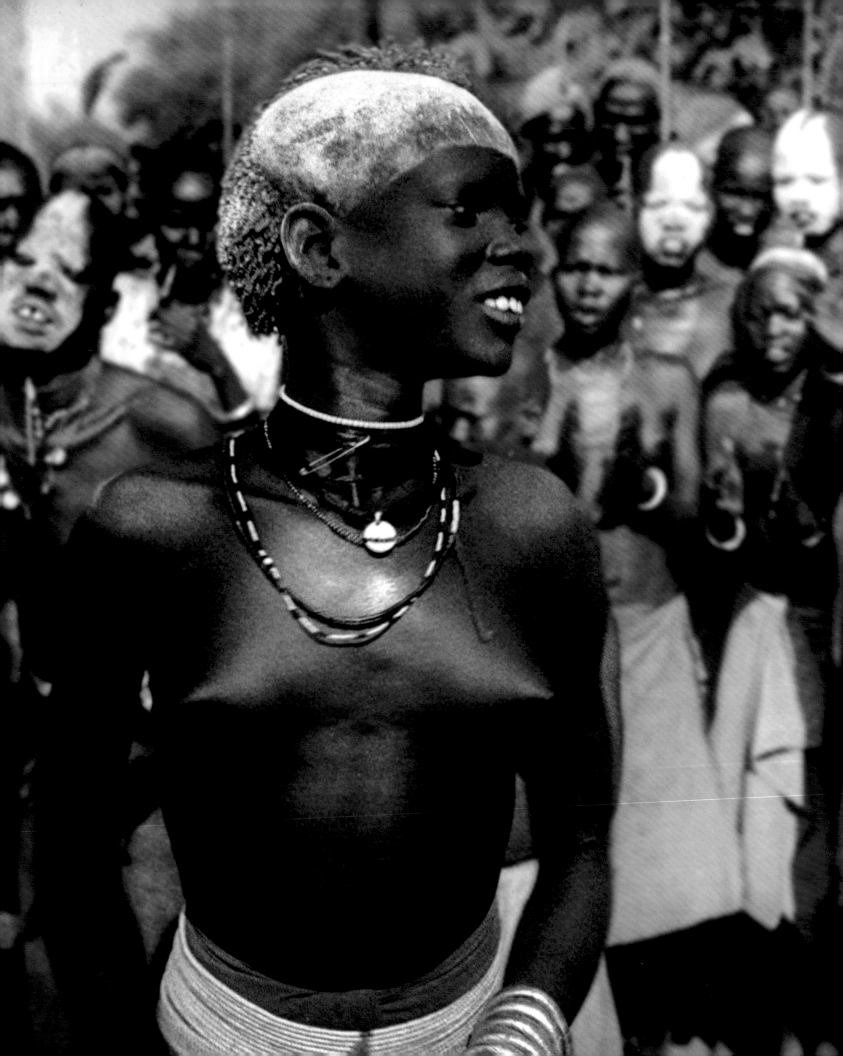

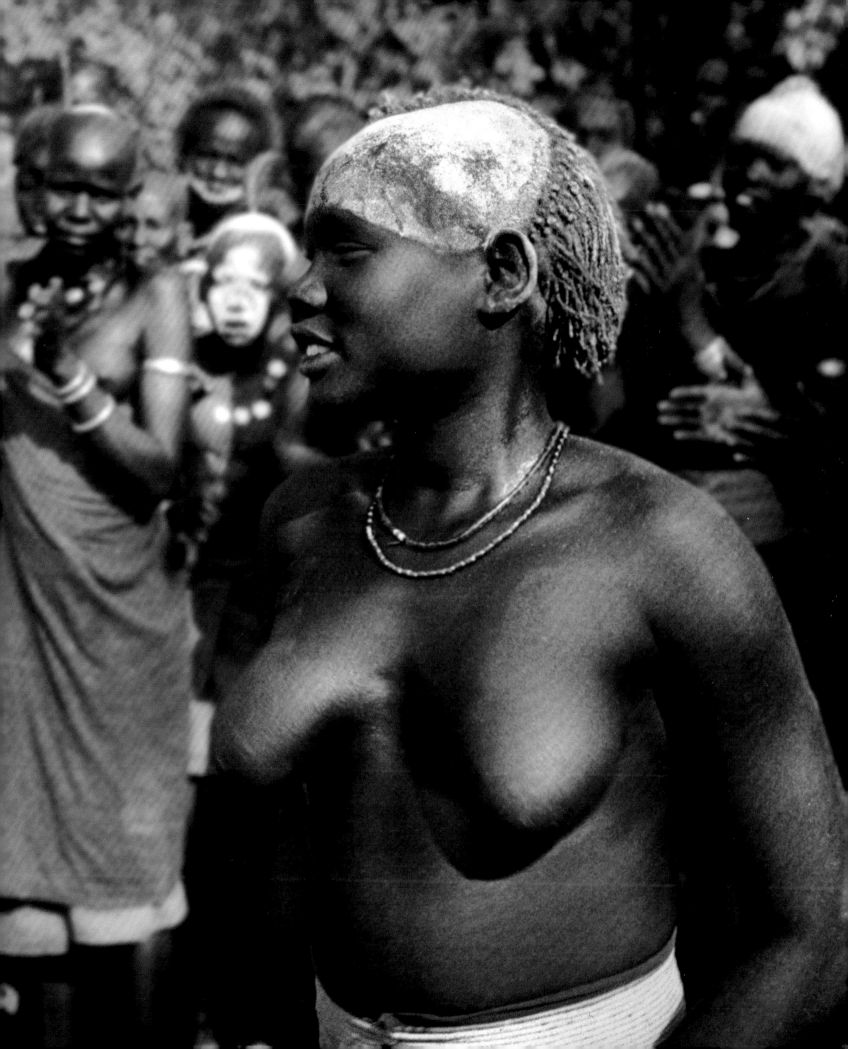

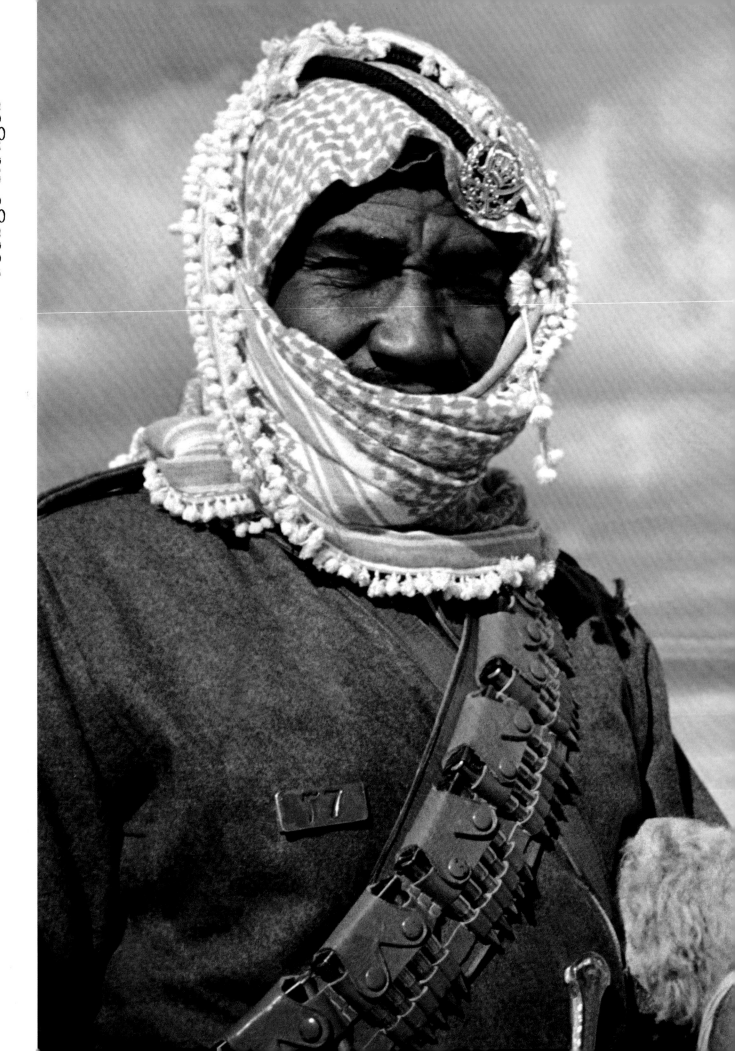

George Rodger

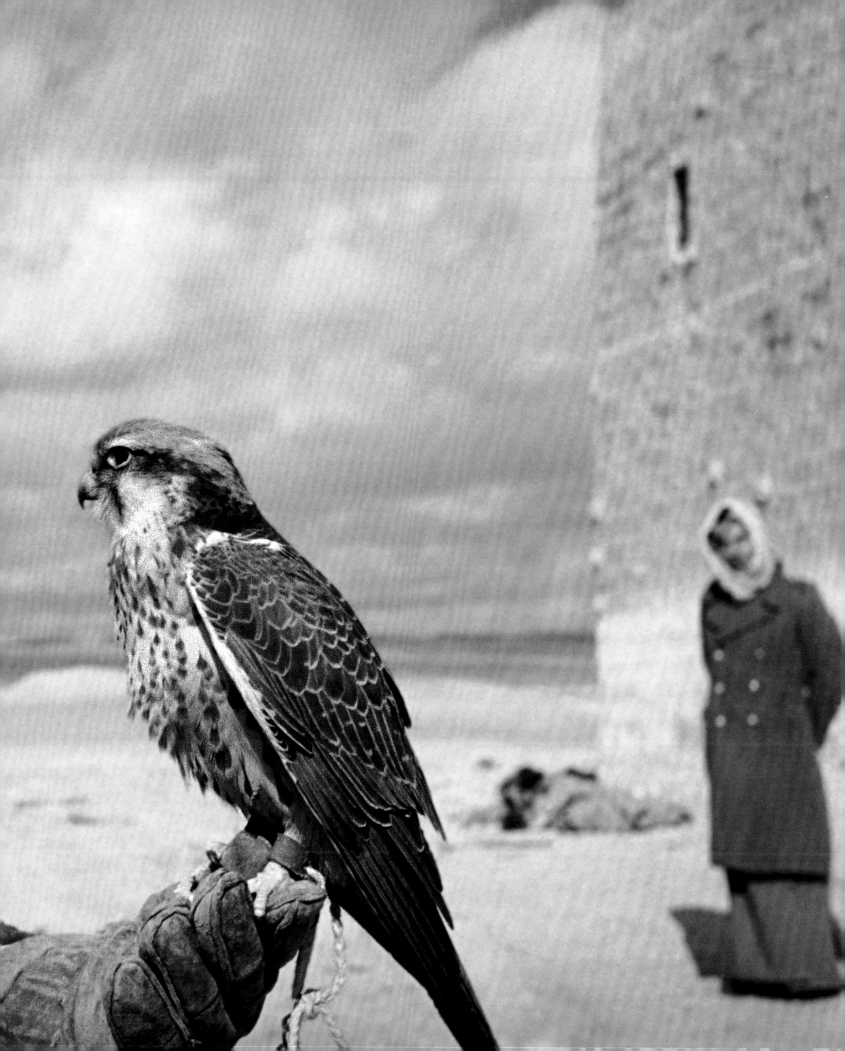

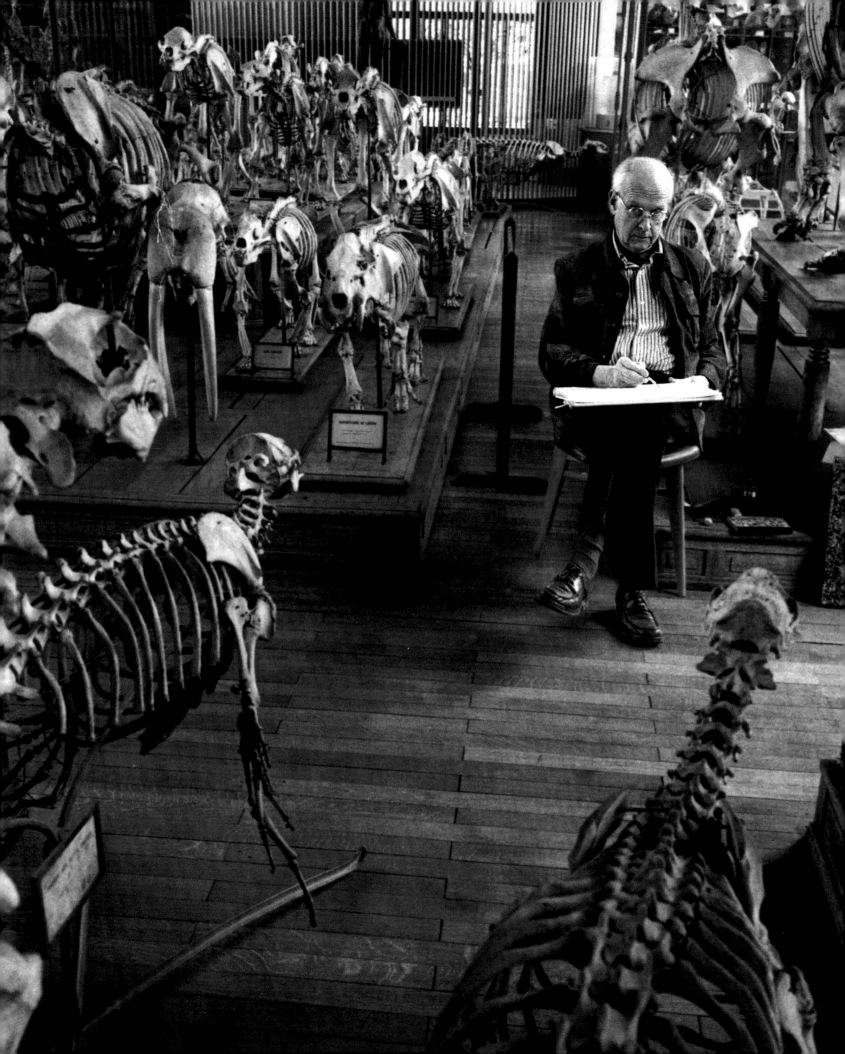

Henri Cartier-Bresson

The striking intuition of one of the all time greats of photography, who knew how to capture the decisive moment with a rigor that was instinctively geometric.

A backlighted photo taken in Africa by Martin Munkácsi: black boys running toward waves breaking on the shore of Lake Tanganyika. It is a simple backlit scene, where the movement frozen by the film strikingly expresses a zest for life and a fleeting lightness. Henri Cartier-Bresson is 23 years old, is starting to approach the Surrealist movement, and reads the great Russian and French literatures. He has already taken his first photographs during the year spent in Ivory Coast, but he is especially attracted to painting. Upon returning to France after having contracted a tropical fever, he sees a photograph taken by Munkácsi in an art magazine and is struck by the pictorial possibilities within photography. The year is 1931.

When he set off with his Leica to explore Mediterranean Europe, he already knew that this would be his future, even if cinematic experiences were intriguing him: in the United States with Paul Strand, in France with Jean Renoir and Jacques Becker. American "straight photography" had just rehabilitated spontaneous – not manipulated – shooting as an art form, and it was from a similar concept that Cartier-Bresson began to develop his poetics of a decisive moment.

The camera became "a notepad, an instrument of intuition and spontaneity," filtered with great discipline and concentration. Each image that excites him and is meaningful to him must be captured on the fly with a split-second click, yet it must go further, showing a miraculous balance between light, dark, shadows, highlights and the geometries of the composition. The picture must be recognized as clearly representative of that event or person. It must be emblematic, decisive, in fact, or it must be discarded, without any intervention aimed at improving the quality of the negative or print. The actual experience, the here and now that heart and head have built together, should not suffer the abuse of artifice.

Martine Franck photographs the French master in the Museum of Natural History in Paris. Despite the rows of skeletons, the photo communicates concentration and great serenity.

August 22nd, 1908 - Chanteloup-en-Brie, France • August 3rd, 2004 - Montjustin, France

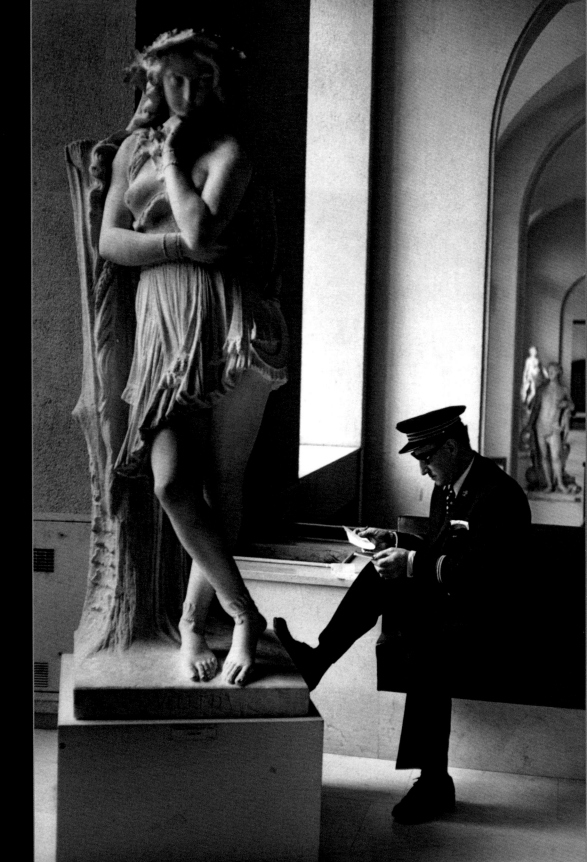

56 - Louvre Museum, Paris, France, 1975 Fascinated by painting and art in general, Cartier-Bresson often frequents museums, where, over the course of his long career, he will realize shots of great interest. These images perfectly combine some of the characteristic features of the language of the French photographer: the rigorous composition, a geometric order functional to a simplicity that results in effective communication, and the ability to record totally spontaneous gestures involving the observers and making them feel part of the scene.

57 - Tretyakov Gallery, Moscow, USSR, 1972 A group of visitors – probably a family – intent on looking at the same painting in a Moscow gallery offers the French master an opportunity for expressing that striking relationship between intuition, total vision, reaction, and gesture, which plays a central role in his philosophy. The moment is fleeting; the art of the photographer consists in being aware of it, stripping away all of its needless trappings and capturing the essential on film.

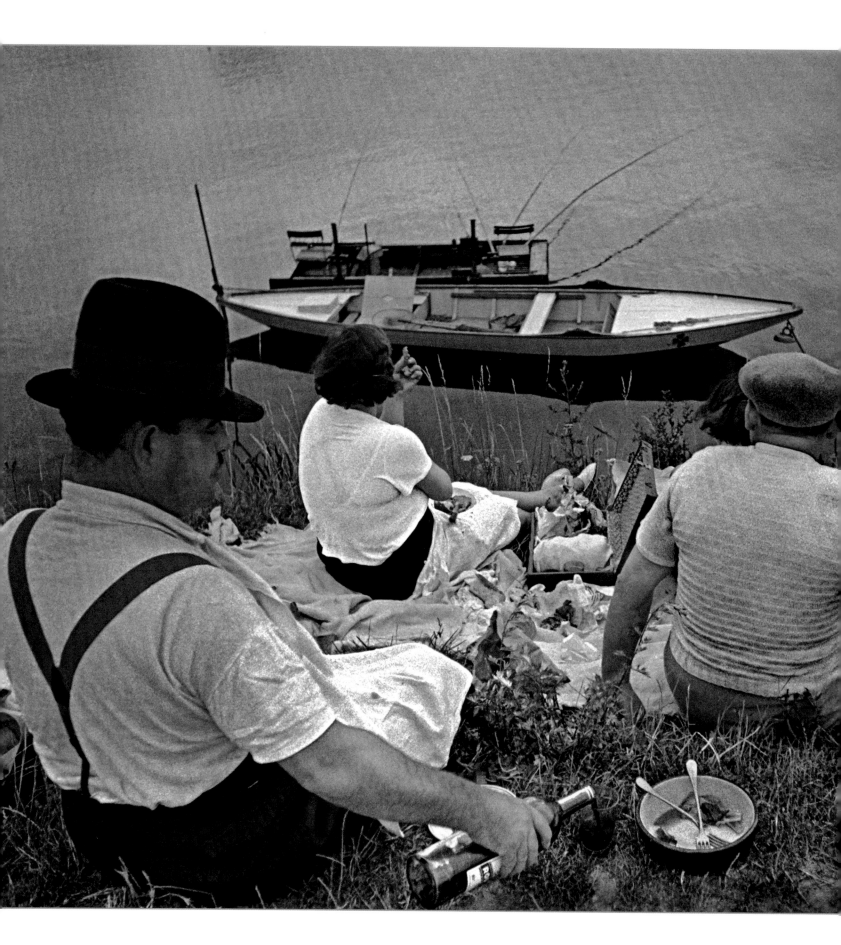

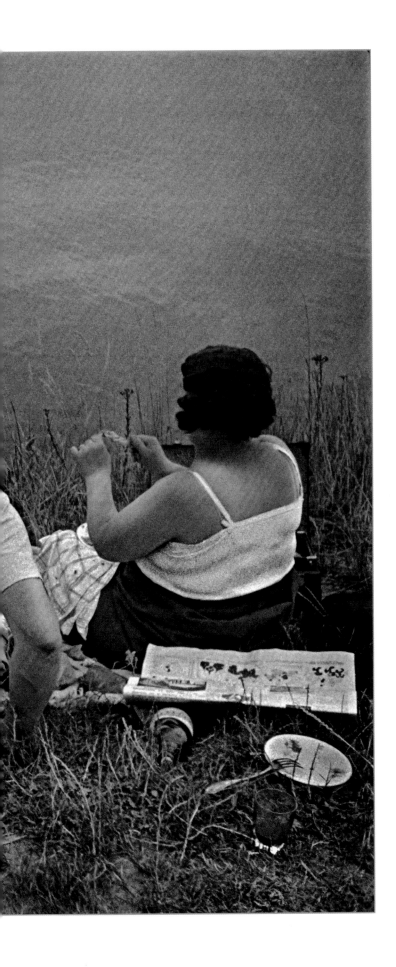

Cartier-Bresson combined the clarity of thought and love for reality with a lyrical impulse and a touch of irony. "I'm just a nervous type," he said of his swift ability to grab the perfect shot. And to reiterate his determination not to apply know-how in the dark room, he added: "As for photography, I don't understand anything." Yet the photographer must know the camera perfectly so that it becomes for him a docile instrument to be set correctly at the time of shooting without hindrance.

The result he obtained is amazing because he himself liked to be surprised. He did not want to decide, plan, or "pre-see": he wanted to *see*. He wanted to become like weather-vane, to know the precise moment when to hold his breath, shoot and capture a moment of truth, real, but already strictly organized. He wanted to be caught by surprise, to feel wonder, emotion and the ineffable happiness of one who knows he has communicated to others.

France, 1938 It is the snapshot that in the collective imagination represents the classic Sunday in France. Cartier-Bresson carries the viewer into the action: in this case it is impossible not to feel as if seated in that meadow along the Marne sharing a glass of red wine. The realistic style, the composition – not minimalist, but totally free of disturbing elements – are graphic details. The gesture frozen in time allows the eye to pause and record an authentic slice of life.

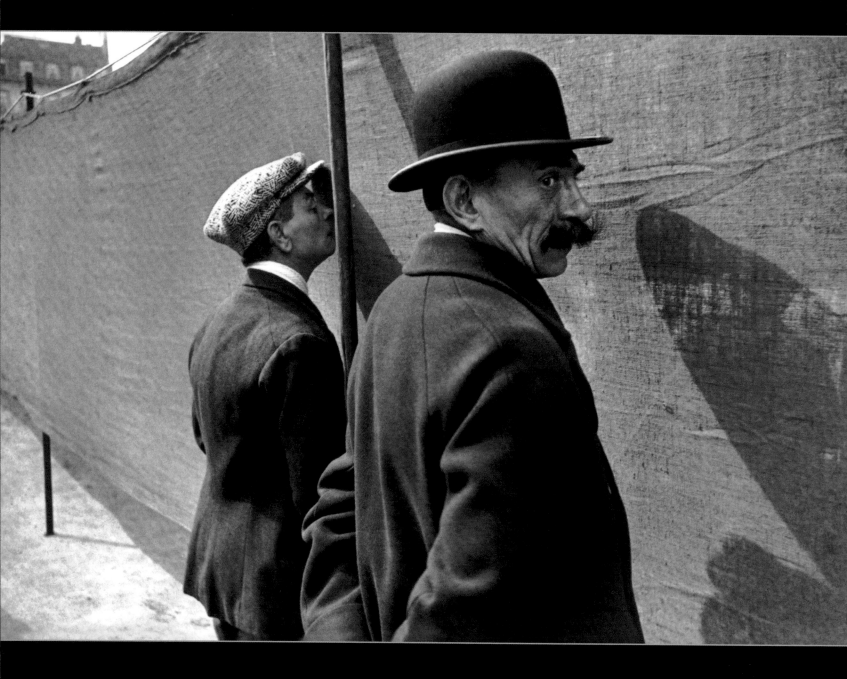

60 - Brussels, Belgium, 1932 Curiosity, tickled by the cloth and shot with a 50mm lens, dominates in this picture thanks to an essential composition that leaves no way out: the two diagonal lines highlight its strength, suggesting other mysteries to unravel. This is the moment captured in a lightning-fast and orderly way that makes Cartier-Bresson's photos exceptional.

61 - Mexico City, Mexico, 1934 The story of a difficult job, in the slums of what will become the largest metropolis in the world, is a portrait rendered almost allegorical by a paradoxical make-up. In this photo, the story of two prostitutes affects not only the eye, but also the sensitivity of the observer, creating a subtle discomfort: I am there, but I would like not to be.

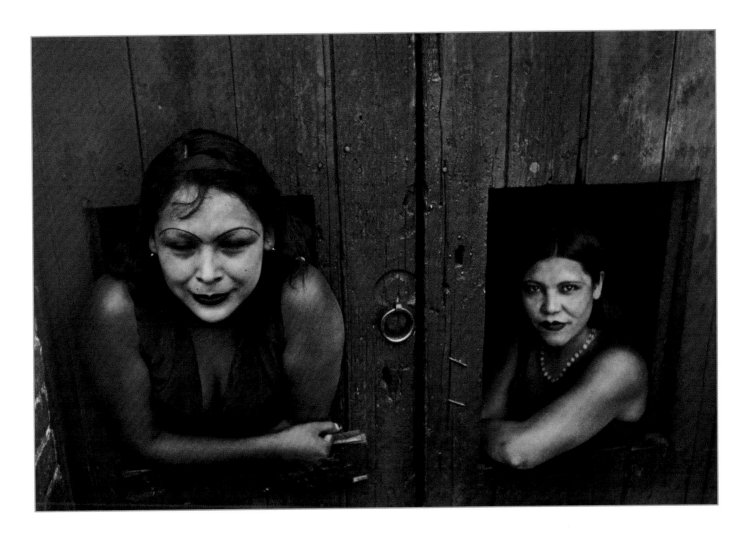

All this is evident in the snapshots that Cartier-Bresson produced in rapid succession anywhere in the world: the old woman with a tattered Stars and Stripes wrapped around her neck in rural America, another one shivering on a bench in Hyde Park. Matisse interacting with doves, two Belgians who try to spy through a cloth wall. A Chinese person with a bench, a cap and his soup. Giacometti crossing the road in a downpour, pulling his raincoat over his head, children playing in Andalusia, Indians reaching out to grab sugar balls, Indian women spreading their saris in the sun. His many sleepers: on a Romanian train, on an American couch, on the bed of a lover in Mexico, on a lawn in Trieste or Marseille, on British steps crammed with crowds attending a coronation, and his wonderful weightless flights of those jumping from a puddle or his shining wet asphalt.

Cartier-Bresson covered the 20th century without missing a thing: the political commitment during the civil war in Spain, imprisonment during the Second World War, escape and resistance. He crafted informal everyday life portraits of major world characters: from the masters of Cubism and Expressionism to Martin Luther King, Nixon, Stravinsky, Faulkner, Sartre, Marilyn Monroe, Coco Chanel, Camus, and Capote. He was one of the two photographers allowed to attend Gandhi's funeral (the other was Margaret Bourke-White). He struck up a friendship with Robert Capa and founded (with him, David Seymour and two others) the mythical Magnum Photos. He did everything with passion, curiosity, and rigor. Commenting on his thirty-five years behind the lens of his Leica, Cartier-Bresson will say: "Photography is not a job, we do not work; we allow ourselves tough enjoyment."

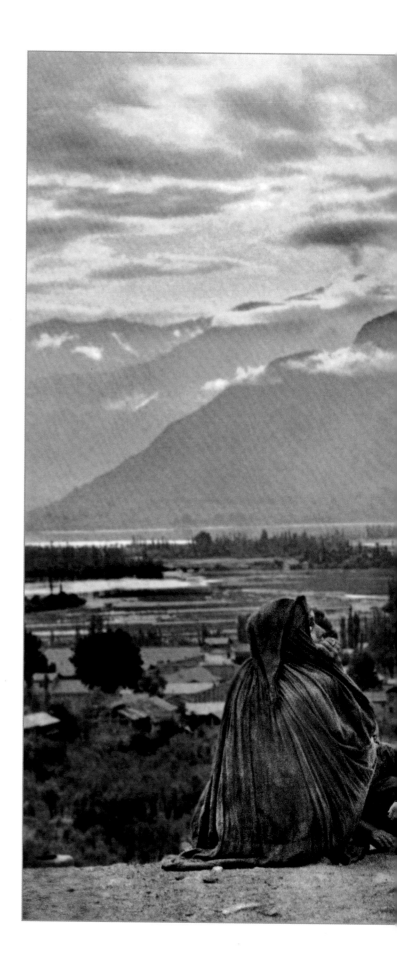

Srinagar, India, 1948 At the foot of the Himalayas, Cartier-Bresson snaps this photo with an uncustomary approach for a photographer who is renowned for his ability to create order in graphic elements. Slow, almost suspended in what may seem like the beginning of a new day, stands the powerful figure of the woman with her hands raised in some sort of blessing. The gesture imposes on the vaguely confused play of the lines that define the scenes. All the tension of this photograph is concentrated in the dialogue between the hands and the intense light that filters through the clouds.

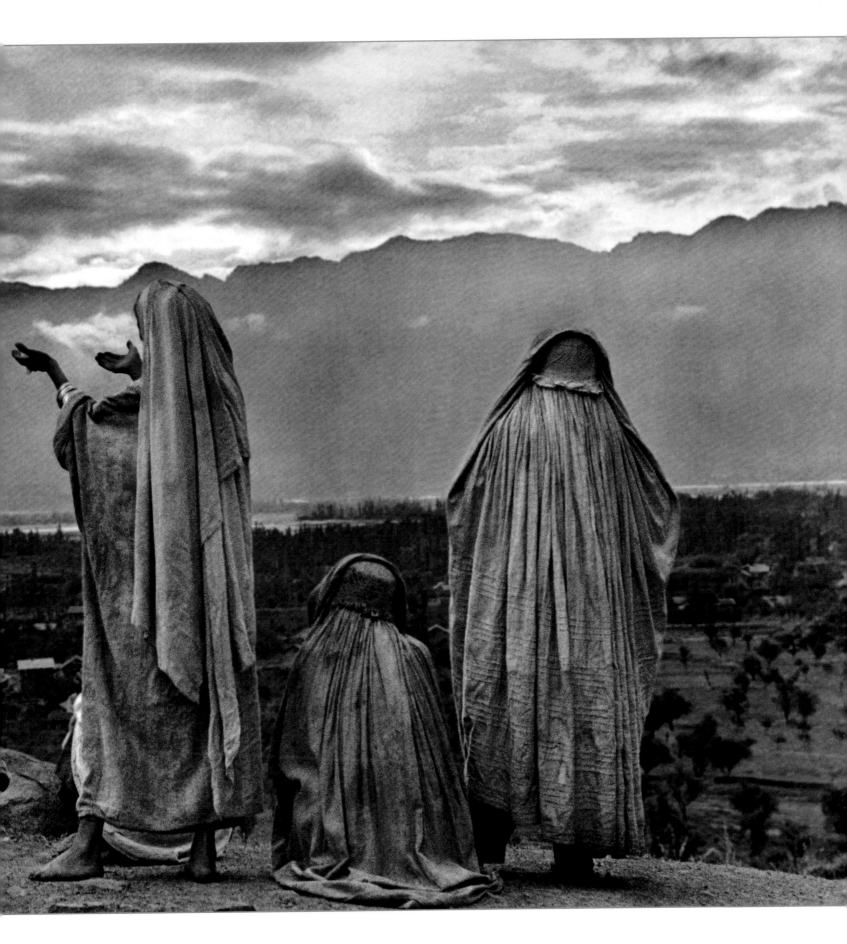

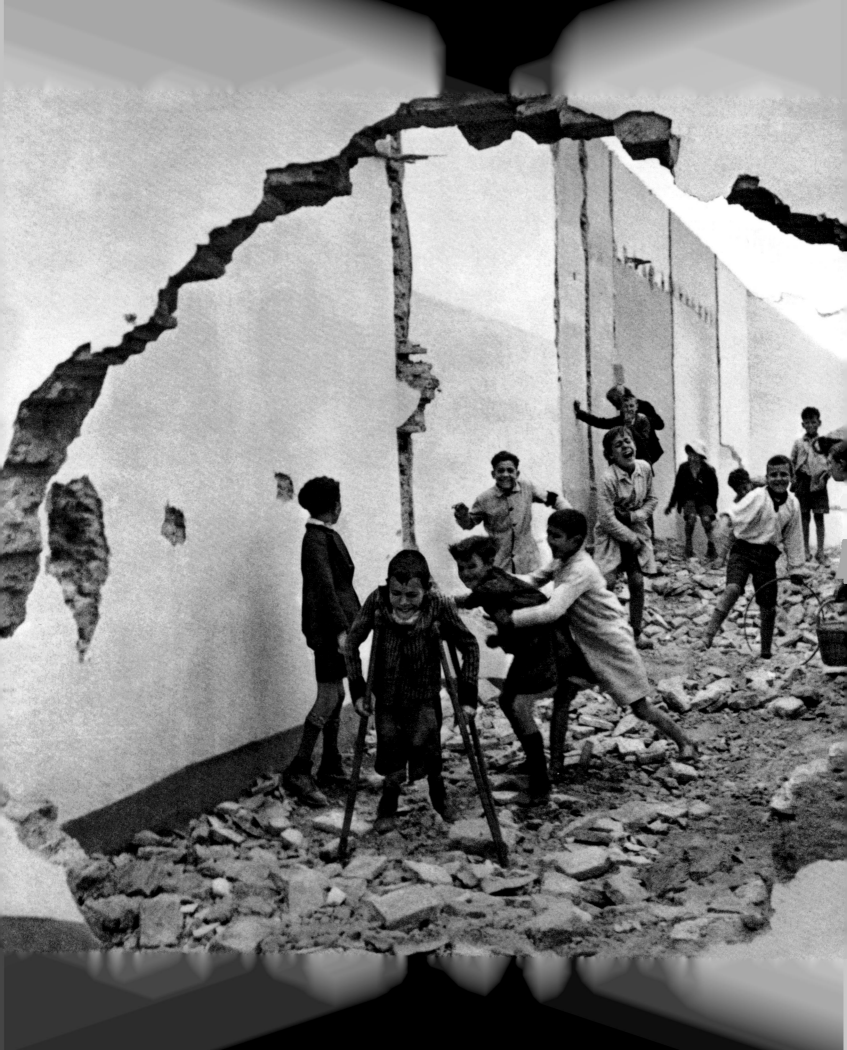

Henri Cartier-Bresson

Seville, Spain, 1933 Kids playing war amidst the ruins of a war that has yet to begin. Drama, lightheartedness, action and disaster circumscribed by the geometric strength of a crack in the collapsed wall. The energy has no way out and forces the gaze to focus on the group of young people. It is the art of composition, which evidently reflects Henri Cartier-Bresson's disposition even before his career as a photographer. The subject of interest is a view often fleeting; the camera is given the task to be fast and to respond precisely to the intent of the photographer.

November 20th, 1911 - Warsaw, Poland • November 10th, 1956 - Suez, Egypt

David Seymour

Through the filter of children, who with their innocence are able to navigate horror in order to overcome it, Seymour tells of the terrible destruction and madness of war.

The children of his photographs tell of a denied childhood. They are children of war. They are presiding German fortifications on the border with Belgium holding a pickaxe or a slingshot. They breathe in coal dust in the mines where they work, in northern France. They are breastfed by women whose faces are marked by fatigue and hardship in a village of Extremadura. They are crowded into an underground shelter while bombs fall on Menorca. They sit upon the shoulders of their fathers in procession to commemorate the dead of the Paris Commune. They learn to embroider in Naples, in the Bourbon Hospice for the Poor, and on their solemn faces the flashback of rape is imprinted. They wait for their meal clutching aluminum glasses in a Greek refugee camp. Perhaps these children understand what they live through, maybe not. In any case, they feel it. They absorb it daily, by osmosis, even when they laugh or play in bombed houses as if they were in scenes from an imaginary castle. Someone makes faces while clutching a rag doll, and someone squeezes, fervently, a warped box full of cigarette packs. Some rake a stony ground as if it was the king's garden, and others use a blanket thrown over their shoulders as if it were a magical cloak. Some are balancing against a wall; others smile despite the rigid corset for spinal tuberculosis, whose incidence grew exponentially after the war. And if there is the illegitimate son of a British soldier, framed in swaddling bands completely forsaken in the rubble of Essen, then there is also Miriam – the first child born in Alma, an Italian settlement in Israel – whom the young father happily raises to the sky. The war resets boundaries, crawls through barbed wire and spreads its poison, no matter what language you learn in school. David Seymour knows eight languages, and this, combined with an eclectic culture and an internationalist spirit, facilitates his understanding and empathy, which is devoid of sentimentalism toward the subjects he photographs.

Ironic and positive, Seymour's gaze has always withstood the horrors that his camera has depicted. This masterful portrait was taken by his friend Elliott Erwitt in 1956.

David Seymour

Borghese Gallery, Rome, Italy, 1955 The American art collector Bernard Berenson pictured while admiring Canova's famous *Pauline Bonaparte as Venus Victrix*. In the years after the Second World War Chim (Seymour's pseudonym) spent a lot of time in Rome to photograph the places and rites of Christianity and to take portraits of famous people. It was probably a break after the horrors photographed during the war. Like his friend Henri Cartier-Bresson, Seymour loved the atmosphere of museums, where he took many photos which convey that sense of peace and serenity that comes from the contemplation of art.

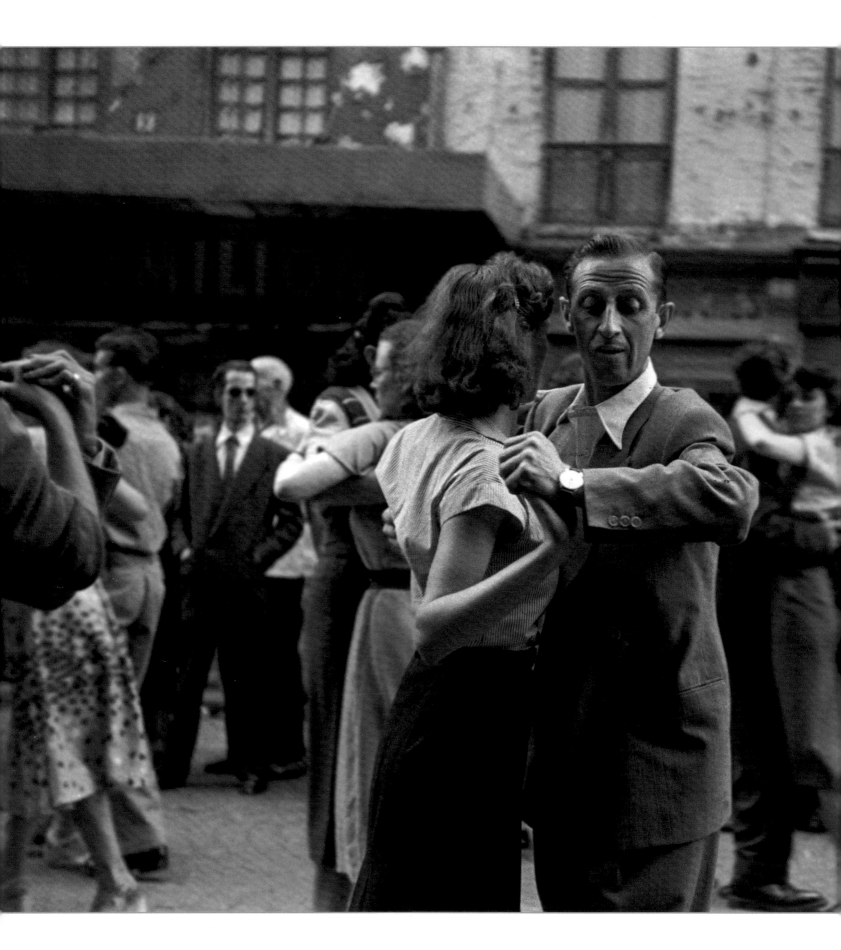

The reportage by UNICEF on war orphans, published in the book *Children of Europe*, has immediate resonance. It becomes finger-pointing against the senseless violence and the permanent trauma that children are forced to suffer. A painful denouncement that is impossible to ignore. Seymour, with his studies of graphic arts in Leipzig and a degree in chemistry and physics at the Sorbonne, began his career as a photographer portraying Parisians working at night. By this time he had already documented the Civil War in Spain, the expatriation of 150,000 Republicans to Mexico, and the invasion of Czechoslovakia. Naturalized as an American citizen, he enlisted in the U.S. Army as a cameraman and an interpreter able to decipher aerial photos of war zones. His family was exterminated in the concentration camps. Torn, he continued to photograph: always attentive to the human aspect of the conflict, to the fragments of pain, of loss, of dignity preserved tooth and nail and represented in the expressions and gestures of the people, and to their timid signs of hope.

Paris, France, 1952 More accustomed to photographing despair than celebrations, Seymour took this picture on July 14th, 1952 during the festivities for Bastille Day. The image balances a pragmatic approach to photojournalism and the photographer's ability to "see" the moment. The choice to put only the central couple in focus contributes, along with their compositional isolation, to giving greater visual weight to the subjects.

David Seymour

After the war he portrayed celebrities, preferring a graceful Audrey Hepburn in a dancing school or in the park, holding a bunch of balloons, and Picasso before details of his *Guernica*. He honed his street photography technique and entered quietly in museums and art galleries, where the atmosphere was particularly congenial to him.

The subsequent phase coincided with the death of Capa in Vietnam. Seymour became President of Magnum Photos, of which he was co-founder, an office he would hold for only two years. On November 10th, 1956, during the Suez crisis, while he was on a mission to photograph a prisoner exchange between Arabs and Israelis, an Egyptian sniper's submachine-gun fire riddled with bullets the jeep he was traveling in. This was the end for David Szymin, aka David Seymour, born forty-five years earlier in Warsaw and known in the history of photography as Chim.

Matera, Basilicata, Italy, 1948 One could almost call this photo timeless, since the visual impact of the Sassi today is not very different. Though the Sassi di Matera are now a destination for tourists, in the post-war period the city experienced very harsh conditions. Perhaps encouraged by his friend Carlo Levi, Seymour took a series of photos at Matera, including this glimpse of calm, almost rural, landscape, and the famous *Peasant Girl*. He claimed that he had rarely seen a level of poverty comparable to this isolated corner of the world, and judged the conditions of children in Basilicata to be among the worst known in peacetime.

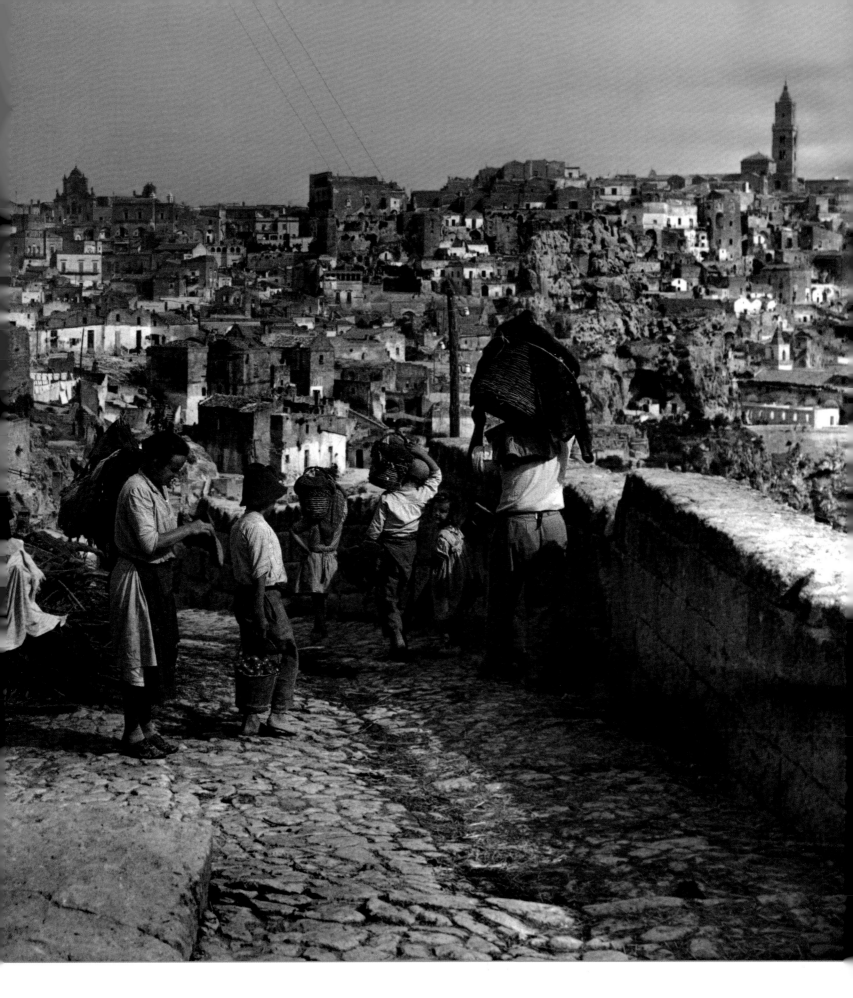

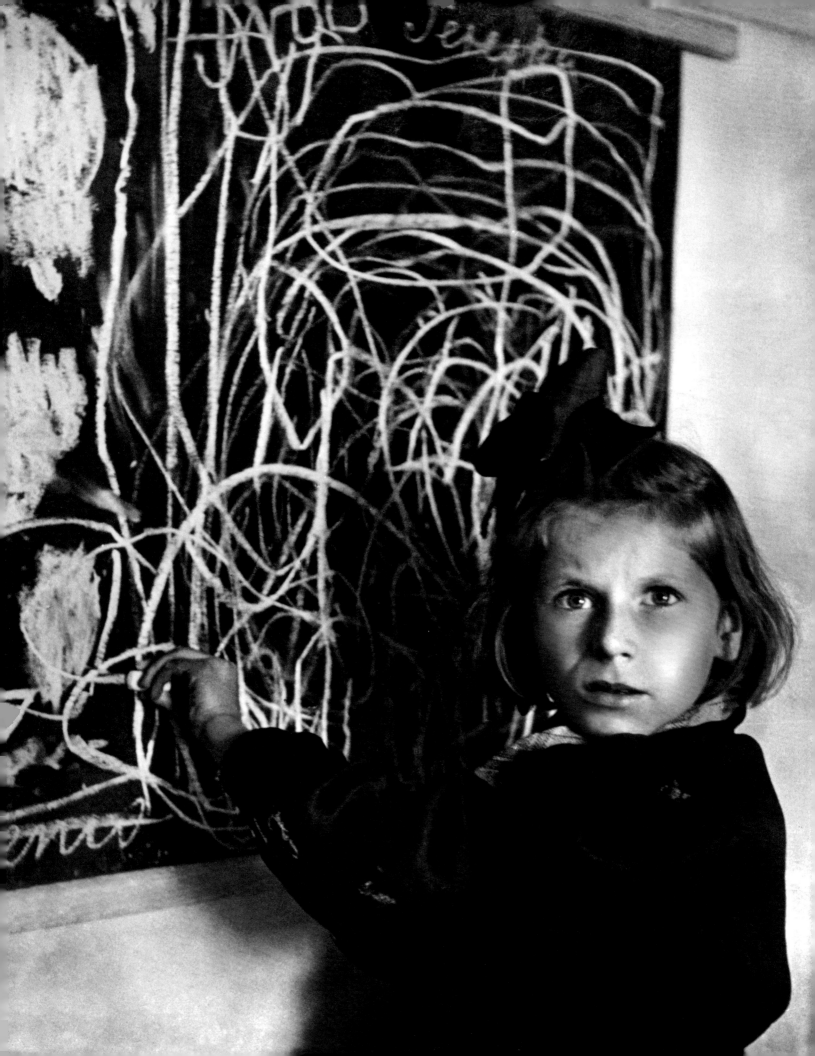

David Seymour

Warsaw, Poland, 1948 After the end of the war, Seymour worked for UNICEF to document the situation of war orphans. He poured all of his sensibility into this work about lost childhood and created his most important work. A striking series of images that would shock the European public by showing the desperate conditions in which thousands of children were living, mutilated both physically and psychologically. This is the portrait of Tereszka, a polish girl who grew up in a concentration camp. The shapeless labyrinth on the chalkboard behind her is what she drew when asked to illustrate the word "home."

April 14th, 1912 - Gentilly, France • April 1st, 1994 - Montrouge, France

Robert Doisneau

La *vie en rose* – which our "fisherman of images" would like to live – comes to life in front of his lens, which captures the Paris of intellectuals, the lively city of the boulevards and the working class town of the *banlieues*.

If you were to write a screenplay for a film on Robert Doisneau the photographer, the elements to be assembled would be simple, ordinary and very limited in space.

A maze of streets cut out from a Parisian *banlieue* (where Doisneau was born). Extras: an accordion player; a drifter smoking, leaning against the wall; a woman with her hands shoved in the pockets of a faded coat; a group of children with a beret and a rough sweater knitted by hand; a sleeping dog; a French cop. Considering their narrative potential as if it were another movie and the cast required Jean Gabin, the following would happen: A woman is walking fast, in one of her pockets she is clutching a string of stolen pearls. She quickly throws the pearls to the accordion player (a crook, her accomplice) and slips away, hampered by kids throwing stones at the dog. The drifter, even before he is approached by the cop brought to the scene, misleads him, pointing with his chin in the wrong direction.

None of this, however, if instead of a cop a shy guy holding a camera enters the picture: in the role of Doisneau in his early twenties, who observes from behind a corner and shoots photos.

In this case the woman is walking slowly, absorbed; the accordion player strikes up with feeling *Nuits de Chine*; the dog shakes off and hops to a (invisible from here) glimmer of the Seine; the kids are doing somersaults and engaging in a competition to see who can walk better on hands. The woman suddenly perceives the sound of an accordion, smiles, and hints at a few dance steps on the curbside; after all, *Nuits de Chine* is a fox-trot. The drifter recognizes in her a lost love, calling her by name. The music stops and resumes, this time with passion, when they kiss tenderly.

Doisneau looked – through his lens – at reality with this light-hearted and benevolent filter; a reality of which he narrated the most poetic, minimalist aspects. He himself was a creature of the neighborhood. He said he could not stay away from home for more than three days; he deeply loved the suburban characters, the boulevardier and bistro spirit that privileges kindness, harmony, and life as a play or dream.

Robert Doisneau with his beloved Rolleiflex in a photo taken by Peter Hamilton in 1992. That good-natured smile perfectly encapsulates his vision of the world and his photographic style.

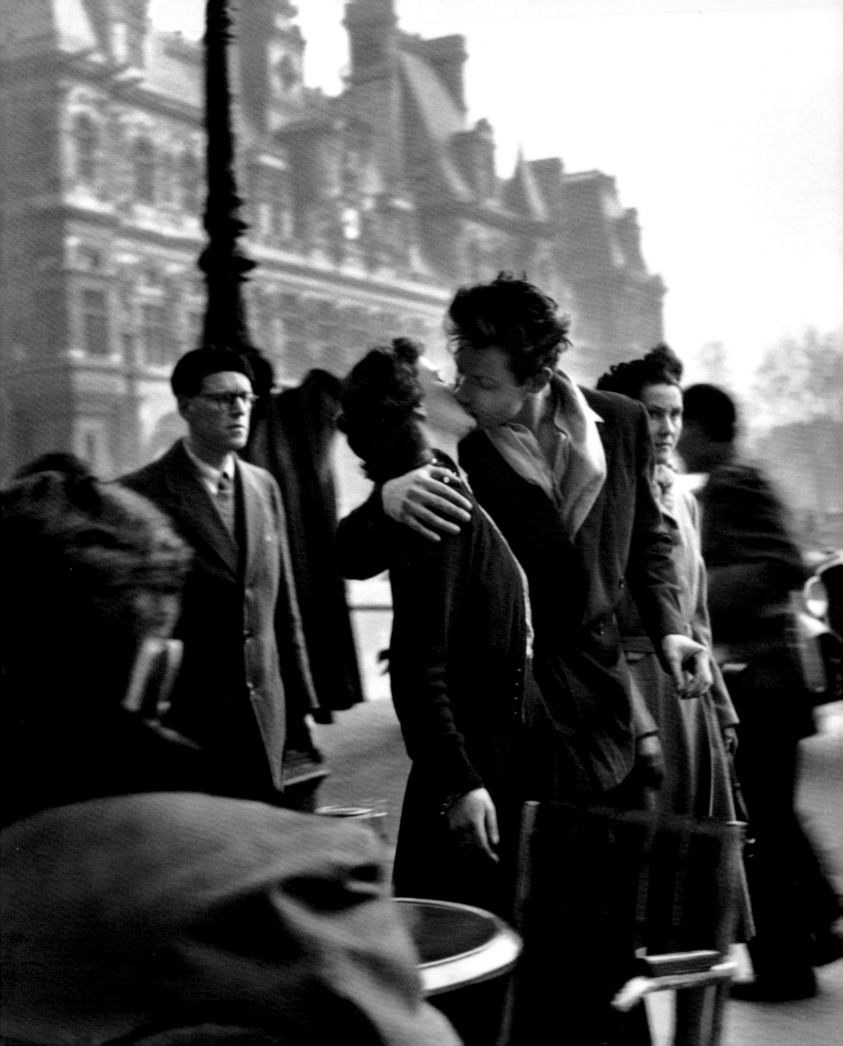

Yet he will say of his youth: "I have recollections of a time of great anxiety," and he will describe the first work experience at Renault – five years as an industrial photographer among the workers at the assembly line – as indignant awareness and the beginning of his civil commitment, among "smells of hot oil and exhaust gas (...), the dull thudding sounds, the hammering, the electric crackling."

Not being able to paint the world that he dreamt with a Chagall brush, when he believed it was the case, Doisneau did not hesitate to sweeten reality, giving it a little push that made it resemble Frank Capra's *It's a Wonderful Life*.

"All my life I had fun, I made my own little theater," he will say. The fisherman of images – as he liked to define himself – organized short plays and filmed them as if they were snapshots, in order to see the world not as it is, but as he would like it to be. In this way he staged some of his most famous photographs, including *Kiss de l'Hôtel de Ville*. During the years when Paris meant fashion, glitter, and worldliness, Doisneau proposed an unconventional and peripheral style. His Paris is light years away from that of Josephine Baker with banana skirt and cheetah at the Folies-Bergère; far removed from that of the defiant girls smoking, dressed and combed *à la garçonne*. It is not even the tragic Paris angrily sung by Édith Piaf.

Paris, France, 1950 It is the most famous and celebrated photo by the Parisian photographer. It is a very successful staging; you could easily think of a shot stolen from the street. The two young people were asked to pose for this photo: a shining example of Doisneau's inventiveness, a world where all is well, where every gesture takes a positive turn. Accomplices are the wise choice of a slow shutter that gives dynamism and the spontaneous attitude of passersby that emphasizes the effect of a snapshot.

The Paris of Doisneau is the Paris of Prévert: its boundaries are the benches of the Seine banks, homeless sleeping under the cast-iron street lamps, impatience and insolence of schoolchildren who are eager to play, ashtrays crammed with cigarette butts on outdoor tables, faces telling nostalgia, love, booze, and regret. Doisneau and Prévert met immediately after the war and immediately became friends. They shared the idea that the possible salvation of the world is in love, in childlike innocence, and in language – photographic and poetic, respectively – simple and ordinary, which does not dig deep, but rather reflects easily comprehensible human emotions of the ordinary man. Whoever loves Prévert loves Doisneau, highlighting their sensitivity and lyricism. Those who hate the one, hate the other, criticizing a "feuilleton-like" approach, despite the intermittent use of humor and irony. For Doisneau, the years spent between his birth (in April 1912) and his death (in 1994, again in April) are unhurried, without whirling movements. After all, in this regard, Doisneau had explicitly pledged: "I am determined to prevent the flow of time."

Paris, France, 1934 It is a typical laid-back Sunday, with the bourgeois walking in the park under the sun. The photographer even seems glad that the child spoils the photos: it is hard to imagine that the scene was not organized. However, the message of "the fisherman of images" remains clear: it follows that street scene and reveals a city that is smiling and looking to tomorrow with optimism.

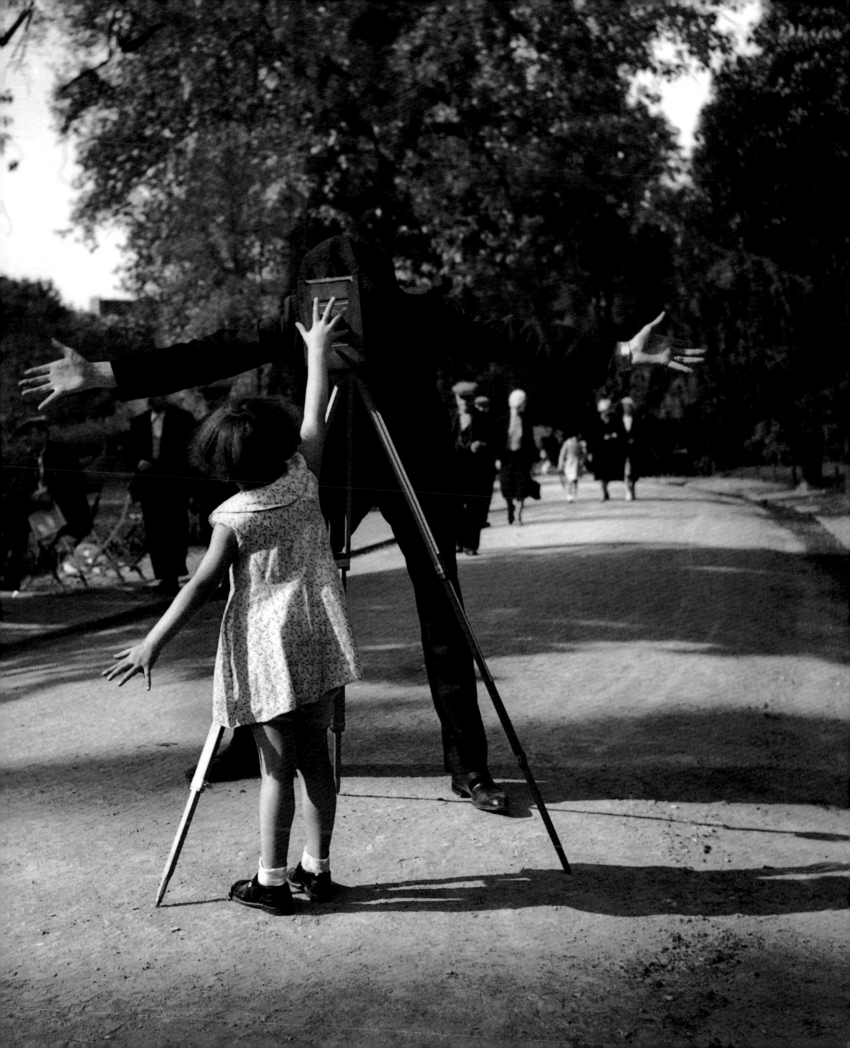

Robert Doisneau

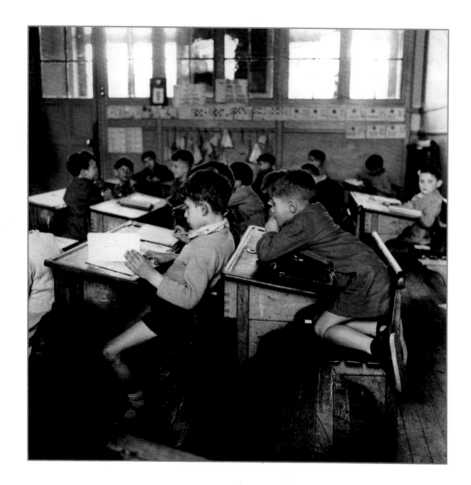

82 - Paris, France, 1956 The children's section is important in Robert Doisneau's vision. These images show kids how they ought to be: curious, full of anticipation, and perfectly unaware of the concerns that agitate the world.

83 - Paris, France, 1953 You can notice at a glance, in this photo, the thread of a contradiction: the convergence point of diagonal lines that leaves behind the joy of the youngsters, to let us experience a cold, almost lonely, street. As if the future, at the expense of the photographer, wanted to have its say.

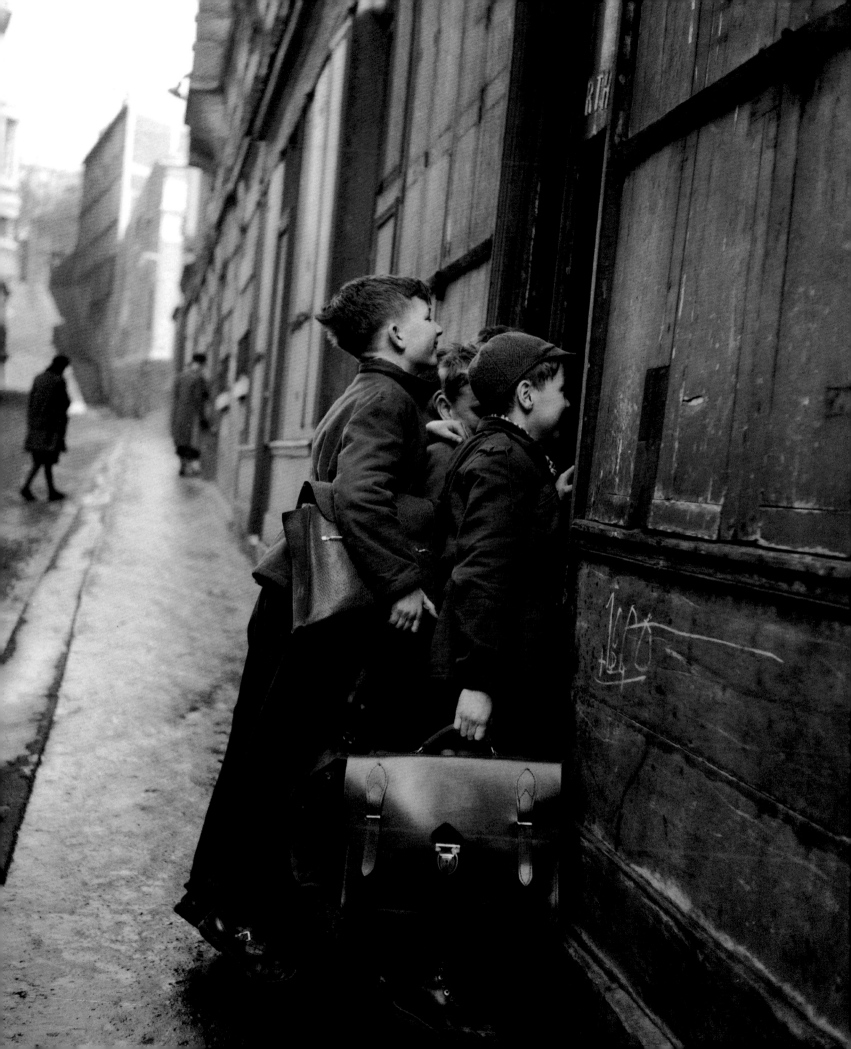

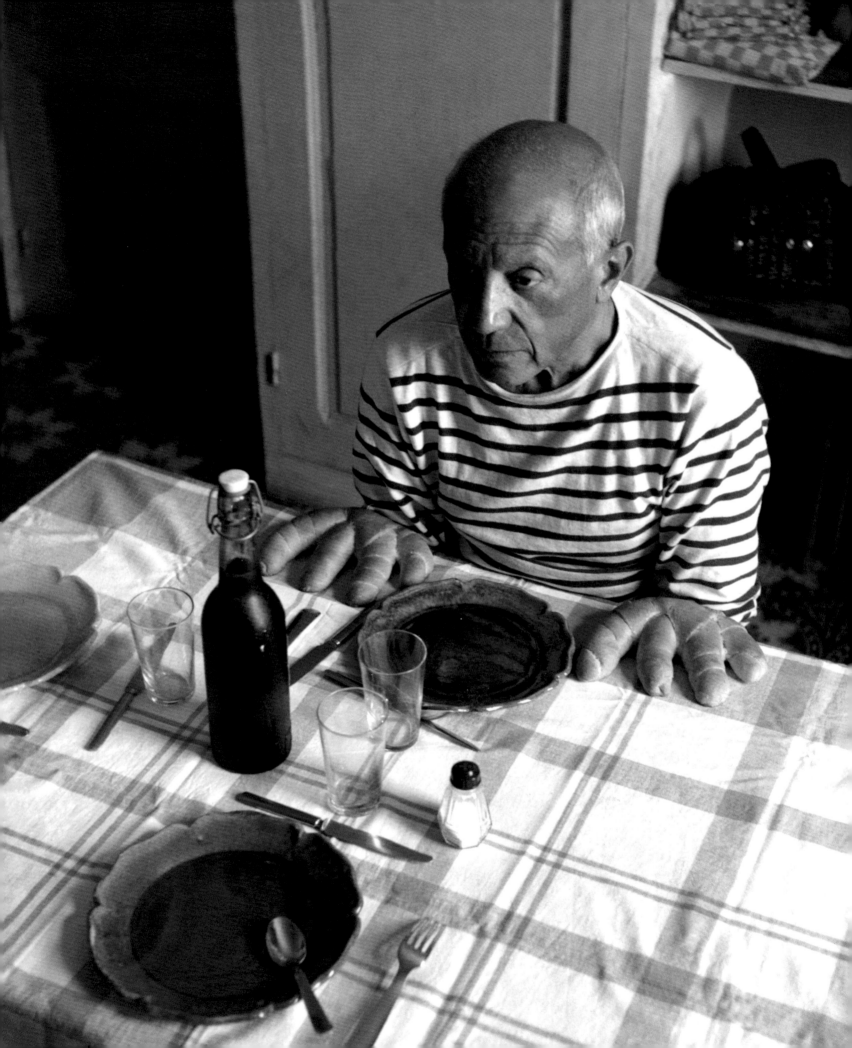

Robert Doisneau

Vallauris, France, 1952 Vallauris is far away from Paris, and far indeed for this photographer who did not like to move from his districts. And yet it is a trip to Vallauris that results in one of his most beautiful images: where irony becomes playful and engages the great artist with disarming simplicity. No staging around, only a home table. The focus is on the tablecloth, fixed on those unlikely fingers; yet the crucial element is the serious and deep gaze of Picasso, which makes the two loaves-hands even more absurd.

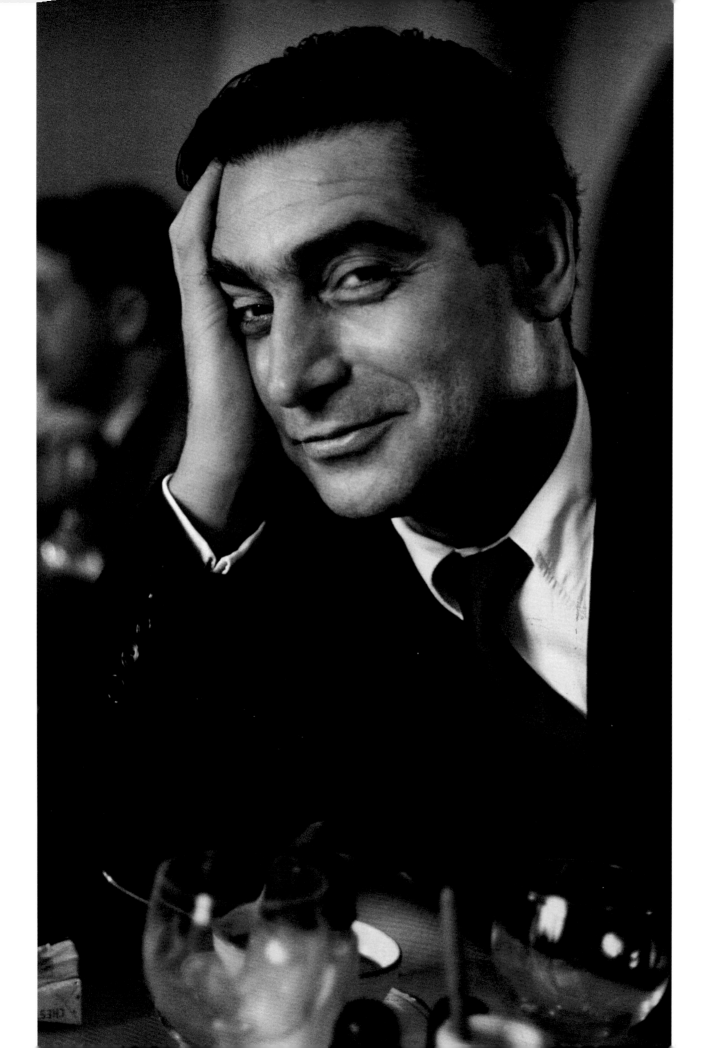

October 22nd, 1913 - Budapest, Austro-Hungarian Empire • May 25th, 1954 - Thái Bin, Vietnam

Robert Capa

Capable of venturing into the hell of any war to capture so masterfully its brutality on film, Capa would pay the ultimate price for his courage and his determined decision to be on the front line.

Through the multitude of words expressed to tell his story and that of the shots taken by his cameras, Robert Capa comes off in the foreground: a powerful figure in motion, in black and white and *slightly out of focus,* as he titled his journal written between Normandy, North Africa, and Italy.

Robert Capa, of Jewish descent, was born in Budapest in 1913 under a tragic star. He tried in every possible way to build a different fate. He left Hungary, where the regime of extreme right suffocated him, and settled in Berlin, but the Nazis were coming. Then off again; this time to France, where he worked as a freelance photographer. His escape instinct and social commitment against dictatorships and war were very strong; they became reference points in which the story of the young Hungarian began to write itself. Precisely in Paris, the man born as Endre Ernő Friedmann chose a new name and a new autobiography. He now presented himself as Robert Capa, an American photographer who arrived in Paris together with Gerda Taro, a photographer herself. They were both animated by a stunning civic passion and courage that was often reckless: they worked together in Spain on the front of the civil war. From 1936 to 1954 Capa, mingled with soldiers, will participate in the Spanish Civil War, the Chinese resistance against the Japanese invasion, and the Second World War, as well as the Arab-Israeli conflict, and the First Indochina War. He will follow an incredible number of military actions, often on the front line, to take pictures from close range, because "If your pictures aren't good enough, you're not close enough."

To document and report the hell and the senseless cruelty of any war, Capa parachuted twice together with the Allies: in '43, at night, on the Sicilian coast; in '45, on the banks of the Rhine to cross the river and reach the heart of Germany.

Robert, called Bob, took thousands of photos, superb and exciting, of soldiers and civilians, victims of the same murderous rampage. He also portrayed poignant scenes of minor firefights, which, perhaps, are able to emphasize even more their absurdity.

Ruth Orkin, an American photojournalist and director, here photographs an atypical Robert Capa: cheerful and at ease, far from scenes of war, in a Paris café. It is 1952.

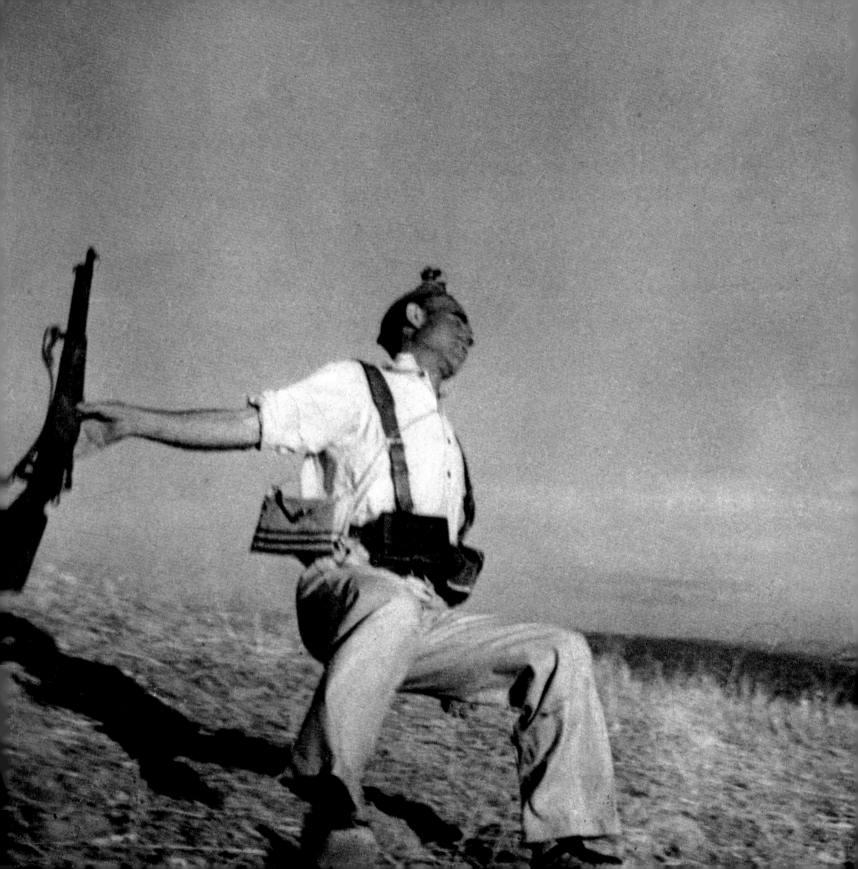

The farmer on a Sicilian mountain telling an American soldier, crouched next to him, the direction taken by a German tank; the little girl sobbing, whom no one has time to console; a collaborator with a shaved head holding in her arms a baby – the son of a Nazi – pained while passing through the crowd celebrating the liberation. Capa became famous for the photos that came directly from the front to the editorial staff of *LIFE*. In '47 he – along with Henri Cartier-Bresson, David Seymour, George Rodger and William Vandirvert – founded Magnum Photos agency, from the start a magnet of great talents without constraints and dedicated to deep social commitment. Meanwhile, Capa became increasingly important. For some he is the greatest war photographer of all time. Yet he was far from being a one-dimensional man. He loved writing and even wrote a series of journals on the same fronts he photographed. He was a friend of artists such as Steinbeck, Hemingway, and Picasso.

Spain, September 5th, 1936 Death of Republican Federico Borrel García, live. His most famous photo, as soon as it becomes widespread, is immediately considered one of the best war photos of all time. It goes beyond the boundaries of reportage; death becomes not just tragedy, but also a visual story that changes in level and increases the value of the image. This picture, which has become an icon of photojournalism, continues to be discussed. In the 1970s some critics also discuss staging, and they suggest investigation to clarify whether that gesture is original or orchestrated. The doubts of detractors show little signs of diminishing. Undoubtedly, what remains is the image of the frontline told firsthand in such a raw and highly symbolic manner.

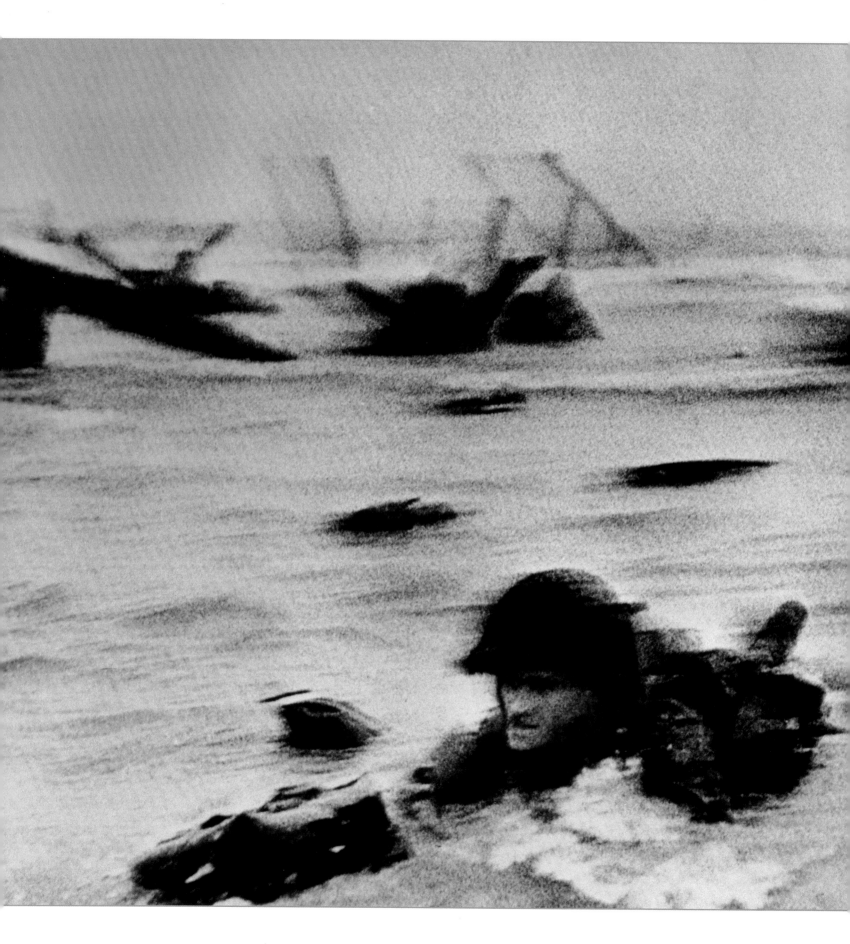

Capa had a passion for women, poker, and horse betting. His gaze seemed to be crossed by a light-hearted irony, as in the famous photo taken of him by Ruth Orkin in '52 in Paris. Despite the achieved fame, boost of energy and courage that Capa brought into play in the round, his fate will always be adverse. Gerda is 26 years old when she is accidentally hit by an allied tank. Out of 106 frames documenting the first landing in Normandy, only 11 were saved from an error during the printing process (but they will become the Magnificent Eleven). His most famous photo became a contentious battleground. Finally, the last act of a destiny that had never been generous with Capa takes place in Vietnam, southeast of Hanoi. It was May, '54. Bob was following a French squad advancing in the muddy water of a rice farm. He went up on an embankment, pulled out his camera, and stepped on a landmine. He was 40 years old.

Omaha Beach, France, June 6th, 1944 It is D-Day, the day of the Normandy landings, the beginning of a huge attack against Nazi Germany. Omaha is the codename of a beautiful Norman beach which that day became the stage of the bloodiest hours of the Second World War: a hell hard to imagine and recount if it were not for witnesses such as Capa. Despite the horror, he managed to push the shutter button of his camera. In this image, only blur, totally random, can restore fatigue, fear, cold and death.

Sicily, Italy 1943 The sun in Sicily hits hard in August. Near the village of Troina, a Sicilian peasant points out to an American officer the direction the Germans have taken. One photo that tells many different stories: the old man, the young soldier, the intersection between what the voices are saying and what the gestures are saying. You could write a story about what Capa manages to suggest with this image that unites two worlds. The two men do have one point in common: the wish to see the end of this damn war.

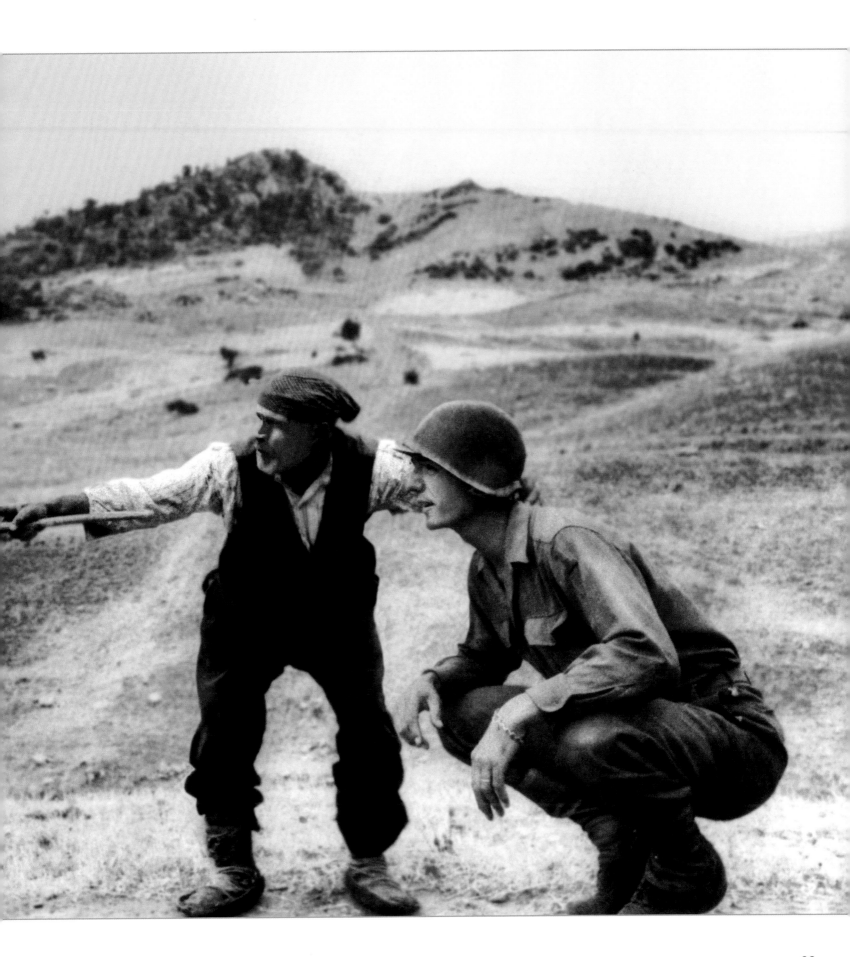

Robert Capa

Chartres, France, August 18th, 1944 In the liberated cities there is not only joy and enthusiasm, but also a few scores to settle. A woman who had a child by a German has had her head shaven in punishment, and is accompanied to her home by police officers, surrounded by a crowd hurling insults at her. Capa's ever-reactive eye does not miss even the most disparate aspects of war reporting. The breadth and scope of his photography from the war is one of his work's greatest legacies.

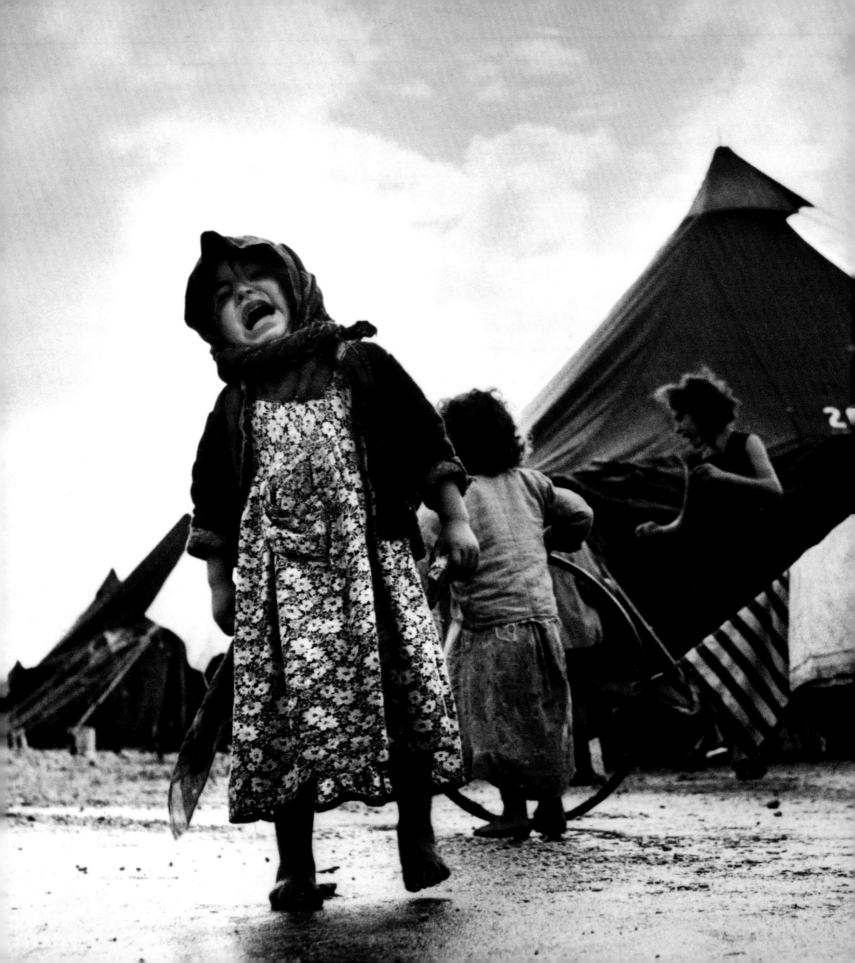

Robert Capa

Near Haifa, Israel, 1950 Capa knew how to translate emotions into moments. Not only at the frontline, but in every place where there was suffering, where life was hanging by a thread of hope or despair. Moments captured and secured so as to bring the observer to center stage; the sense of participation that involves and makes everything real and close, transcending the boundaries of distance and time. In this image Capa places himself below the perspective of the subject. It is no longer a little girl in tears seen by a man. It is the crying of the world as seen by a child. Experience and technique placed at the service of a deep sensitivity.

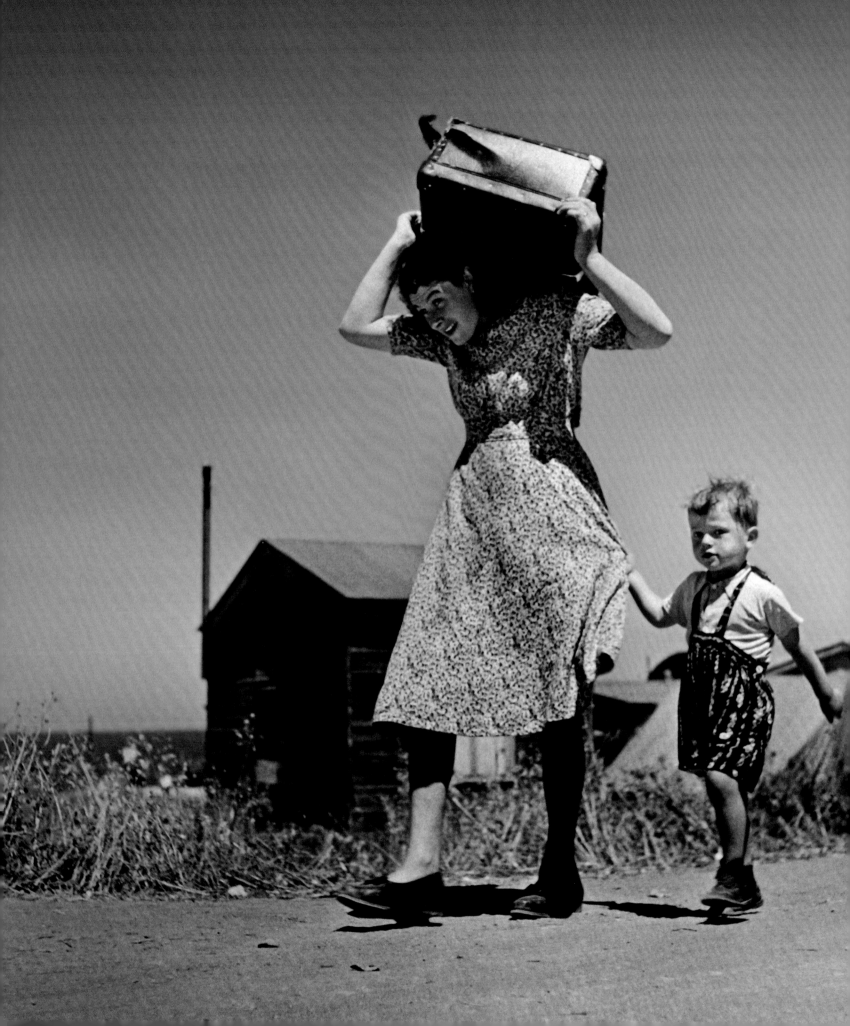

Haifa, Israel, 1949-50 Immigrants arriving in Haifa, in the new Israel. Hopes and fears overlap, which the radiant day mitigates and makes lighter. It is a new beginning that is opening to people who have left behind the old life, whatever it was: a whole society on their way to the refugee camps. In this photo, Capa once again chooses the perspective from below to emphasize the gesture and the atmosphere. A snapshot taken standing would not fully reveal the determined and optimistic expression of the mother.

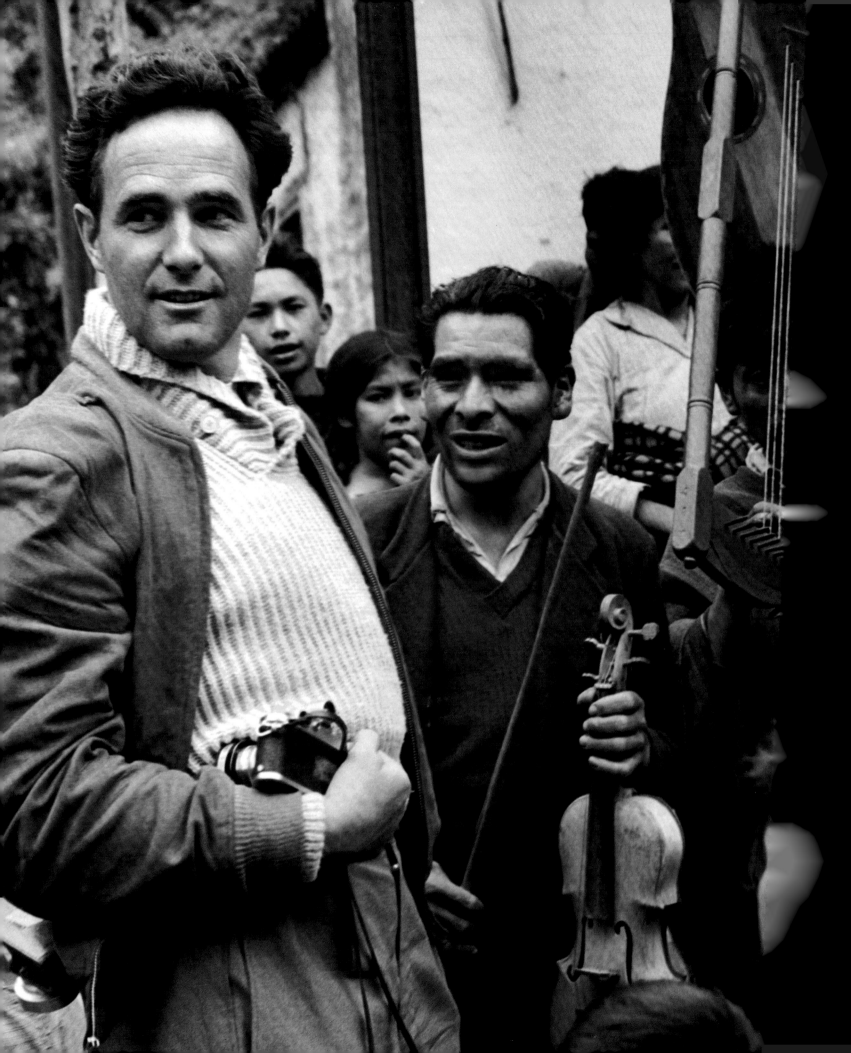

Werner Bischof

Once again war features prominently, but not at the front. Instead Bischof captures – first in Europe, and later in Asia – the heavy wake of death that war left behind.

A fifteen year-old boy is riding his bicycle in the surroundings of Zurich, where he was born in 1916. He attends an art school, studying with passion the new possibilities offered by graphic design, envisioning himself as an artist. His name is Werner Bischof; he also studies photography, but with no intention of becoming a reporter. He criticizes the sensationalism of many magazines of the time and their ravenous search for scandals and special effects.

In '39, in his early twenties, he moved to Paris, which in those years was an extraordinary international laboratory full of turmoil and excitement. He planned to open a painting studio, but history held something else for him. At the outbreak of the Second World War, Bischof returned to Switzerland to serve in the military. There, he published photo shoots in various magazines, especially *Du*, and as soon as he could, he re-opened his photographic studio in Zurich.

With well-established graphic skills he devoted himself to fashion, the study of brands and advertising material. In this way he refined his technical knowledge, mastery in handling lights, play of contrasts and hues, and depth of field. He became increasingly proficient in linking together the various elements that compose an image. Deeply interested in all kinds of visual experiments – especially with respect to motion – Bischof came into contact with the hot heads of the European avant-garde and was impressed by Dalí's studies on optical illusion. He learned to combine the dynamic force contained in an object with the story that through that object he wanted to tell. But the recent war was an unbearable burden that unsettled Bischof's soul and plans with tragic vehemence. In the fall of '45 he was back on his bike, now taking pictures. But a passion for photography still did not motivate him; it was rather – as he will say – the need to "explore the true face of the world." The following year he traveled around Germany on his bicycle. Then he went to France, Holland, Italy, and Greece.

There is a common thread in the portraits of Magnum photographers in the early period: an ironic and optimistic look that belies their dramatic lifestyle. Here Eugene Harris captures Bischof on the road to Machu Picchu, in 1954.

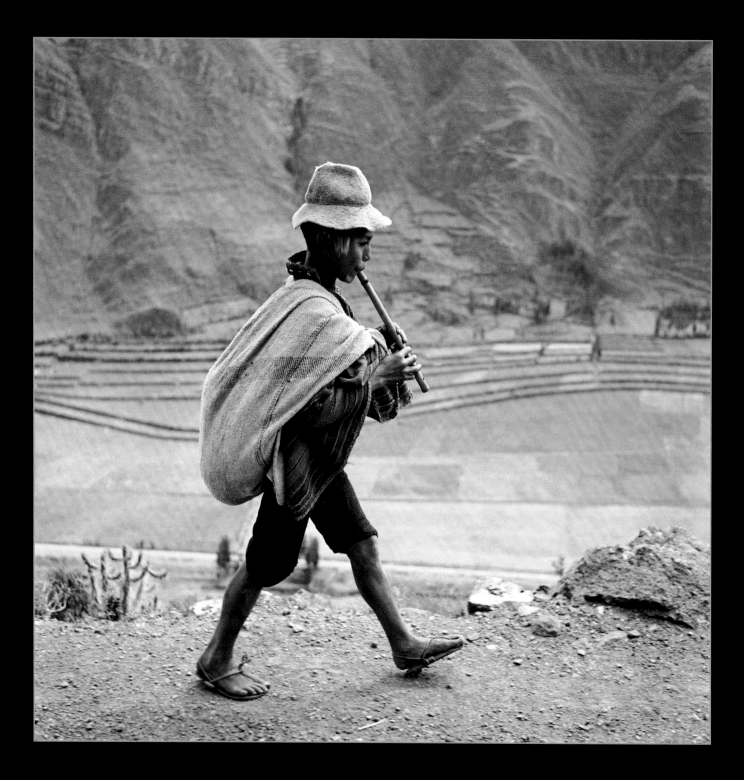

Peru, 1954 Here is a clear example of Bischof's art: being present, perhaps close to the subject, as in this case in the Urubamba valley, but "invisible," so as not to affect in any way the subject he photographs. It is not a matter of technique or equipment, nor of telephoto lenses. This is sensitivity and Werner Bischof's constant ability to be unobtrusive and to maintain respect for the subjects he captures. He is the ideal reporter: one who recounts a place, an honest gesture with transparency, without leaving any trace of his presence.

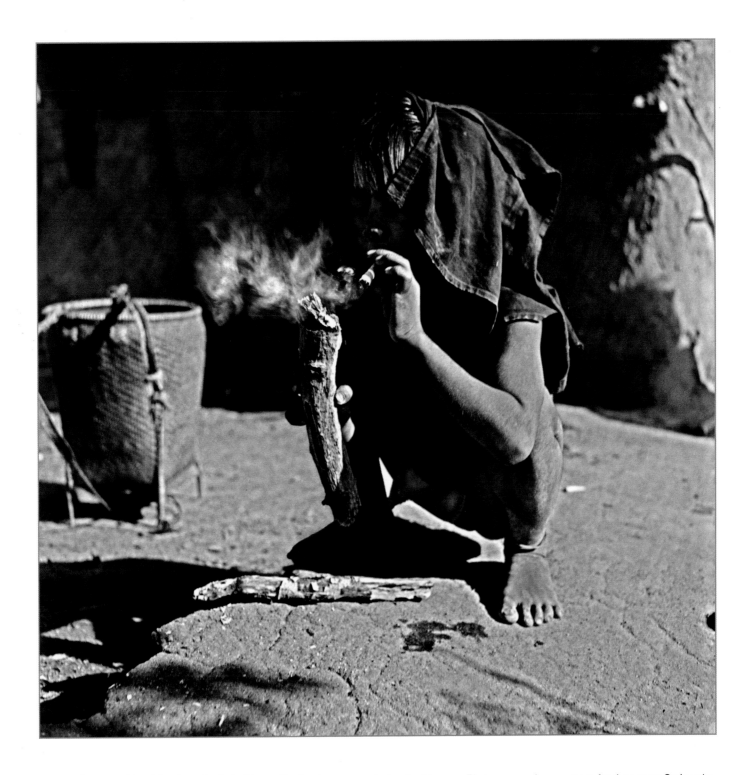

Barau, Vietnam, 1952 His trip to the Indochinese Peninsula on commission for Magnum Photos was a key moment for the young Swiss photographer. He had traveled less than the other great photojournalists of the era, but nevertheless had already developed the ability to see with great clarity and understanding the "alien" realities with which he came into contact. This region of the Far East, troubled by a series of conflicts, was torn between the Middle Ages and the modern age, but its people seemed unaware of the momentous change underway. This child crouching down to smoke captures well this idea of a life in a land out of time.

The wounds, the ravages of war, the difficulty of survival, healing and rebuilding upset him. This time the snapshot is within him and suddenly will bring to light his greatness as a photojournalist, though Bischof will always be reluctant to be defined as such. The photo shoots published in *LIFE* made him famous; the great names at Magnum Photos welcomed him as the first partner in their agency. Then the storm of war faded, and in the early 1950s we find Bischof going off to India and the Far East. Here, regardless of the situation in which he was involved, his interest as an observer and witness remained deeply rooted in a singular form of empathy; between him and the photographed subjects there is always humanity and a heightened sense of respect. The photographer recognizes how to step aside to give priority to what he frames, often relinquishing a dialogue of gazes. It is a rare instinctive form of non-leadership that distinguishes his work and makes it unique.

Famine in India touched the artist, more than the fighting during the Korean War or Vietnam; the barbed wire at Geoje, from which the prisoner's clothes hang out to dry, is like a fist grabbing and clutching the observer's stomach like a demon. Meanwhile, other experiences in the East broaden the range of his perception; the Zen elegance of Japanese culture fascinated him and heightened his desire for perfection.

London, UK, June 2nd, 1953 It is the day of the coronation of Queen Elisabeth II. The whole city is on the move, the crowd presses, but once again Bischof does not seem to be there; he does not take up space, and he does not attract attention. He perfectly portrays the wait, made of anticipation but also of boredom and distraction; all the excitement of a momentous occasion when the hours pass before something happens. Without even resorting to an extreme wide-angle lens, the photographer takes us to the center of London and makes us feel like we are the protagonists.

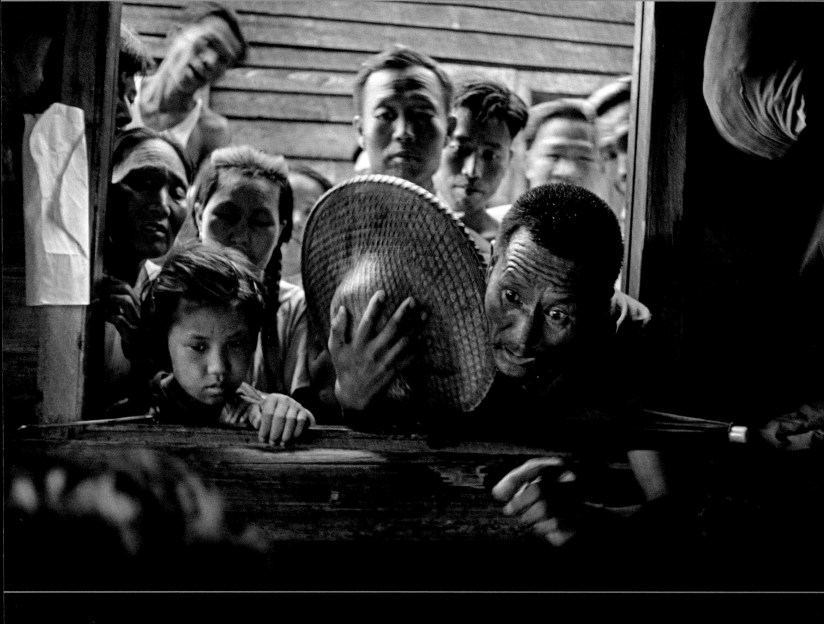

Hong Kong, 1952 At the end of the Second World War, hundreds of thousands of Chinese are seeking refuge in Hong Kong, administered by the British, in an attempt to escape the civil war between Nationalists and Communists that is tearing China apart. The choice of the photographer to change field and capture the desperation of refugees from the point of view of the authorities is brilliant - of those who might change their fate; whereas the slow shutter speed gives a blur which makes the demand for food even more urgent, in a shining example of black and white.

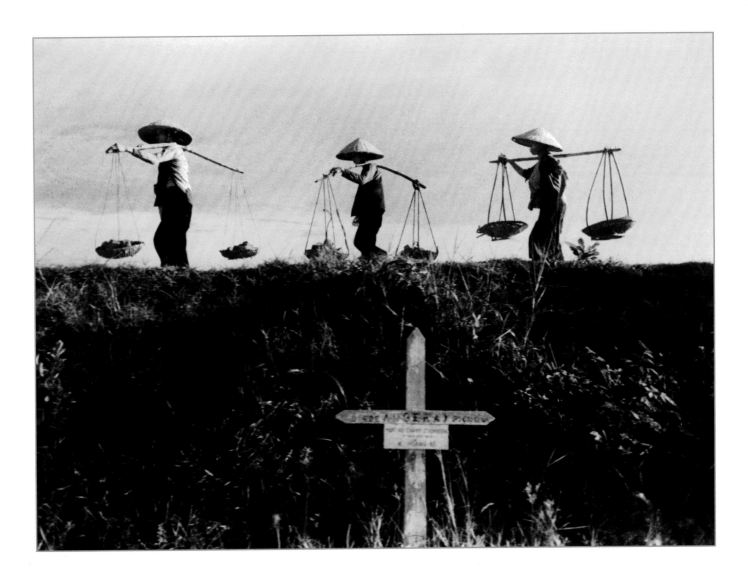

Tonkin, Vietnam, 1952 Between 1945 and 1954 the first Vietnam War saw the French opposing the independence movement. After the Vietnamese victory, the country was divided into a North controlled by Ho Chi Minh and a South controlled by the French. The emotional impact of this image arises from the contrast between the cross planted in the grass, which speaks of the drama of a French soldier buried who knows where, and the Vietnamese farm workers who walk carefree in the countryside with their baskets hanging from bamboo rods. Everything is shrouded in a sense of immobility that characterized the reportage in the Far East at the time.

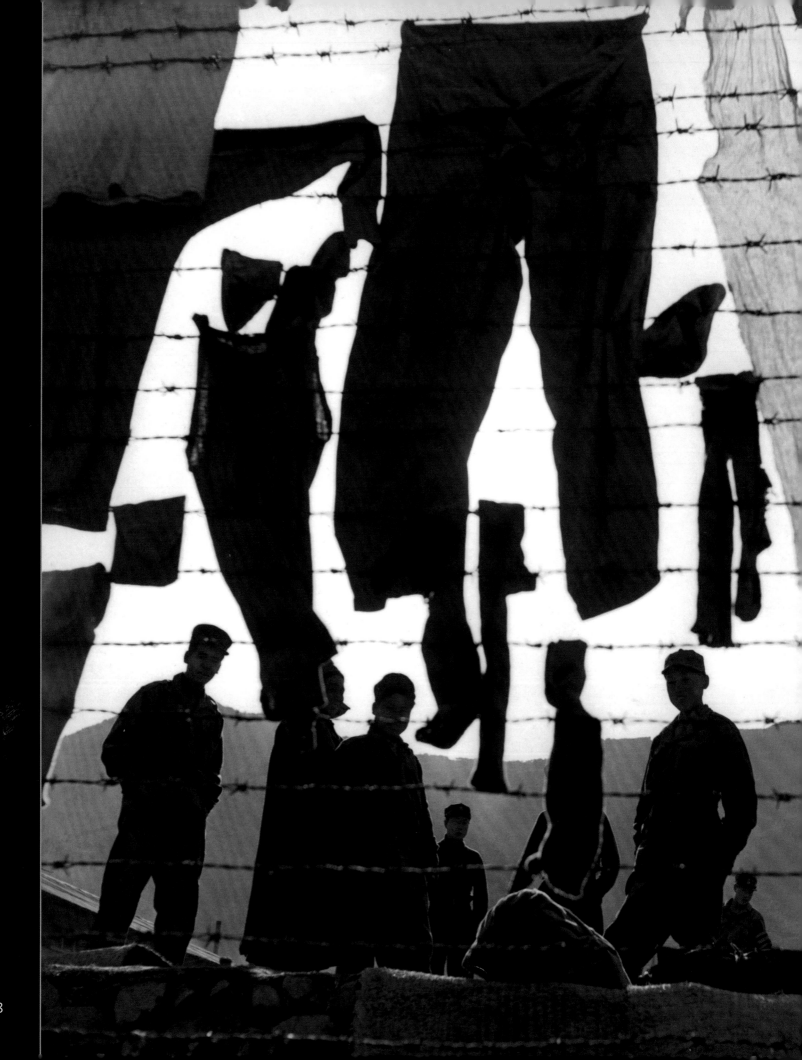

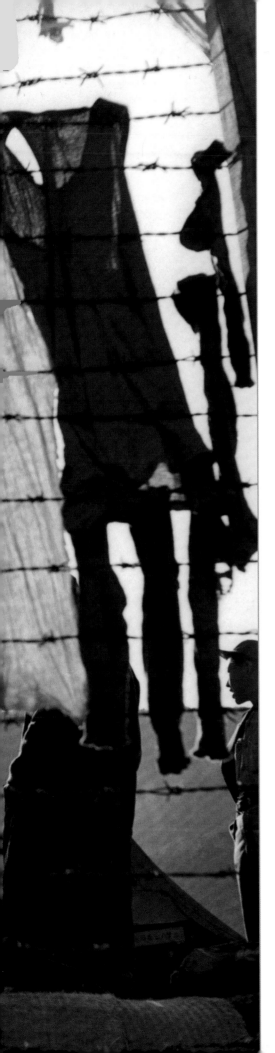

Werner Bischof

These same characteristics, far beyond a stylistic choice, remained intact during location shoots in Mexico and Peru, where he portrayed the daily life of ancient people, and of children, above all: asleep in *mantas* hanging on the back of their mothers; on their way, accompanied by a flute in an Arcadian, Andean landscape. Focused, as Budapest children looking out stunned from a train window, or children of Indochina, crouched to light a rolled leaf with a firebrand found by chance.

Still in the Andes, the Peña de Aguila landscape became the background to the moment in which Bischof, traveling in a jeep toward a high-altitude mine together with his camera, his instinctive humanism, and self-recognition of himself as an artist, fell into a ravine and crashed. Nine days later Robert Capa, his great friend, died in Vietnam during a military skirmish.

Geoje Island, South Korea, 1952 At the height of the conflict that will lead to the division of the two Koreas along the 38th parallel, Bischof is on a mission for the Magnum Photos agency and snaps this photo of rare power, where the prisoners themselves become ghosts tangled in barbed wire. It is perfect, evocative, and capable of telling a story: that of the concentration camps, burning in the post-war period. In fact, it is laundry hanging on the barbed wire that the guards seem to be watching over; but the atmosphere is one that gives this photo huge symbolic value, and that the choice of backlighting renders even more effective.

December 30th, 1918 - Wichita, United States • October 15th, 1978 - Tucson, United States

W. Eugene Smith

An unflinching, uncompromising man, who considered photojournalism to be an art form and pursued his ethical, social, and humanitarian ideals with passion and unbelievable commitment.

The biographical notes on W. Eugene Smith strike their readers as sudden rain and hail showers alternating with patches of sun. Blizzards and partial clearings, yet able to provide a complete picture: the desire to photograph "sinking in the heart of the picture." Not only to create emotions, but also to raise awareness of social issues, cause reactions, and make the world a better place.

An ambitious project that Smith chases, honing a technique based on his extraordinary ability to use contrast, light – a light that almost explodes – electronic flash, and the dark room; all while highlighting the importance of feeling. "I've never made any picture, good or bad, without paying for it in emotional turmoil." "What uses having a great depth of field, if there is not an adequate depth of feeling?"

Equipped with an astounding determination, Smith was only 14 years old when his first photos ended up in the *New York Times*; he was 18 when Notre Dame established a photography scholarship for him. He was just over 20 when he was fired from *Newsweek* for refusing to work with a 4x5 Graphic. Too bulky. Over the years, increasingly unwilling to compromise, a perfectionist and a brilliant troublemaker, he will work for *LIFE* only in fits and starts, between quarrels and reconciliations; and he will leave Magnum Photos over differences with Cartier-Bresson. For Smith, it is essential to place each shot in a creative vision. If necessary, he will also reconstruct scenes, touch up frames, and even mount several negatives together, though he never denied the truth of an image; indeed, he reinforced its stylistic coherence and symbolic meaning. His journalistic investigation (sometimes a scoop) is like an art form: poetic and dramatic. He will continue to work with such conviction on the steep path of civil commitment, without ever losing sight of ethical goals.

W. Eugene Smith photographed by Philip Gould during a moment of leisure. Calm, with an expression of curiosity, no trace of the troubles that haunt him.

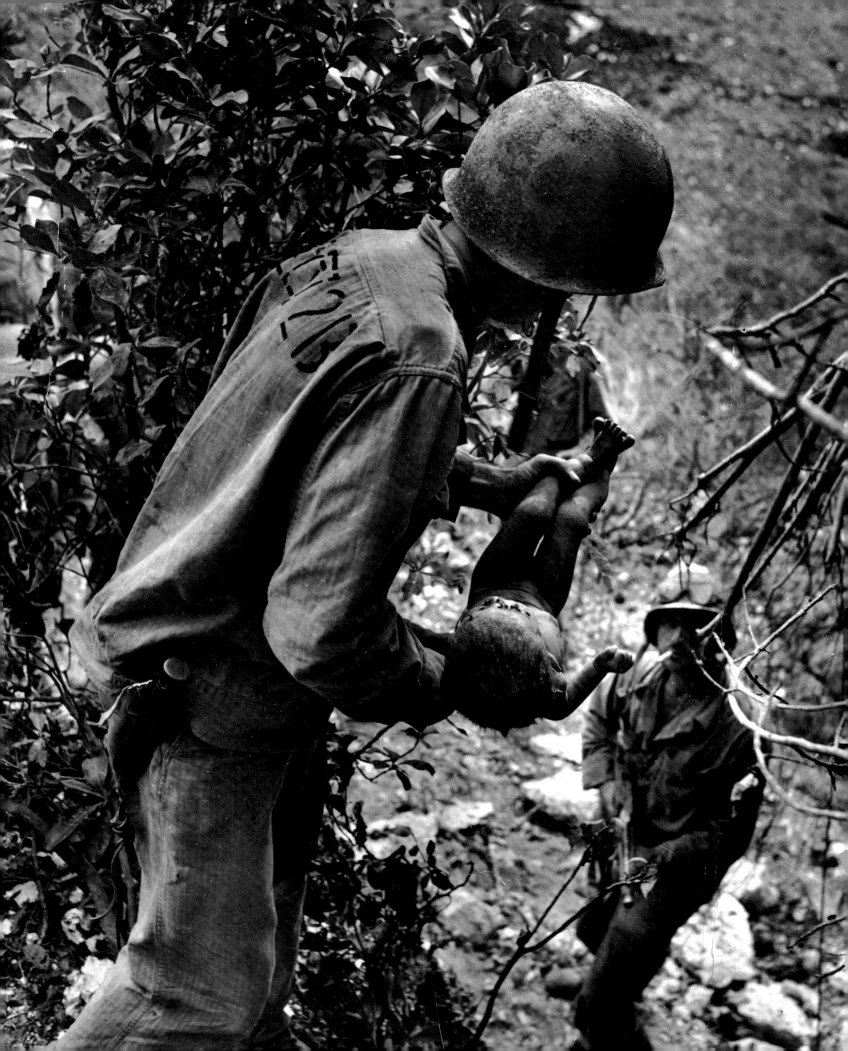

Despite rifts, divorces, bankruptcies, and bouts of alcoholism, he is always ready to start anew. He does so from a very young age following his father's suicide; at the age of 24 when he was wounded during a mock battle for *Parade* magazine; and in '45, when, while working as a war correspondent in the Pacific for *LIFE* magazine, in Okinawa, he was seriously wounded by grenade fragments that pierced his hand and lodged in his face, while other pieces wounded his chest and back. For two years Smith underwent painful surgery that left him dependent on drugs, profoundly distressed, and with the specter of not being able to return to photography. It is his children who trigger a process of rebirth, while walking in the woods to a fairytale clearing where the light promises happiness. They are like two little friends of Alice' who manage to get out of the rabbit hole. The photographer follows them, handling the camera while trying to counter the violent pain running from his hand to his spine. He takes a picture which becomes the dream of regaining a paradise lost.

In subsequent photo essays he invests an incredible amount of energy, passion and time. He expands the projects entrusted to him and transforms them into thousands of shots. Intolerant of orders and compromises, he personally follows their development, fixing, printing, and – while quarreling with publishers – selection, sequence, and layout.

His great reportages of the 1950s covered the life of a general practitioner in the Colorado countryside, the daily life of a black nurse midwife in North Carolina in times of intense racial discrimination, the life of peasants during the Franco regime in a village in Extremadura almost fixed in the Middle Ages, or the work of Albert Schweitzer in Gabon.

His spectacular use of black and white tracks with the same intensity a portrait of New York with blinding neon signs behind the grids of snow-covered fire escapes; or Pittsburgh, with its steel mills and the bridge over the Ohio River lit up like trails of stars in the industrial skyline.

Saipan, Northern Mariana Islands, July 1944 War photography made up the first part of W. Eugene Smith's career. In this phase the American photographer took more than a few risks (and he would indeed be seriously wounded) but also took several iconic photos of the battles that he witnessed. This image shows instead the sensitivity of his photographic eye, which here has set aside for the moment the vicissitudes of the front to capture a profoundly human act: soldiers – who are not only warriors – who are working to save a newborn baby, who has perhaps just been born. The photo was taken in a difficult context, and the way it provides just a glimpse through the branches of a steep terrain leads our gaze to the child and stirs our emotions.

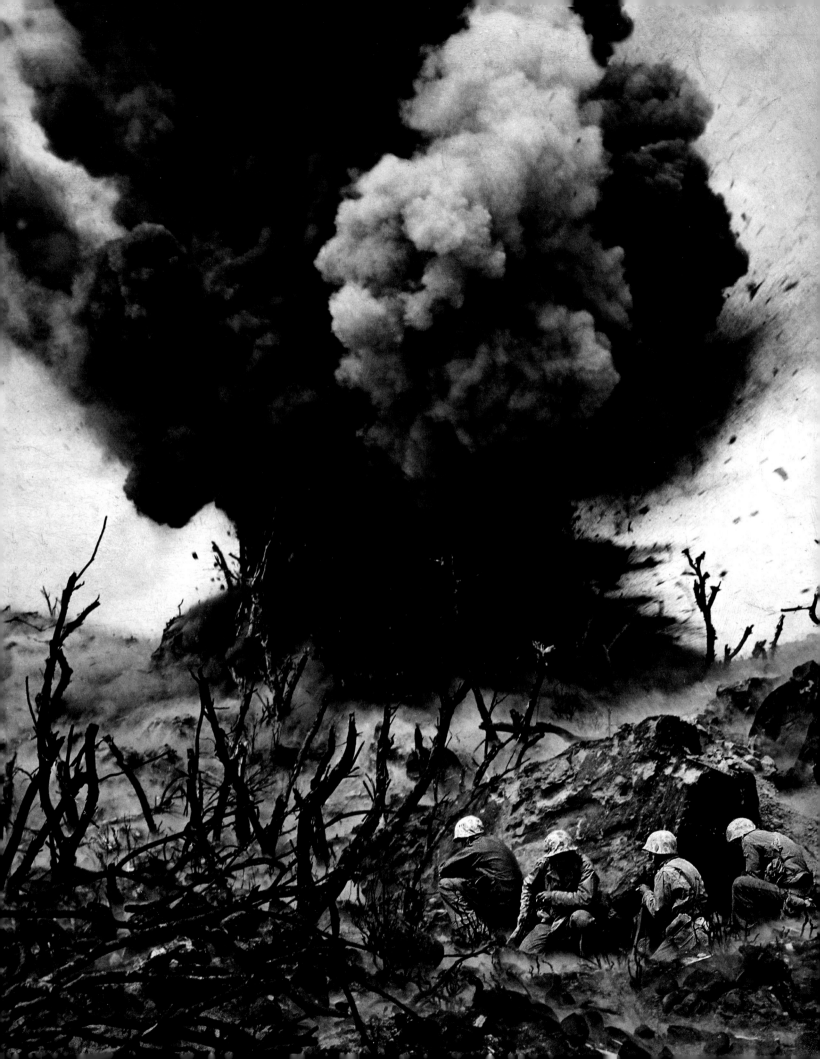

W. Eugene Smith

Smith realized two of his own magnificent photo shoots: one set in a loft in Manhattan, where the great masters of jazz were rehearsing for their concerts (for a total of 40,000 photos and 4,000 hours of jam sessions recorded); the other a shocking reportage about a tragic environmental disaster. Smith documented the terrible malformations of the children of fishermen, due to the waters and fish poisoned by mercury dumped in the Japanese bay of Minamata. He will pay dearly for this, as he is beaten savagely and temporarily loses his sight in one eye. But, among them all, his unspeakable image of little Tomoko, devastated, taking a bath in the arms of her mother, will shake the world.

Iwo Jima, Japan, 1945 Shortly before being wounded, Smith documented the draining work of destroying the network of tunnels and forts that had made Iwo Jima such a hell. This was the only battle in the Pacific where the Americans lost more men than the Japanese. The working conditions for the war reporters there were hardly less terrifying than those of the soldiers: constantly surrounded by stray bullets, explosions, nighttime raids, and deathly booby traps. In this photo the dark enormity of the explosion makes the figures of the soldiers appear even more fragile as they cower down for shelter. It is the contrast between these two elements that gives the image such power.

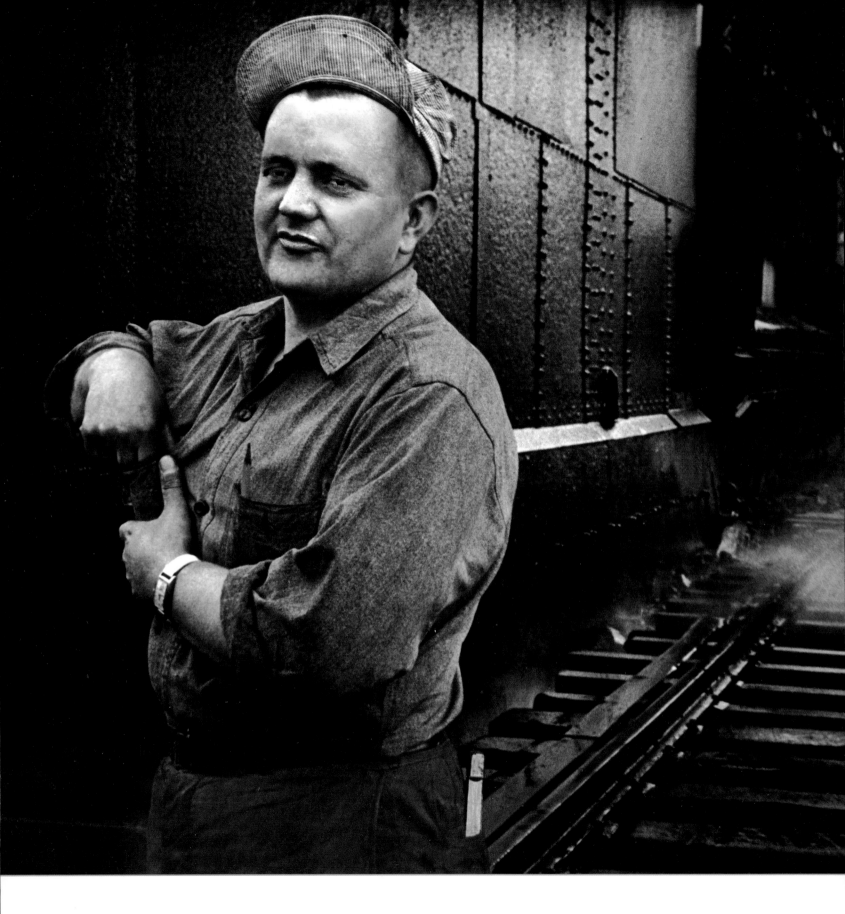

W. Eugene Smith

Cleveland, Ohio, US, 1948 Back from the war, after two years of slow recovery, Smith started taking photos again, and was looking for new subjects to shoot. Here he photographed the working conditions in the steel mills and coal furnaces of Cleveland. He united his experience as a reporter with his vision of the world and managed to obtain photos of great worth and symbolic power. What jumps out from this photo is the contradiction between the almost ironic expression on the worker's face and the way in which tracks stretch out into the smoke and darkness. Its superb compositional layout gives the image dynamism and impact.

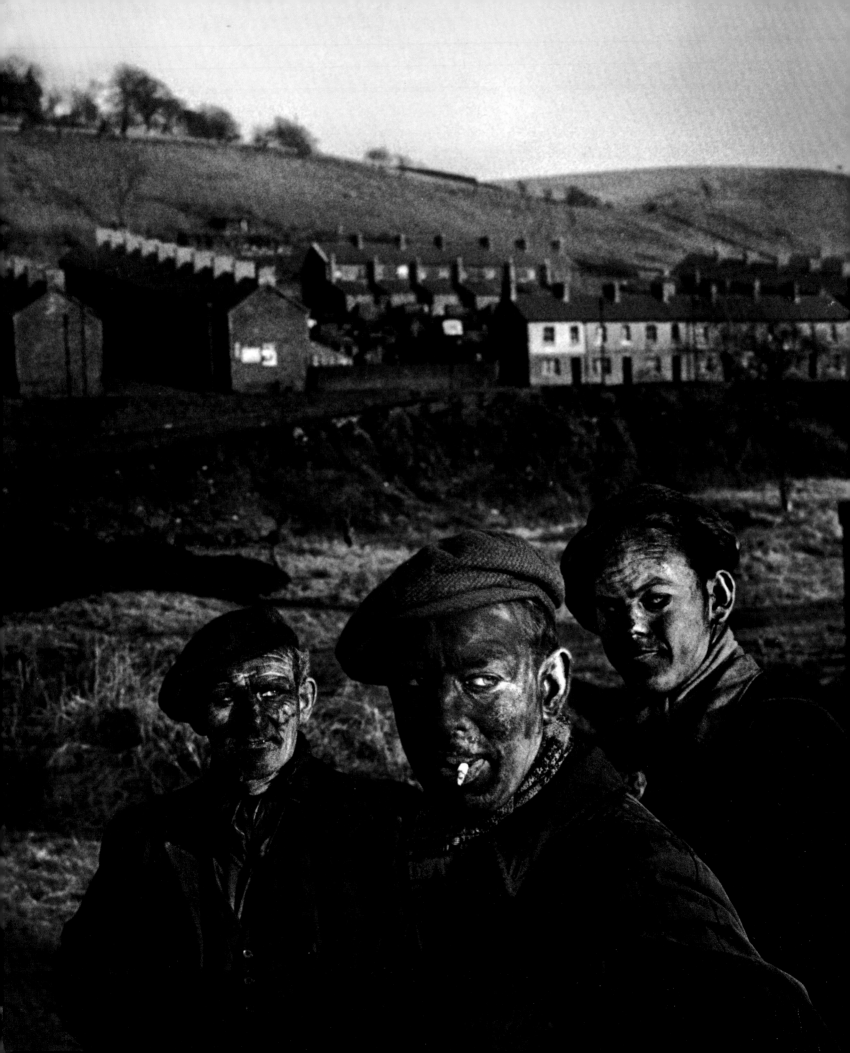

W. Eugene Smith

Wales, UK, 1950 Here faces have been turned to masks. The three Welsh miners re-emerge from the tunnels after a day's work covered in coal dust. The rows of townhouses in the background help paint an even grayer picture. In this case the picture coincides with the story. It is an image which, even by itself, taken out of its context in a larger work, manages both to encapsulate and denounce an established reality: one of the most important characteristics of photography in general.

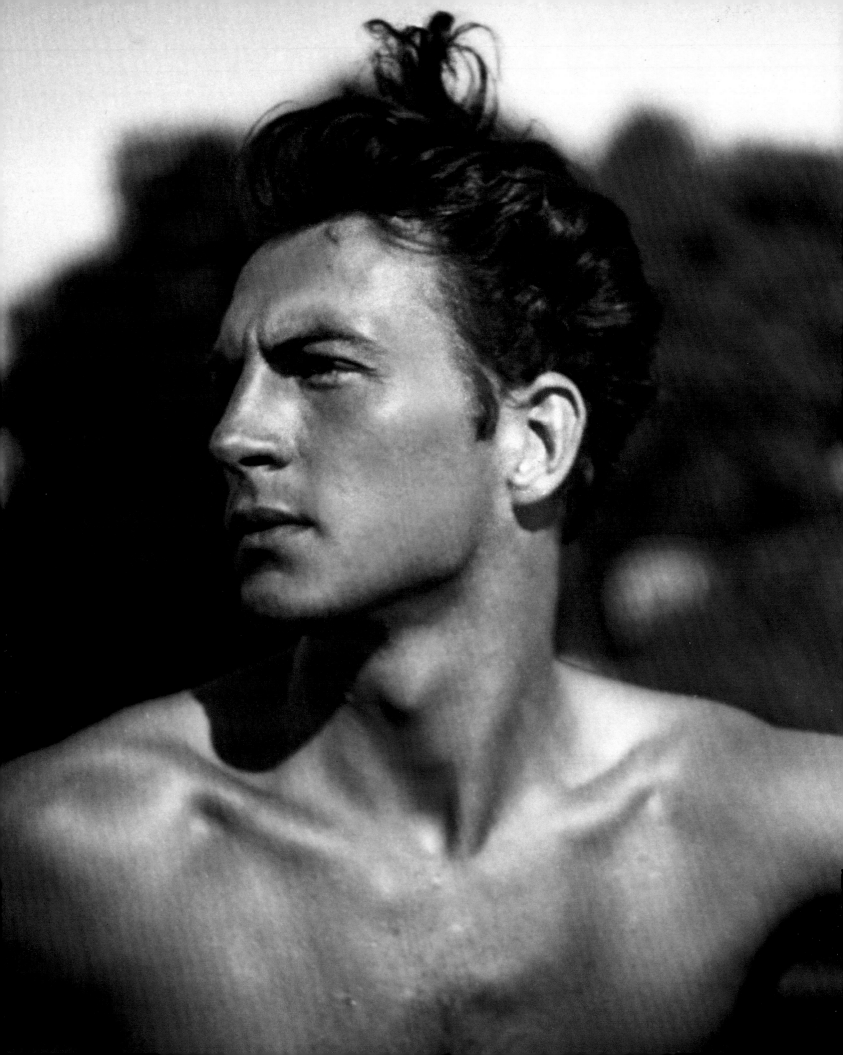

Ernst Haas

The study of movement, and above all of color, as the promise of rebirth. As experiments that will give way to a profound transformation of the concept of photojournalism.

To fully understand the role that Ernst Haas has in photography, it is necessary to contextualize it by looking at his shots while imagining their birth date. If this is true for every photographer, it is even more so for this Viennese photographer who began his career in the late 1940s, without the aid of today's increasingly refined and widespread technologies that allow photographers to achieve any special effect with automated systems. It is clear, then, how his use of color, his study of movement, and his pictorial references have been revolutionary.

The post-war years were gray years for Europe. The aftermath of the conflict and its heavy consequences covered dreams with dust; they were a burden that hindered the natural right to happiness. Werner Bischof knew something about it. With a bicycle and a camera, he traveled in dismay rubble-strewn roads and bombed cities. Overseas the mood was anything but. There euphoria and growth set the tone. The United States were singing in the rain in yellow raincoats, following Marilyn Monroe swathed in pink silk, and watching Pollock drip pure colors on paintings spread out on the ground. These are Technicolor years that sing the praises of the American way of life through advertisements and magazine covers. It is in this New York that Ernst Haas arrived in 1951. He had to interrupt his medical studies, which the racial laws prohibited Jews from carrying out. He abandoned his plans to become a painter, traded a Rolleiflex for a 20-pound block of margarine, and was noticed by LIFE for a photo shoot on the repatriation of Austrian prisoners. He forged a deep friendship with Bischof and, at Capa's behest, joined Magnum Photos. He had already moved from black and white to color. In New York color became a symbol of rebirth for him, of hope for a new world and a pure expression of joy: "One does not think joy. One is carried by it." At the same time he began experimenting with motion, combining it with bright chromatics in a highly innovative mode of expression.

The profile of a quasi-mythological figure on a splendidly sunny day in Greece: this is how the Austrian Ernst Haas chose to depict himself in a self-portrait in 1943.

March 2nd, 1921 · Wien, Austria · September 12th, 1986 · New York, United States

Dynamism of framing is at the center of his interests. In order to go beyond the static image and insert it in both space and time without freezing it, Haas will also deepen the panning technique: by moving at the same speed of the subject, he will transfer the motion effect to the background alone. Haas fiercely defended his freedom of style and opposed any poetics based on fixed rules. "A formula," he says, "is the death of everything [. . .] if we reach a formula we must try to infringe it." He states that the goal is not to represent reality, but to reorder and transform it, in a balance between science and art, without deforming it.

Bodh Gaya, India, 1972 Religious ceremonies in this part of the world are always accompanied by an explosion of color that is well suited to the style of Haas. Here is evident also the conflict between his attempt to bring geometric order to reality and the overwhelming disorder of prayers blown by the wind.

The result will be a series of reportages in which stylistic pursuit and expression of beauty come to the fore, more important for him than capturing the soul hidden in the places and characters that cross them. In this way Haas portrayed New York ("Magic City") and the tumultuous bullfights in Spain for LIFE, transforming urban and natural landscapes into elegant extreme graphic effects, achieving results that bring him close to abstraction or futuristic geometries. Hungry for joy and the future, he wrote: "Don't ever overanalyze your results! [. . .] One does not try to catch soap bubbles. One enjoys them in flight and is grateful for their fluid existence. The thinner they are, the more exuberant their color scheme."

Japan, 1984 Men in ceremonial robes; they are praying under the spray of a waterfall. In this case the color is not enough to the Viennese photographer, who resorts to the panning technique to emphasize the immobility of human figures surrounded by the energy of flowing water.

125 - Wayakama Festival, Japan, circa 1984 Sometimes reportage photos speak perfectly. In this case, the photographer's task is not to intervene; rather to isolate them from the context in order to guide the observer's eye straight to the intended message or to the heart of the story he wants to tell. Here the subtraction rule gives us an essentially graphic image.

126-127 - Bullfight, Spain, 1960 A subject dear to Haas; the bullring is a very suitable setting for his brand of experimentation. In this color photo, composition and blur contribute to creating an image where drama and blood leave room for poetry.

128-129 - New York, US, 1978 In that "Magic City" where Haas found a second life and a source of inspiration, he takes thousands of pictures, trying every possible application of color photography: reflections, graphic repetition, and movement. Here the yellow of the taxis in traffic, in an intersection, becomes the metaphor of dynamic energy that the photographer feels flowing throughout the city.

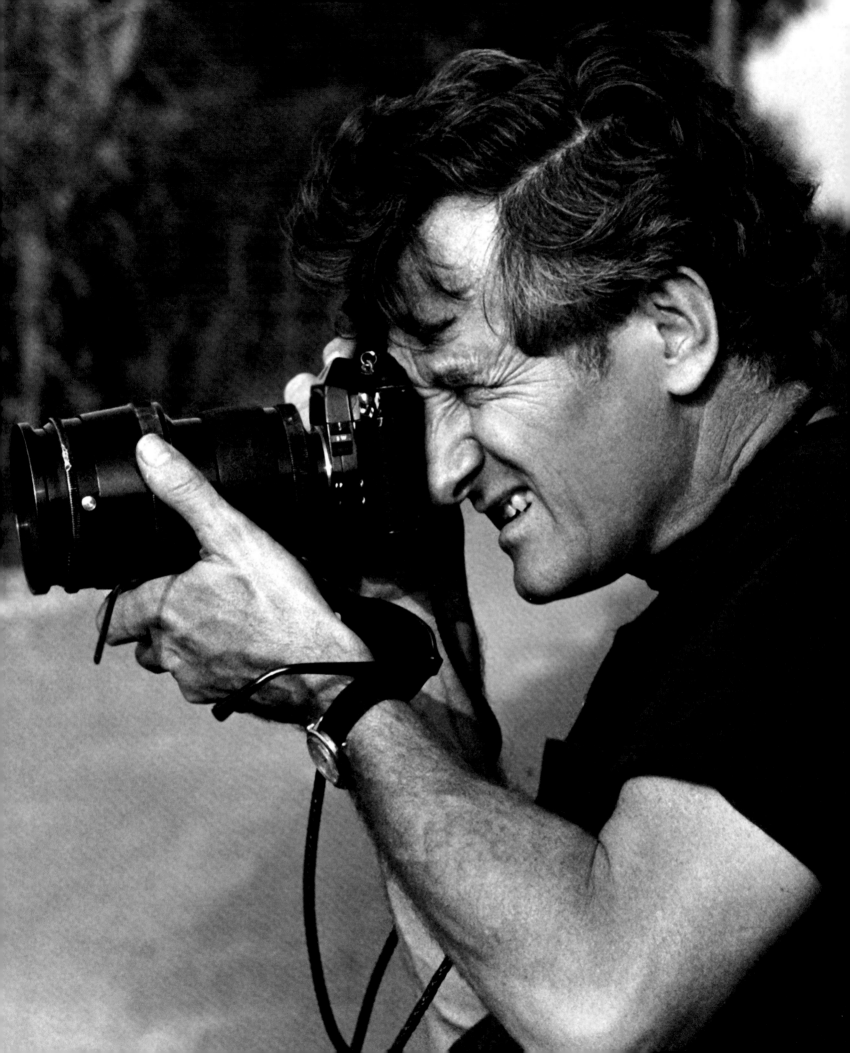

Marc Riboud

His lens is able to experience wonder and to capture lightness and gracefulness, whatever is in the frame. No special effects, no rules, just a sort of "visual tenderness."

The girl is seen in profile: 17 years old, an uncombed bob cut, flowers on her dress and a flower in her hand, perhaps a chrysanthemum. In front of her a row of pointed bayonets. The photo is by Marc Riboud. Two years earlier Allen Ginsberg had named the non-violence movement Flower Power.

When Riboud died in Paris at 93, *The New York Times* gently paid homage to "The photojournalist who found grace in the turbulent," recognizing in him a human quality capable of finding beauty, confidence, and lightheartedness even in the most difficult situations.

Precisely lightheartedness qualifies one of his most famous photos: a worker in overalls painting the Eiffel Tower while balancing precariously on a beam, as if he were an angel in the spirit of Chaplin or Buster Keaton, or the mime Baptiste, as a painter straight out of *Les Enfants du Paradis*. With this very photo, he would enter Magnum Photos, where Cartier-Bresson would be his "salutary tyrant."

Riboud, mechanical engineer, left his job, got in a Land Rover and went on the road "out of curiosity." He wanted to photograph. For thirty years he crossed Asia, Eastern Europe, China during the Cultural Revolution, and the Soviet Union. He often went to South and North Vietnam (in Hanoi he sipped tea with Hô Chí Minh). He is everywhere something significant happens – from Beijing to Japan, from Algeria to West Africa – and yet, more than parades, wars and notable characters, he prefers to capture ordinary people in everyday situations.

He was always on the side of libertarian movements and civil rights. After having participated in the French Resistance, he was a reporter sympathetic to colonial independence, student protests (in Paris as in Tiananmen Square), anti-war and anti-apartheid demonstrations, and to the strikes of Polish workers and Liverpool Dockers.

Here photographer Bruno Barbey gives us a Marc Riboud concentrated on his work in Algiers. A great traveler and a great reporter, the Frenchman was never without his camera.

June 24th, 1923 - Saint-Genis-Laval, France • August 30th, 2016 - Paris, France

He was not afraid of the notion that simplicity is trivial; indeed he believed in the evocative power of delicacy: "a common denominator in all my photos: a natural approach, no odd angles, and no technical or lighting effects. A distance, but at the same time a visual tenderness."

His vision of the world is poetic (sometimes he will be criticized for excessive romanticism). During the trial of a Nazi official who had terrorized Lyon, his hometown, he would be caught off guard by the kindness that he read on the man's face.

Riboud has no pretensions of objectivity, he does not want to testify or be heroic or find the latest scoop; rather he wants to tell what intrigued or surprised him. He wants to extract it from the confusion of stimuli, then simplify and reorganize it. He composes images by distributing the attention among various interacting elements, rather than concentrating it on a single subject. He defends the childish ability to wonder and the importance of dreams, which for him does not contradict accuracy. Reading his words and observing his shots gives the same empathy. Such as the Japanese girl who, while standing on a stool, is laughing and talking on a phone that is bigger than her; or his sleepers: lying on a hammock over pineapples lined on the floor, or on a small Indian wall in the company of silly manikins, or on a mat a few steps from a field burned by napalm; and his figurines of passersby that become a set of frames, beautifully framed in glass cutouts of a door looking out on a street in Beijing. Riboud is almost 80 years old when, with the enthusiasm of a boy, he talks about photography and says that photographing life, as intensely as possible, is his obsession. "It's a mania, a virus as strong as my instinct to be free."

Paris, France, 1953 They call him "the Painter of the Eiffel Tower," but he is actually just a worker in charge of repainting the tower, not an artist. Riboud turns him into (or rather reveals him as) an inspired tightrope walker who paints while almost dancing, unconcerned with emptiness around him. The image emphasizes the geometrical order of the latticework structure of the Eiffel Tower, which from below can seem like a labyrinth of steel beams hurled up toward the sky. The photographer's eye recognizes the gesture and rests on a few details: the foot in an unstable position, the brush that is for the iron but looks like it could be painting the air. Riboud on the other hand, also high up in a precarious equilibrium in order to take the picture, was not at all at ease, and would later say that "I felt dizzy and I had to close my eyes every time he leaned over to dip his brush in the paint can."

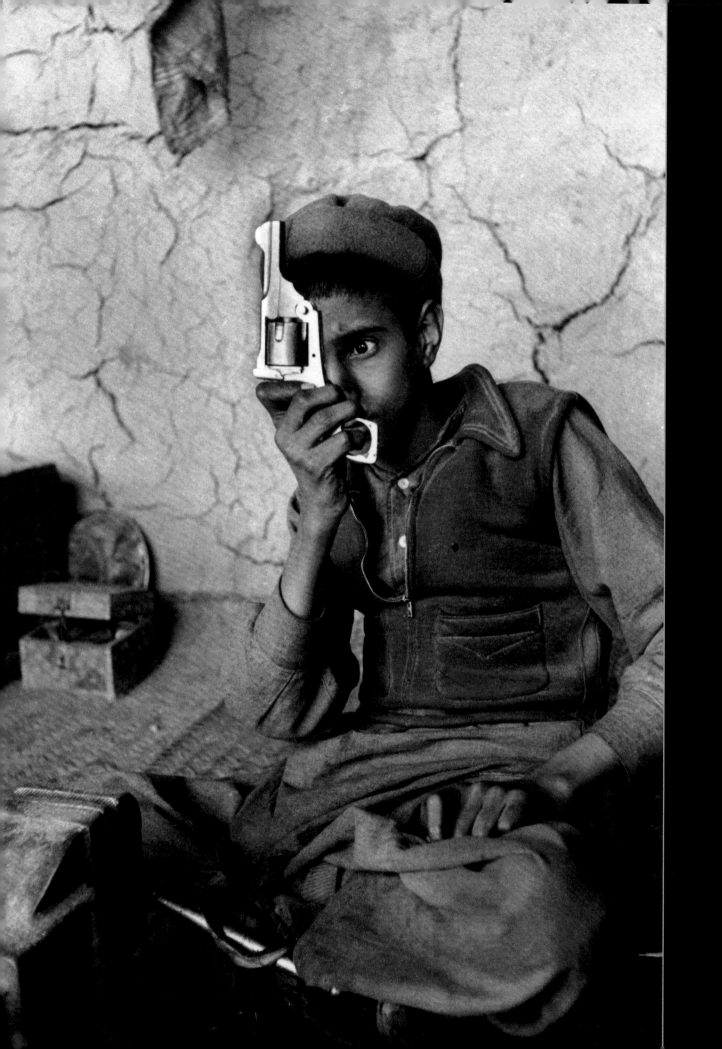

Marc Riboud

Afghanistan, 1956 Notes from the great voyage. In 1955 Riboud arrived in Istanbul in George Rodger's Land Rover and continued on across Asia, stopping for a time in China and ending the long journey in Japan. This portrait taken in an unlikely ammunition plant on the border between Afghanistan and Pakistan, with its tension between the vitality of the boy's intent gaze and the instrument of death in his hand, encapsulates all of the contradictions of war, which involved even very young men who were brought to the front.

Marc Riboud

Moscow, USSR, 1960 Typical of Riboud's art is his ability to crystalize the atmosphere he wants to depict. In front of the Kremlin, the menacing gaze of what is probably a soldier represents what the West thinks of the Soviet Union. We do not know if the allusion is deliberate or by chance; it in any case refers one to the debate over the presumed objectivity of photography. The whirling snow, blown by the wind, renders the Cold War that much colder.

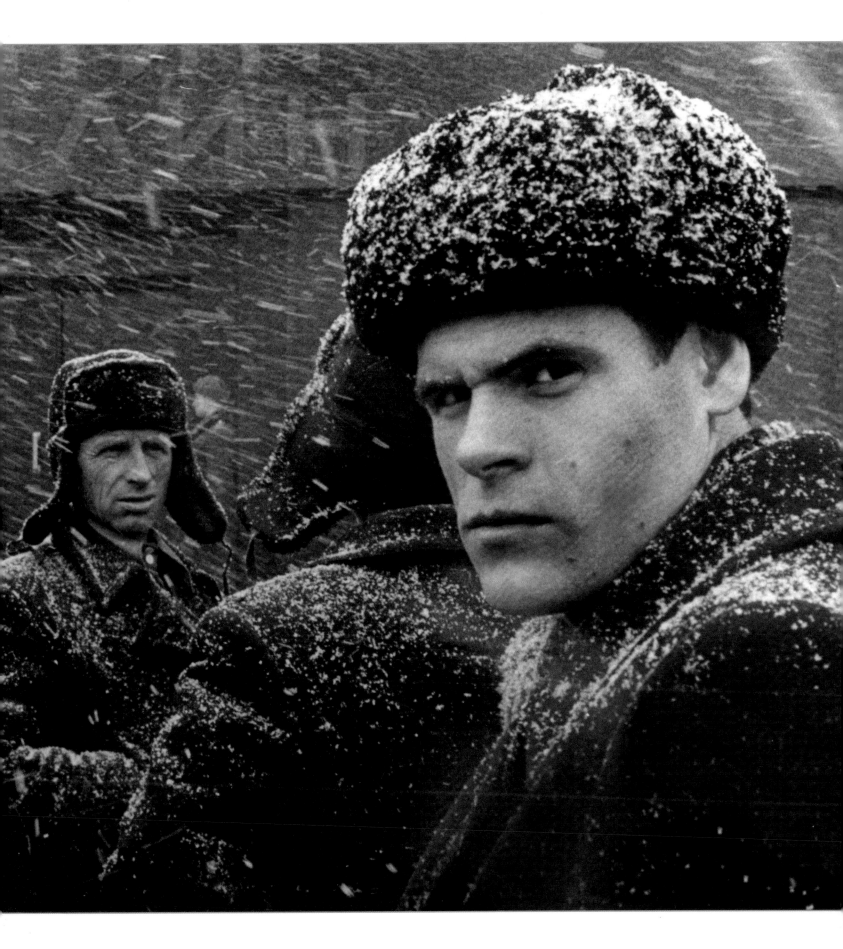

Marc Riboud

People's Republic of China, 1965 Mao Zedong is about to launch the Cultural Revolution. Riboud photographs a parade using his by now well-developed language that allows him to create images of great impact, characterized by their clear lines of separation between different atmospheres and dynamics within the same frame. Notable here is the contrast between the stillness among the people, who appear as uncertain spectators, and the activist's explosive fervor.

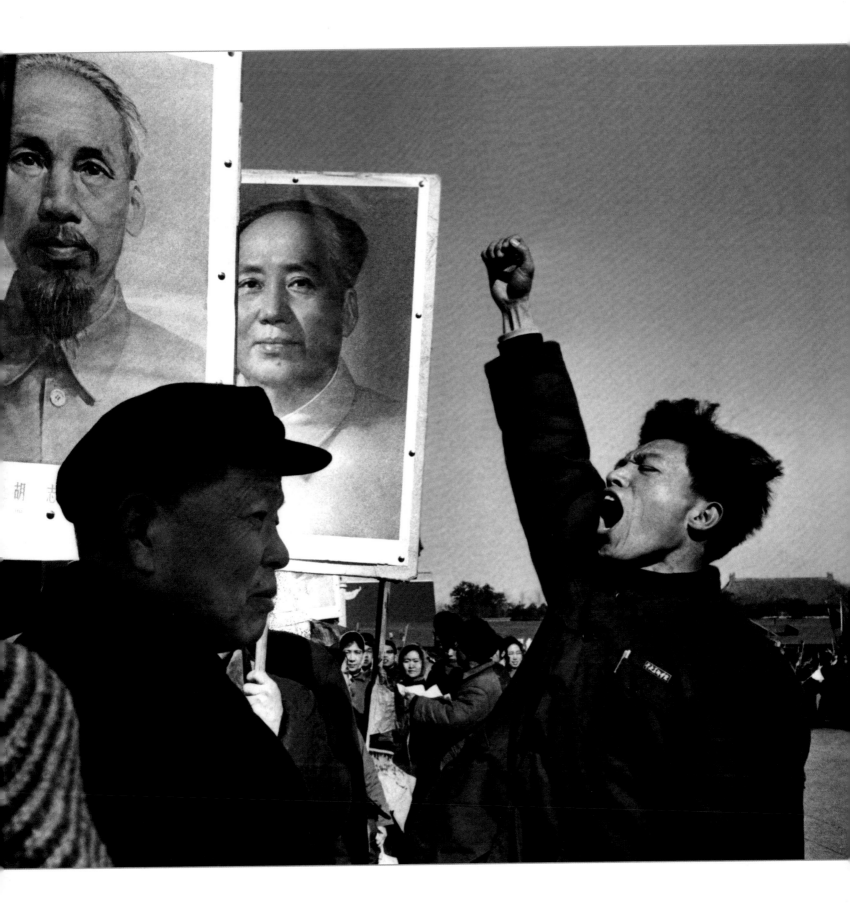

Washington D.C., US, 1967 One of the French photographer's most famous shots, and a symbol of its time. High-school student Jan Rose Kasmir faces the National Guard in front of the Pentagon during a march protesting the Vietnam War. The juxtaposition between the gray, out of focus soldiers with their bayonets, and the girl holding out a flower is very striking and effective. The line that cuts the image in half vertically also symbolically divides the world: war/peace, past/future, death/life. The choice is up to the viewer.

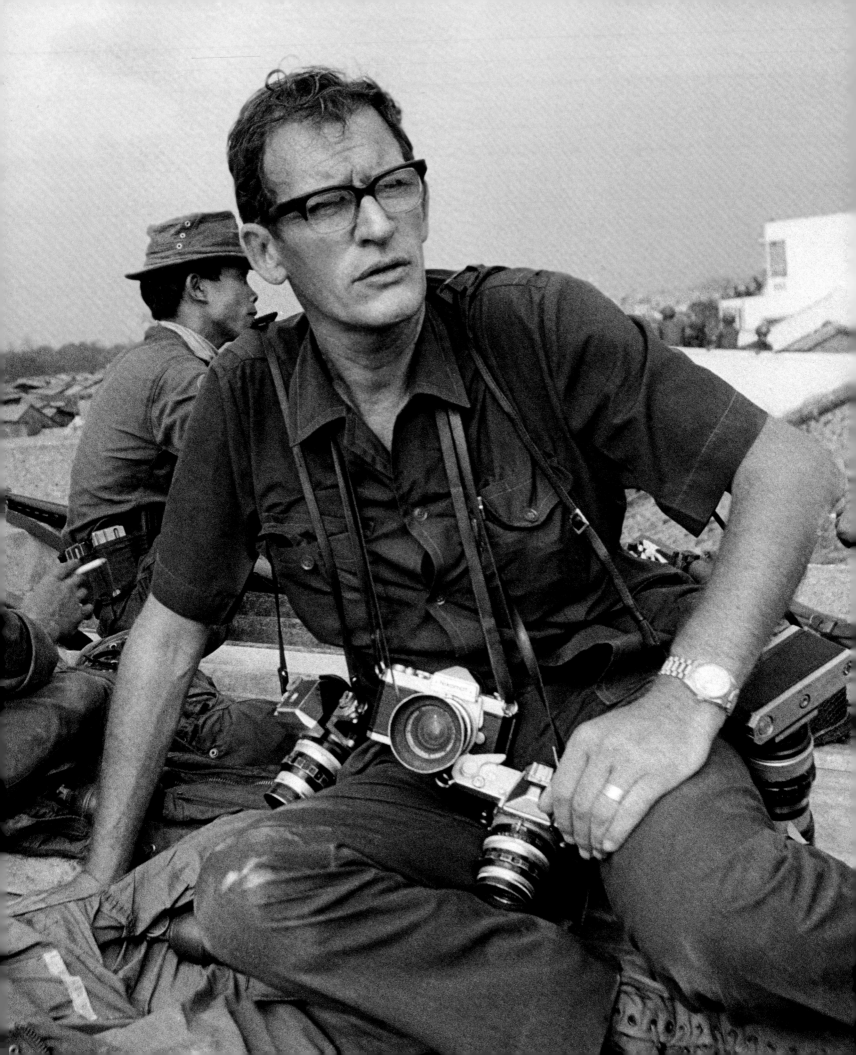

Larry Burrows

No one bore witness like he did with his images to the endless, tragic war in Vietnam, participating in person both in ground and aerial warfare.

Although his work as a war photojournalist includes images taken in Lebanon, Congo and Iraq, Larry Burrows is synonymous with Vietnam. More than a war, it was an escalation of a bloody catastrophe, two decades long, which was extended to Laos and Cambodia; a tragedy that involved an impressive deployment of the U.S. Army, Navy, and Air Force in a sensational and devastating defeat.

Burrows documented the war for LIFE between 1962 and 1971; years spent at the front, involved not only as a correspondent, but also almost like a soldier, living in military camps and active on the front line in land and air combat missions.

Larry Burrows, a Londoner, had the reckless courage of Robert Capa. And, like Capa, he died at war: Capa at 40, Burrows at 44. He fell to his death in a helicopter during the Lam Son 719 operation over Laos. With him in the same helicopter were three other photojournalists: the Franco-Vietnamese Henri Huet, Kent Potter – from Philadelphia – and Keizaburo Shimamoto, from Seoul. They all perished: it was February 1971, and it will take another thirty-seven years before their remains be located, transported across the ocean and buried under the floor of the Newseum in Washington, dedicated to information and journalism.

From Burrows' Vietnam, the war emerges clearly as incandescent nonsense, able to suck everything and everyone into a single vortex of destruction and grief: soldiers, civilians, nature, hopes, futures, physical and mental health, psychological stability. His images, deeply compelling, also communicate through the power of color. The British photographer understood its explosive force, capable of conveying an acute sensation of immediacy and the harshness of impact. His photos are never reconstructed and are seldom purely instinctive; more often they are meditated, anticipated and chosen after long observations on the battlefield; and yet this approach does not compromise the effectiveness and immediacy of the emotions they express. "I am very happy with the equipment I have. All I need is time and patience to use it to the fullest degree," says Burrows. "War is my story, I want to see it through."

There are no fewer than four cameras hanging from the English photojournalist's neck. Sitting among a company of Vietnamese soldiers in a moment of respite during the second offensive against Saigon, his photo was taken by Christian Simonpietri in 1968. The fatigue and tension on his face are evident.

May 29th, 1926 - London, United Kingdom • February 10th, 1971 - Laos

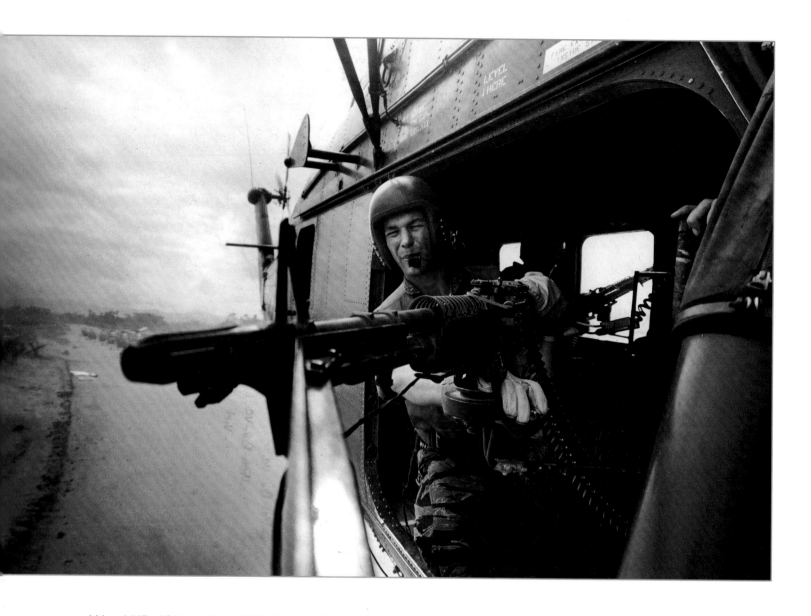

144 and 145 - Vietnam, March 1965 Above the forests of Vietnam even the sky is a theater of bitter war, struck through with bullets and the whistling of the bombs dropped over villages. Burrows is on one of the helicopters in the mission, the Yankee Papa 13, and captures the hell of combat with a series of extremely dramatic shots, even using a camera mounted on the fuselage. The pilot from another helicopter has been loaded on board, shot dead. When the machine gun jams, the crew chief yells to his men for help. The tension expressed in this shot becomes almost unbearable, especially when one recalls that Burrows himself would be killed during the war when his helicopter is shot down.

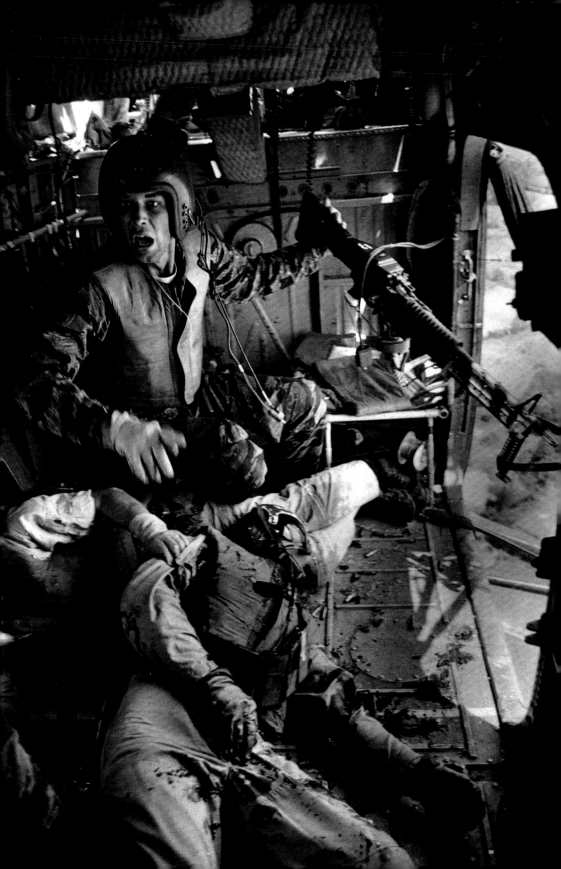

The subjective shot of a pilot, looking out the window at a burning forest, set aflame by napalm. Prisoners with their arms and neck bound, loaded in a row on a boat. Soldiers engaged in an amphibious warfare or running toward the helicopter that will transport them into action. Ominous fireworks drawn in the night sky by tracer bullets. But above all photos of a wounded humanity, trampled on, that the war was drowning in desolation. A soldier trying to lift a fellow soldier who had slumped in the mud of the Mekong. Piles of corpses on the delta. Terror in the eyes of a youngster threatened by an American soldier with a bayonet to make him confess. A simple, tragic photo: a man and a boy suspected of being Vietcong, flushed out and pushed through a rice field by a soldier walking behind them with his gun pointed, in a sweeping landscape, serene, that in the extended field seems in conflict with what is happening.

Vietnam, February 1968 American helicopters bring supplies to marines under attack from North-Vietnamese forces at the Khe Sahn Combat Base. An extraordinary shot, with the red lamp of the flag in the foreground, and, in the center, the cloud of dust emphasized by an almost surreal effect of the light, which nonetheless does not detract from the realism of the scene.

The poignant gesture of a wounded marine, moving swiftly toward a motionless fellow soldier on the ground, while others try to restrain him in order to take him to the rescue helicopter.

Emotion, participation, pity; one of Huet's snapshots shows Burrows, with a camera around his neck, helping a group of soldiers make a breach in a tangled pile of elephant grass to transport a wounded soldier. From the pages of LIFE, Burrows tells the other side of Southeast Asia: its non-literary face, not mythical, not pre-packaged, but that of the brutality of war. And through large photographs, at once raw and compassionate, he elicits breathtaking shock. His images, writes David Halberstam, "brought the war home, scorching the consciousness of the public and inspiring much of the anti-war sentiment that convulsed American society in the 1960s."

Hill 484, Vietnam, 1966 One of Burrows' most famous images features the marine Jeremiah Purdie as – his head wrapped in a bloody bandage and supported by medics – he rushes over to a fellow soldier who is wounded or perhaps dead. This exceptional photograph perfectly captures both the torment as well as the attempt to defend human feeling in an absolutely inhuman context.

Larry Burrows

Vietnam, 1968 South-Vietnamese soldiers help a gravely injured woman during an attack. The photo caused a stir due to the great amount of blood on her face, hands, and clothes. The power of the image lies to a great extent in its color, as well as in its extremely effective composition, with the soldier in the foreground cut from below to give a sense of presence that deeply involves the observer.

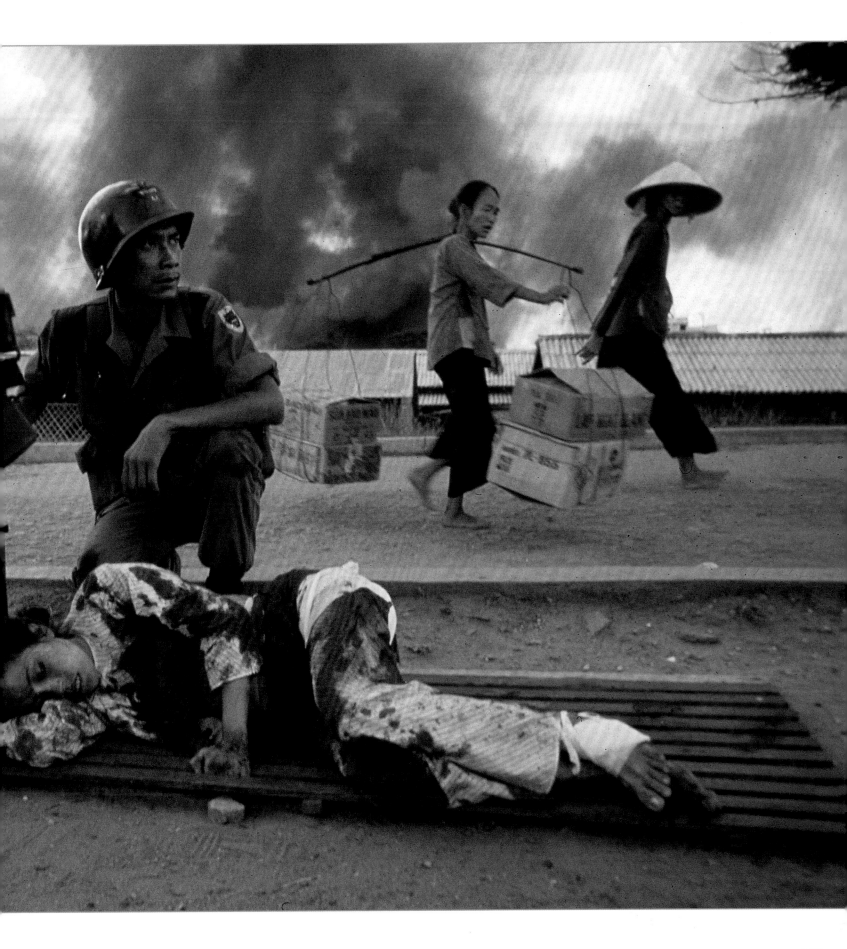

July 26th, 1928 - Paris, France

Elliott Erwitt

Curious. Fun. A lover of jokes, quips and life in general. You laugh when you have to, he says. And when you have to, you cry. Always with ironic optimism.

"Once I was walking down a narrow street in Kyoto behind a lady who was walking a dog that looked interesting. Just to see, I barked. Immediately, the lady turned and kicked her bewildered dog. I guess we had the same kind of bark." A handful of dazzling words summarizes some of the traits that perfectly describe Elliott Erwitt. The intense curiosity with which he looks at the facts of daily life around him, the fun with which he knows how to intervene to change them, the great irony with which he recounts them – with his voice, through writing, and with the camera – his predilection for the absurd and the surreal, his love for dogs, which will be the subject of four of his books. Elio Romano Erwitz is primarily a cosmopolitan: he was born in Paris into a Jewish family of Russian origin. He spent his childhood in Italy, and then returned to France, but on the threshold of adolescence, he immigrated with his family to the United States to escape the Fascist racial laws. First in New York, then Los Angeles, where he printed photos of Hollywood stars to be signed and sent to fans. Still very young he went back in Europe while enlisted in the U.S. Army as an assistant photographer, and in New York he had a decisive meeting with Robert Capa; though the two artists will take significantly different paths: one is a war photographer, always busy on a front; the other one is a fine street photographer and portraitist.

In '53 the arrival of Erwitt at Magnum Photos (of which later he will become President) secured his place in the Pantheon of photography greats.

To those who look at his photographs, Elliott Erwitt seems to say: have fun, enjoy life, do not just be a spectator or a witness. Participate as an active subject in what you see, without giving up either a critique (paradoxical, eccentric, comic or sharp) or an empathic feeling. And even when you'll be famous, celebrated by the magazines that publish you, never stop going out to take pictures for yourself, for your pleasure and nothing else. Relax, wait until your next picture "happens" and comes to you. Then, seize the right frame, original and formally perfect, with promptness and intuition.

On March 2nd, 2010, Jonas Cuenin took this sober portrait of Erwitt, captured here in the tranquility of his home in New York. The focus on his right eye emphasizes his alert and disillusioned gaze.

Elliott Erwitt

North Carolina, US, 1950 One of Erwitt's best-known photos. Its message is clear and strong; there is no pulling punches in this condemnation of racial discrimination. The sparse composition emphasizes the content. The gaze of the man on the right – who looks as though he is not even authorized to fully occupy the photographic space – rests directly on the water fountain for Whites. The photo also shows a little of the great photographer's ironic side, which in this case is aimed at ridiculing the absurdity of certain privileges.

The Cartier-Bresson lesson is obvious. Equally clear, on the other hand, is the Charlie Chaplin model, which Erwitt unreservedly admires for two complementary skills: the ability to make people laugh and cry. This attitude toward life, even more than toward photography, leads us to imagine him as a good-humored man, at ease with himself and with others, an ideal companion for walks and conversations around any metropolis.

Allergic to planning, Erwitt takes pictures without following a precise and preordained direction. In front of his immense archive, themes emerge on their own, jumping out as instinctive dominant themes.

Dogs: dogs caught in the middle of a jump, carried around on a stroller or in a crammed trunk, seated impassively behind the wheel, under a hairdresser's hair drier, comically pompous behind ski goggles or with a silk flower tied around the neck, but above all in an emotional dialogue with those who love them. Then children: while staring at you from behind a broken window, while reading the same comic book sitting on a threshold, perplexed in front of a birthday cake, while crossing the street in a group playing the trumpet, or on a bike seat in the company of two baguettes.

Colorado, US, 1955 We don't know anything about the story of this boy. But the image, through several elements, evokes risk and hardship. In the first place there is the way his eye is lined up with the break in the glass, then there is boy's intense gaze and network of cracks around the break which could have been caused by a rock or perhaps by a bullet: in any case it is a spider web that partially hides his face. All of this could dissolve into a playful smile. Or perhaps not.

Elliott Erwitt

158 - Provence, France, 1955 Erwitt is not your typical American photographer who allows himself to be awestruck by his encounter with Europe. He has lived in both France and Italy, and got to know the countries well, his photographer's eye seeking out little details: in this case, against the geometry of the background, the mischievous look on the face of the child on the bicycle, balanced between the grown-up and the bread, two of life's great certainties.

159 - Loire Valley, France, 1952 Around a table in what presumably is a bistro, a family scene of ordinary everyday life, with the gaze of three old men fixed on the same object, perhaps a match. The oldest boy is already big enough to join in with them, while there is evident indifference on the part of the younger child, ignorant of the common interest that unites the others.

Not to mention his portraits: portraits of famous people and ordinary people, portraits that look inside characters with sympathy or good-natured humor. They are never evil, never obsequious, never official. They are often profiles or faces that do not stare at the lens. Grace Kelly, as she walks, contrite, toward two heads turned toward her. Marilyn Monroe, relaxing while reading a script. Che Guevara, Fidel Castro. Sophia Loren on the set with Tony Perkins, and a despondent Jacqueline Kennedy behind the black veil of mourning. Simone De Beauvoir, always looking toward the camera from any angle. Among others, an irreverent Schwarzenegger proudly displaying his muscles directly in front of the camera, a magnificent Kerouac sitting askew on a chair in a jacket and tie, and another great photographer, Steve McCurry. And then, nudist newlyweds; marching soldiers (among them a black man sticking out his tongue), geishas, people sunbathing, kissing; people lined up in front of an improvised confessional. They are caught in a predominantly urban reality, although the famous puffing locomotive, running parallel to a car on a road, captures a perfect image (incidental, Erwitt will call it) of Wyoming, 1950s style.

New York, US, 1956 Here Erwitt displays his astonishing ability for taking portraits of people, whether famous or not, which make them appear natural and spontaneous. He gives us a Marilyn Monroe who is relaxed, smiling, in an intimate atmosphere, perhaps her home. Everything about the photo is perfect, from the choice to leave the background dark and light her face with a soft light, to the focus that subtly exalts her gaze.

Elliott is also ironic about the contradictions of America and Western Europe. Two examples: the provocative snapshot of a decent sink for whites next to another, skimpy and squalid, for blacks in North Carolina; and that of a giant Pepsi billboard planted next to an equally gigantic crucifix. He also engaged in film (as an operator and still photographer), as well as in a series of commercials and essays. More recently, he dedicated himself to the creation of an immense color archive and to "The Art of André S. Solidor" project, where Solidor, a comic alter ego of the photographer, mocks the arrogance and emptiness that infect the contemporary art world.

For seventy years this great author occupied the history of photography with an acute sense of humor and great elegance. For seventy years he took photographs intelligently and humanely, without ever imposing his intelligence and humanity on what he chose to frame.

New York, US, 2000 This shot encapsulates some of the typical characteristics of Erwitt's photography: the dogs' presence, a recurring subject of his; irony, which here rises to comedy thanks to the overlapping of the face of the dog, which is sitting in its owner's lap, with that of the man (the look on the dog's face seems to be asking the photographer "what are you looking at?"); the great elegance in the composition, with the addition of a second animal that looks like it came out of a cartoon.

New York, US, 1974 A masterful composition, once again featuring dogs, and once again capable of transforming the world into a curious place. In this case the photographer's technique contributes a great deal to the result: the use of a telephoto lens isolates details from their context and takes the playful juxtaposition of paws, hooves and boots to an extreme. The same image, taken with a wide-angle lens and crammed with realistic elements, would have lost its impact.

July 4th, 1943 - Bagheria, Italy

Ferdinando Scianna

His magnetic images depict with the same extraordinary precision the Sicily of his youth and the same Sicily revisited as an adult, just as they do the rural world of the Andes or the metropolitan suburbs of New York.

He has a piercing glance that cuts through with unsettling intensity. It's not easy to describe him. A multi-faceted polyhedron: as soon as you catch a glimpse of one characteristic and chase it, others intersect it in a disorienting game, making you feel as if you were inside a maze: Scianna the photographer, Scianna the writer, Scianna who speaks of his own career, photography, literature, and cinema. Equally magnetic and equally creative. The Sicily of Leonardo Sciascia, Elio Vittorini, and Gesualdo Bufalino speaks inside him; the Sicily of his childhood in Bagheria. Sicily – a dramatic land by definition – where the sun is like halogen and the shadows are as dark as a jungle from which you have to emerge "to regain the light and read a face."
In the 1960s Scianna left Sicily. He left a rural world that was losing its meaning. Yet, of course, his land lingered like a wound that never heals, like a "chest from which to draw memories." His land remained primarily as a core identity; essential to understanding where you are going because you know where you began. In fact, in his first exhibition, *Sicily and surroundings*, Japan was included among those surroundings. Scianna traveled from Sicily to Milan, where he worked as a reporter at *L'Europeo*, a weekly magazine; he moved to Paris as a correspondent for the same magazine, and then returned to Milan. He built an amazing culture: studying, traveling, forging friendships with extraordinary characters, often met by chance, but experienced immediately as "mines for my training." The first among them is Sciascia, who will define Scianna as a hunter of images who holds within himself, like tracking down prey, the next potential photo. (Scianna said of him: "He taught me to think, to distinguish authenticity from junk, style from stylistic virtuosity"). The fertile exchange with writers – including Borges and Montalbán – fed, moreover, his intimate marriage of photography and writing, which in Scianna took root and branched out with extraordinary vigor. Then Henri Cartier-Bresson, which of *Les Siciliens*, one of Scianna's books sent to him by mail, will say: "Thanks to this book, I've regained the urge to return to photography." And it will be Cartier-Bresson who will introduce Scianna to Magnum Photos, the first Italian – and the only for twelve years – to be part of this highly selective international agency.

Scianna's gaze in this self-portrait, taken in Milan in 1997, shows the same uncompromising conviction and intensity that one finds in his photographs.

Photography as a glance toward the world. As the need to represent it by choosing what you want to express and how go about it: with what language and form; photography as narrative and, symmetrically, love for prose that flows along an infinite number of details and culminates in a photographic sequence. Once again writing, but this time "visual."

Then in the 1980s a further change of perspective: the fashion designers Dolce and Gabbana selected Scianna to shoot their ad campaign. Hence, next to the Sicily of memory, here is a Sicily revisited through entirely new fashion portraits, bewildering, each of which is full of information and suggestions: the synthesis of reportage in a frame.

"I photograph disorder." Rather, he visually organizes the subject in an instinctive and passionate geometry. As if the elements of any background were carefully orchestrated and knew how to become a rigorous and dazzling setting.

It may be an abandoned and devastated automobile under the Manhattan Bridge; it is a car, but it appears like an alien spacecraft that crashed in the fog. The neon lights of a subway station that steals the scene, framed between a train that appears as if gasping and two children lost in a memorable kiss.

Refugee camp in Mek'ele, Ethiopia, 1984 Observing this photo from a photo essay about the famine in Ethiopia brings to mind a concept that Scianna has expressed in several interviews: the difficulty of overcoming the barrier between the pain and suffering of others and our own looking, the true boundary of reporting. In this situation he has managed to walk that line with great care, so that a story emerges from his photographs that involves one forcefully; the viewer cannot avoid making eye contact with the girl in the foreground bearing a load on her head.

Snapshots of men balancing on a slippery pole, suspended over the water, or a teenager from Palermo standing side by side with a shining model, Marpessa; who knows what emotions are hiding in his chest behind the giant print on his t-shirt. They can be photographs of a procession candles, donkey hooves, swollen legs of peasant women in black stockings folded at the ankles, and Andean newlyweds with their stoic faces, almost carved in the *ceiba*. The intensity and energy of the image is always the same.

In his study, behind a window overlooking a courtyard in the center of Milan, Scianna continues to amaze for his versatility and ability of matching extraordinary refinement with extraordinary simplicity. As soon as he arrives in an unknown place, he says, he goes to look for the windows of local photographers "so I understand the aspirations, the dreams, and the culture of the people there." He eats street food, without wondering what it is. "I taste it, and by tasting, I feel as if I savor the same flavor of the people I must photograph. And that makes me understand them better."

Refugee camp in Mek'ele, Ethiopia, 1984 The hunger here is manifest, not hinted at, not hidden behind the exertion of living. The act of breastfeeding, a symbol of survival and of future prospects, here becomes a message of desperation. Indeed, a shadow of death can be seen on the tiny extremely gaunt body of the child – who is newly born and already old. The composition, lighting and tone all act to block the lines of movement forcing the gaze to rest on the dramatic image that obliges the viewer to take in a little of this pain.

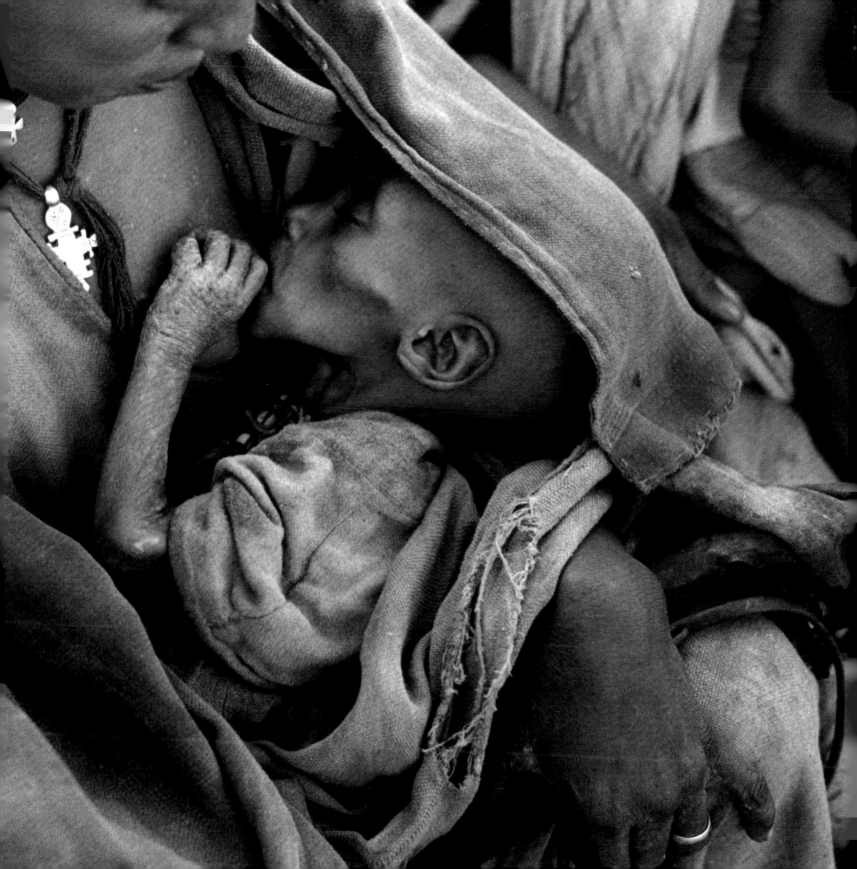

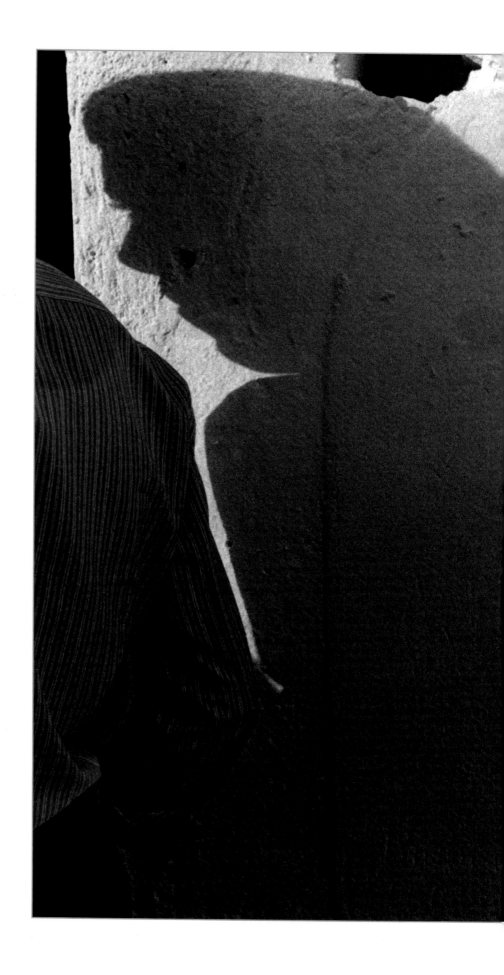

Ferdinando Scianna

Oliena, Sardinia, Italy, 1970 One can only wonder about the story behind this photo. What are the two women talking about? What is the shadow of the man walking away from? In any case, it remains hidden behind that mysterious door drawn on the wall, a door that hints at closed relationships, full of silence and unspoken things.

Caltagirone, Sicily, Italy, 1987 As often happens, Scianna's lens organizes and reinvents the reality it frames and inserts it into a greater narration that comprises discovery, memory, and a vivid imagination. Here, with his model-muse Marpessa dressed in the austere black dress of a rural woman, the photographer manages to capture in a single image the magnificent staircase of Caltagirone, his own Sicilian childhood, and the allure of the idea of woman. With this photo feature he sets out on a new approach to photojournalism, which mixes fashion with a neorealism that has a constant need to document and record.

Ferdinando Scianna

176-177 - Racalmuto, Sicily, Italy Celebrations, rituals, gestures, faces from the religious culture of Sicily. This is where everything began, with hundreds of photos taken in his youth, exhibitions, books, and meetings. And over there everything returns. Scianna knows this world intimately and tells its story through that which made such an impression on him. And when the man, many years later, sets foot in Sicily again, the photographer in him will reconnect with his roots and take photos of great power and vitality.

178-179 - Kami, Bolivia, 1986 It takes seven hours of off road travel to reach this village in the heart of the Andes, 4,500 meters above sea level. Here people make their living from mining and usually die between the ages of 30 and 35. Life is short and the 6,000 inhabitants attribute special value to moments of joy, like marriage. Scianna highlights specific elements of these moments by stripping the composition of every superficial detail. The viewer's gaze moves from the two faces to the banknotes pinned to the groom's suit: a celebration of wealth in contrast to everyday reality of the harshest kind. A world and a story that Scianna would bring to the pages of newspapers.

Abbas Attar

Starting from an exploration of religions, he carries out an extremely complex critical study that moves lucidly and sharply through various cultures.

His name, written in Arabic characters, draws an extremely elegant arabesque. Of Israeli origin, it means "strict." These concepts together form the calling card of this great photographer born in Iran and naturalized Parisian. A man who rarely agrees to be portrayed with his face uncovered; to him, elegance and rigor coincide.

Abbas had always been fascinated by religion, every religion that he gradually investigated: Muslim, Christian, Buddhist, Hindu, and after 2000 also Animist and Jewish, up to Old Paganism and Neo-Paganism. He had an interest in them not only for the form of spirituality that each expressed, but also for the relationship with the society and the system of rites that characterized it, making it distinct from the others. This deep interest merged with another interest: a political and social investigation, especially in developing countries such as Asia, Africa, and South America. At this point it is clear how his passions, his year of birth (1944), the troubled Iran where Abbas grew up, together with his project – outlined at the age of 11 years old, to become a photographer – flow together in a life of research, countless intercontinental travels, studies, evidence, and continuous exploration. All revolutions, popular movements, and the uprisings that troubled Bangladesh, Afghanistan, Tibet, and the Middle East beginning in the 1970s crossed his lens and his committed critical consciousness, making him a formidable witness of all types of conflict: from the Vietnam War to the Gulf War, from the Israeli-Palestinian conflict, to the Nigerian Civil war and the Famine in Biafra, from apartheid in South Africa to IRA uprisings in Northern Ireland, to the Chile of Pinochet.

Particularly extensive were his investigations of the revolution that broke out in Iran – which transformed the Iranian monarchy into an Islamic republic ruled by an *ayatollah* and inspired by Koranic law – and the Islamic world as a whole, from Mongolia to Morocco.

Lost in some corner of the Sahara, Abbas Attar photographs himself to great effect while wearing a turban that covers his head and the lower part of his face.

Abbas explained the violent contradictions that tore it apart; namely, the fracture between a need for renewal and ancient cultural roots, including hunger for petrodollars and disgust for the heavy intrusion of the Western world in the political situation of the Middle East. Unable to find a balance, Abbas distanced himself, physically as well, from Tehran and left for seventeen years in voluntary exile. He returned to his country only in 1997.

During his exile Abbas Attar traveled through an incredible number of countries and did not limit himself to taking pictures: he wrote essays, journals, and notes that were almost novelistic (in the case of Mexico). He followed new paths, questioning the reasons why in a world dominated by technocracy, the irrational and primitive rites come back so strongly. He wanted to discover the elements, which have nothing to do with religion, that hide behind the cover of religious conflict.

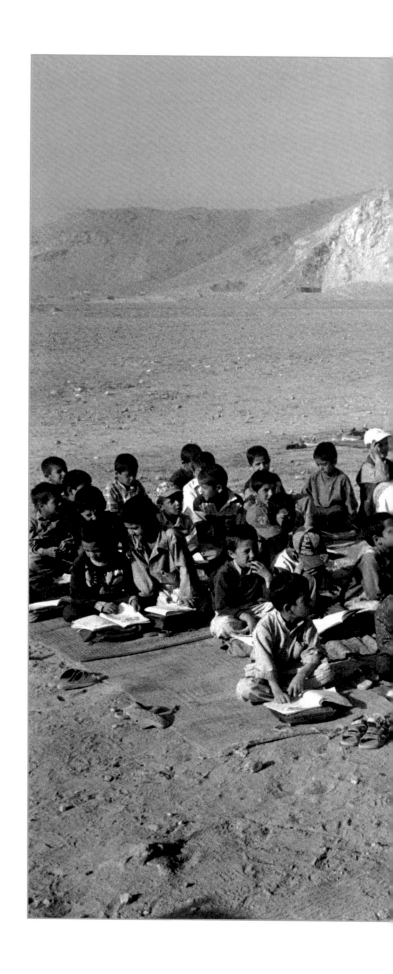

Tara Khel, Afghanistan, 2005 In a difficult balance between wars, revolutions and spirituality, in this photograph Abbas Attar describes the role of education. Under the sun, in the dust, in a field just de-mined, the village school is still there, donated by the Japanese and crowded with children attentive on their mats; they want to learn and carve out a future without bombs.

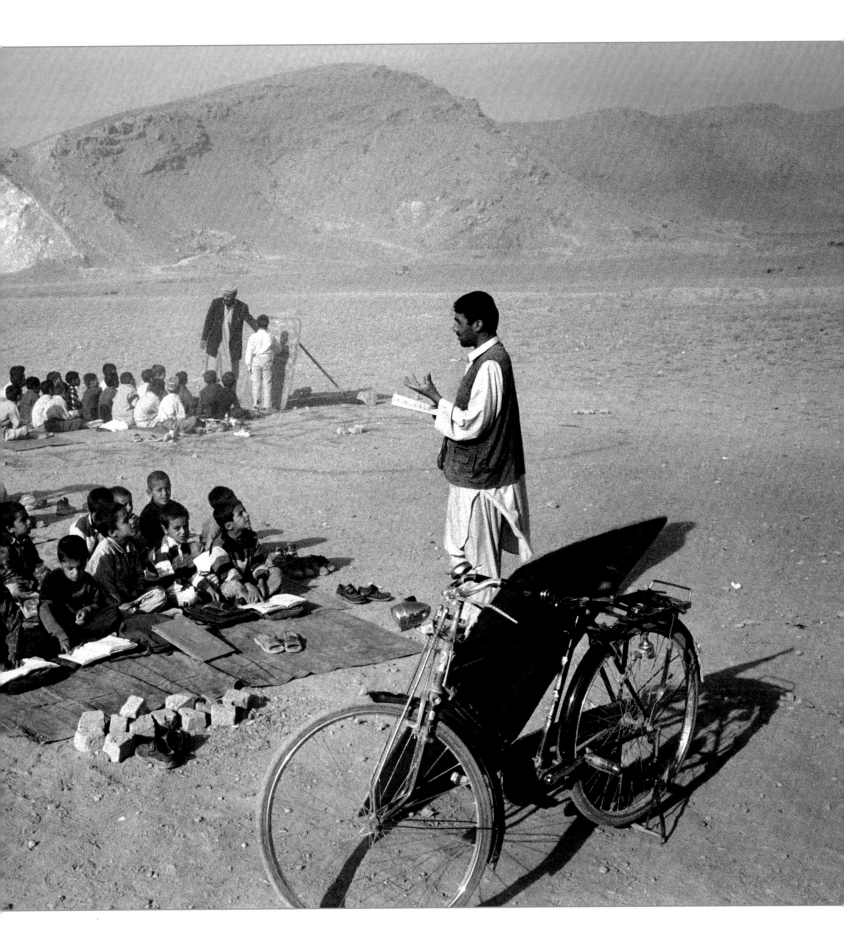

Abbas Attar

Abbas Attar returned to this research after the attack on the Twin Towers, exploring for seven years sixteen countries and questioning the motives of the "creeping Islamization" that was spreading in all Muslim countries, making them dangerous for their own governments before posing a threat to the West.

However, despite his figure as a scholar, a writer, a keen interpreter of cultures, his greatness as a photographer stands in the foreground.

"My photography is a reflection, which comes to life in action and leads to meditation." The image arises spontaneously from reality, and then it is the subject of thorough examination and reflection. Finally, it falls within a selection to compose a coherent sequence with what the photographer wants to say, and that he communicates "by writing with light", in an "exalting and fragile" creative moment.

Sarajevo, Bosnia-Herzegovina, 1993 The portrait of these children evacuated from the besieged city is made even sadder and real by the rain. The two crutches are in the foreground, right behind the drops beating on the glass, becoming tears. The gaze of the injured boy does not express hope or pain, just fatigue. Abbas has already experienced many wars and famines; his photographic eye is quick at finding an elusive image, but one of great impact.

They are wonderful ways to describe the act of photographing and also define the essential features of an aesthetics to which Abbas will remain ever faithful, before and after joining Magnum Photos: shining portraits in black and white of people photographed on the street, war victims and soldiers lined up in obsessive geometries, of children diving, women in black crying and screaming or cloaked in white as small stylized ghosts, and pilgrims gathered around the Kaaba in Mecca. He was always animated by a passion and a skepticism that were able to co-exist, by lucidity and depth of analysis, to serve an incredible eye and a talent that can be refined at these levels only when it is innate.

Srinagar, India, 1992 During the demonstrations following the assassination of two leaders of the JKLF (Jammu Kashmir Liberation Front) by Indian armed forces, Abbas Attar captures the despair of grieving women and portrays no detachment. The caption defines the place, yet the photo could tell similar pain in any part of the world.

Abbas Attar

Karbala, Iraq, 2003 The believers beat their breasts in mourning during Arba'een, the Shiite ritual that commemorates the assassination of Imam Hussein. The photographer is in the thick of the action, but no glance seems to have identified him. Yet he has a camera in his hand and can transport the viewer into the crowd, passion, and sweat.

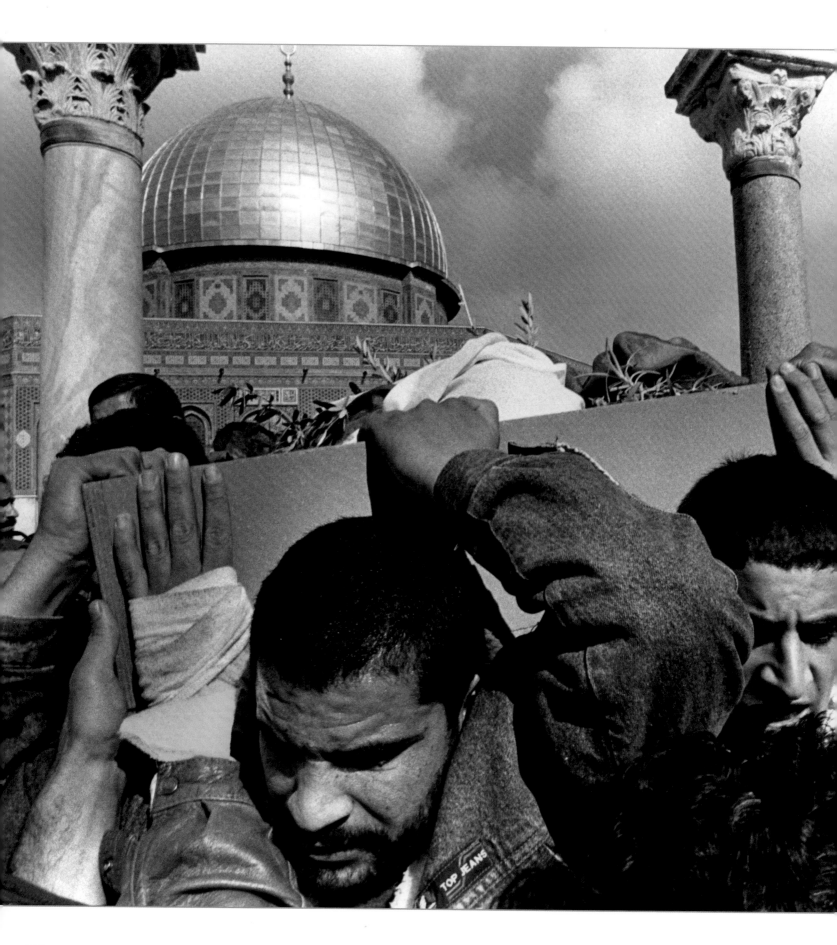

Jerusalem, Israel, 2005 Again the overwhelming sense of participation. In the background of the Dome of the Rock is the body of a young Palestinian killed by an Israeli security guard, carried in procession prior to his burial. Abbas gets in the heart of events where religion, any religion, has a central role. Crucial is the use of a wide-angle lens, but not too forced, which otherwise would have cruelly distorted the faces in a dramatic foreground.

Abbas Attar

Teheran, Iran, 1997 The women of the fundamentalist party Hezbollah express their support of a strict interpretation of Islamic moral code during a political-religious event. It is a world that Abbas Attar knows like few others, giving it to us with great intensity. In this case too, one wonders how he could have been in that situation – among women, and more-over fundamentalist – without causing an explicit reaction. It is an ethical issue, as well as a practical one, that those who do reportage must often face: the photo captures a moment, but what happened just before? And what will happen next?

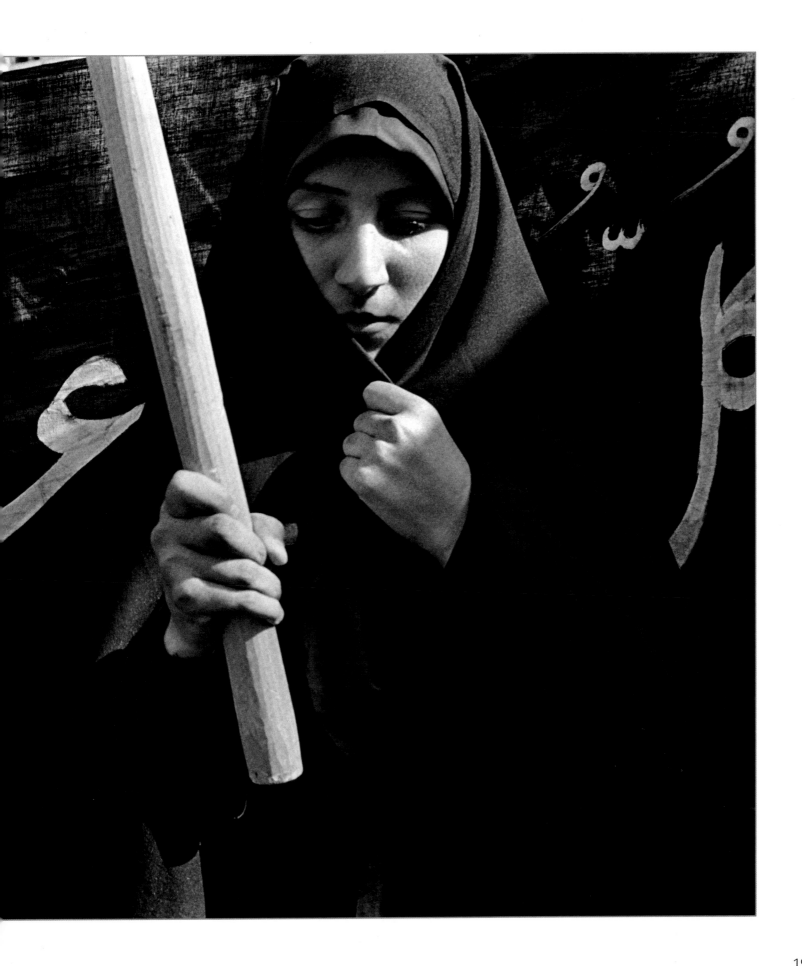

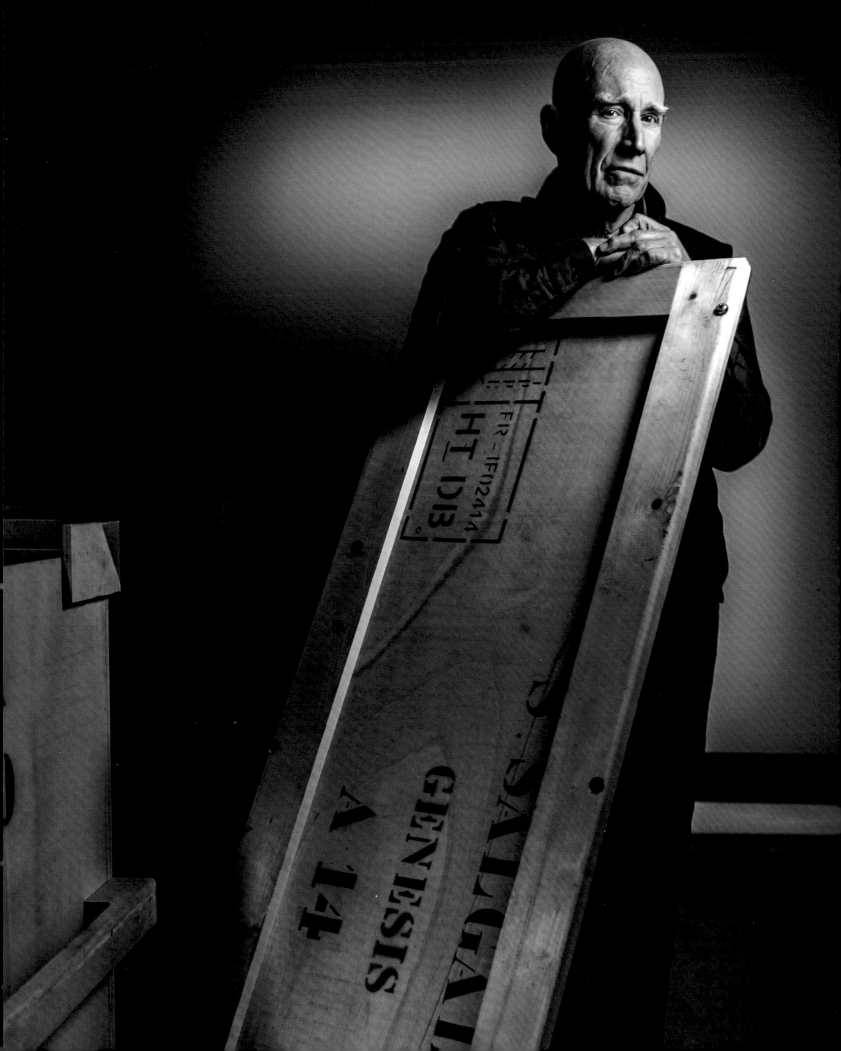

Sebastião Salgado

Salgado's epic vision evolves through images of stunning intensity that document human suffering in all its grandeur, to arrive at a dreamlike search for a lost paradise.

Powerful, immense, epic and symphonic. A lyric poem of images that flows slowly, accompanied by an orchestra in which the sound of each instrument is clearly distinguished, the soul of every breath, the vibration of each string, without affecting the perception of the concert as a whole.

Sebastião Salgado lands here, in this space odyssey of planet Earth: air, trees, water, people and animals, suspended in a vision reminiscent of the magical realism of much Latin American literature, along with the incredible wealth of details of paintings by Bosch.

This is the culmination of a long journey, one that the Brazilian photographer realized starting with his first trips as an economist among South American Indios and in Africa. War – photographed in Angola and Mozambique – was not his way, though Salgado documented the lives of refugees everywhere. Rather, the Sahel drought and famine (where he worked with Doctors Without Borders), captured him and became the keystone of his future: a life and a job that intertwined more and more with the choice of documenting human life through images.

Salgado's projects are monumental; they last for years and years, giving rise to parallel productions of photographic reportage, international traveling exhibitions in galleries and museums around the world, as well as books.

After *Other Americas,* on the rural world in Ecuador, Peru, Bolivia, Mexico and Guatemala, and *The Hand of Man* (26 countries crossed for 6 years, which tell us, even more than the fatigue, the dignity of work), *Exodus* will be released (again 6 years and 40 countries crossed, a book translated into 7 languages), and *Children, Enfants, Kinder*. These collections show a migrant humanity, masses of people fleeing war and hunger, uprooted from the countryside and attracted to the lure of a better life in the vast suburbs of megalopolis, suddenly moved from rural poverty to the errors of hasty and poorly digested industrialization.

April 16th, 2015. Salgado poses for Amin Akhtar in a Berlin gallery, shortly before the opening of his exhibition *Genesis*. The results of that truly titanic work have just been taken out of the wooden crates that the photographer has chosen as his personal set.

February 8th, 1944 - Aimorés, Brazil

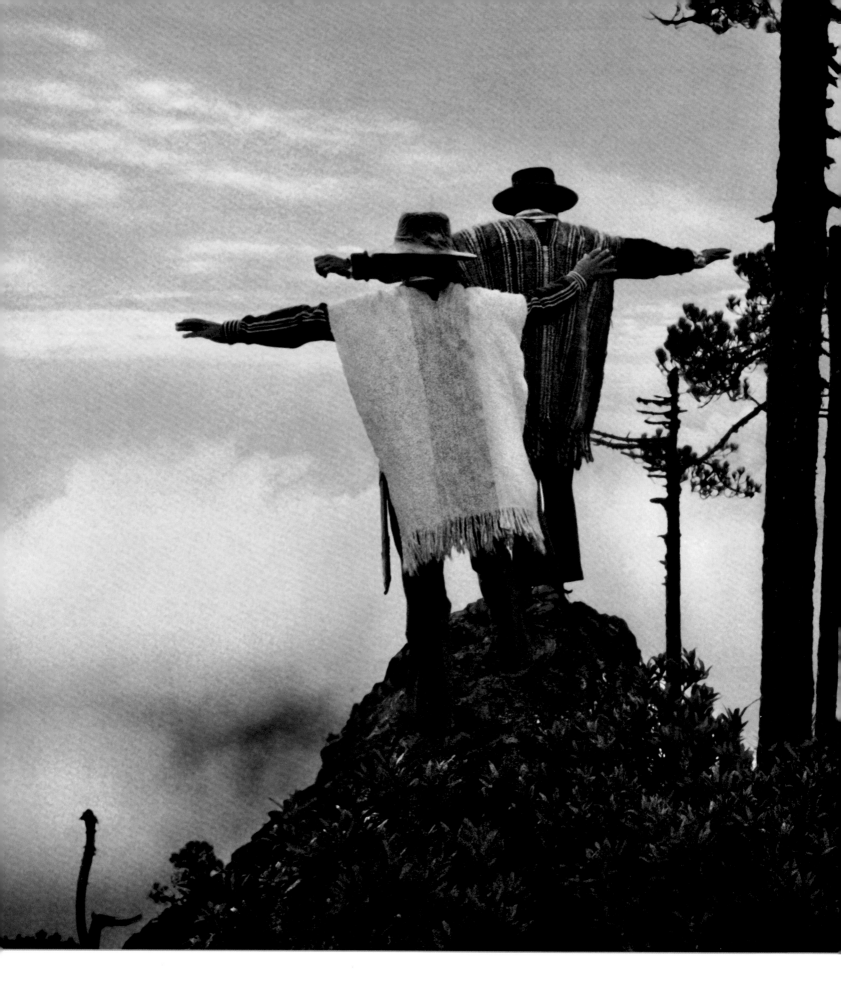

Oaxaca, Mexico, 1980 After a rite of initiation that lasts days, Salgado is welcomed into a community of farmers in the Mexican state of Oaxaca. He follows them in their everyday life and in their rituals: as, in this photo, in the prayer to one of their gods. It is an excellent example of the Brazilian photographer's extraordinary ability of putting man in relation with the environment. The two farmers have their feet planted firmly on the earth but are already in the heavens, above the clouds, to allow their whispered invocations to be better heard by the god.

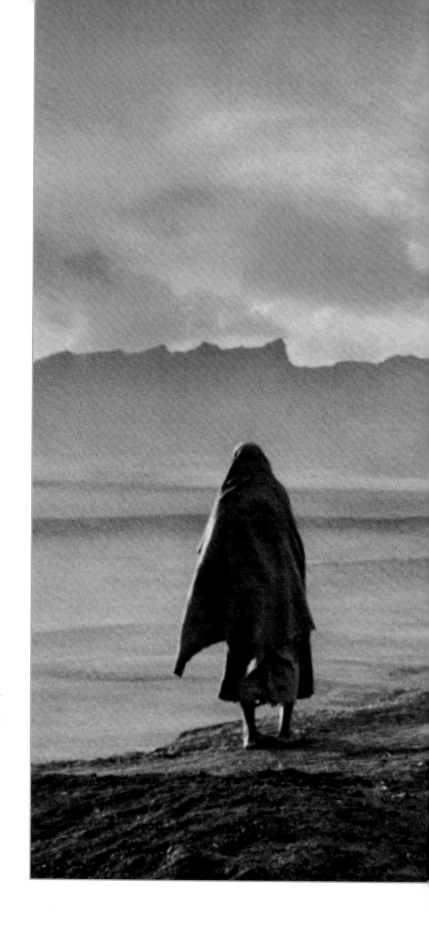

Ethiopia, 1984 With a gaze full of humanity and feeling, Salgado has composed this shot to show, in all of its power and harshness, an environment where it is just possible to survive, not to live. These people in their poverty are lost in emptiness that the eye of the photographer presents to us without filters. All around is a deafening silence.

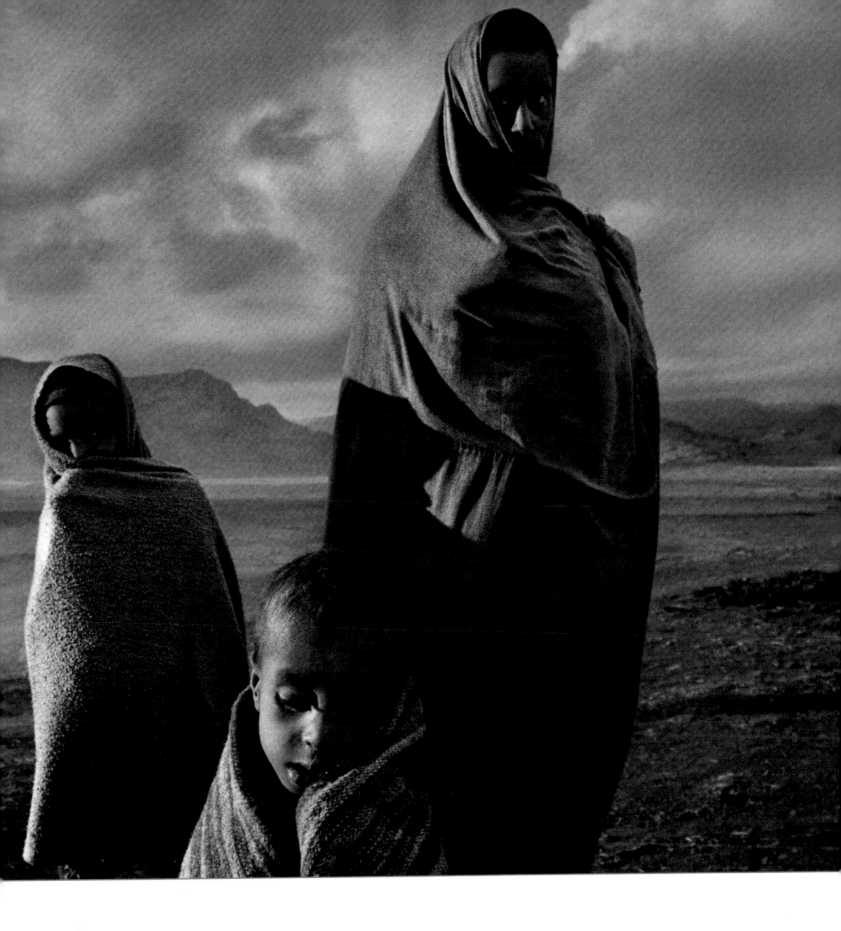

Sebastião Salgado

In Brazil, in the mid-1980s, Salgado made one of his most impressive and spectacular photo shoots among gold miners in the Serra Pelada mine: an immense quarry that is almost a circle of hell, swarming with men hanging from rickety ladders, bent under the weight of sacks of mud to be examined, in the hope of finding a trace of gold filament.

More investigations led Salgado to the East and back to Africa. But this time the genocide in Rwanda was a trauma that left marks on his health and his passion for photography. Salgado was in crisis; he fell ill and ceased to take photos.

Salgado took up the camera again only in 2003, when he began to look at the world from a different perspective. He sought glimmers of light in desolation and suffering.

Serra Pelada, Brazil, 1986 Hell. With the images of the Serra Pelada gold mines we enter a real life Dantesque inferno. But this is no allegory, there is no symbolism here: it is the brutal reality of 50,000 men who are working themselves to death in the most terrible conditions imaginable, crushed like ants under the heel of a richness they will never see. No one is brought here by force, everyone comes because they are drawn by the dream of gold. Once here, they become slaves. Every time they find a nugget, the men of the team that have carried on their shoulders the loads of mud and rock up to the surface, have the right to choose one of the sacks. Inside could be the end of the madness and freedom.

He sought ways to absorb and reflect it, and he found it in an attempt to get back to basics, by reconstructing an intact and untouched world. This nature coincided with the idea of Eden. The world of his childhood returned imposingly, namely the tropical forest where he was born and raised in 1944: Aimores, Minas Gerais, and the Rio Doce Valley. His wife, Lélia Deluiz Wanick, was always at his side: ideally, without ever following him on a journey. She was the one who organized exhibitions and events; she was the one who opened an independent organization dedicated to the dissemination of her husband's works, after working as manager at Magnum Gallery. Earth, viewed with new eyes, becomes a lost paradise to rediscover, defend, and feed, because in turn it protects and nurtures. Earth becomes the longing for an ancient balance between nature and living things, that the photographer searched for everywhere on the planet; a balance that might look like a possibility of remote and primitive life.

India, 1989 A destiny with no hope for the future awaits these miners on the other side of the world, in India. Chosen for the cover for the book *Workers (An Archaeology of the Industrial Age)*, this photo is a tribute to the human condition and at the same time a protest. With his clear vision Salgado restores dignity to those who work and survive in the poorest corners of the Earth.

His camera portrayed these people and places with the delicacy reserved for survivors, as if they had miraculously emerged alive from a nuclear war, protected by bunkers made of rain forests, glaciers, deserts, taiga, and savannas. In eight years of traveling in the Amazon region, Alaska, Indonesia, Congo, from Madagascar to Colorado, from Siberia to Chile, and to New Guinea, Salgado collected a variety of material that flowed into the "Genesis" project, as visionary as the man who conceived it.

Equally visionary was the attempt to restore what was the forest around the *hacienda* of his family, planting more than two million trees of at least three hundred different species. Despite seeming impossible, Salgado achieves what he sets out to do. *The Salt of the Earth* by Wim Wenders tells this story with emotional modesty, describing Salgado through close-ups of his face, which alternate with his own photographs in an extraordinary flow.

204-205 - Trapani, Sicily, Italy, 1991 Like a modern Moses, the *Rais* guides his men in their tuna fishing expedition. Salgado perceives his power, his symbolic role and sums up the bloody ritual in his gaze and in the wrinkles that mark his face. As always, it is the subject that creates the photo, not the photographer: this is the central concept in the vision of the Brazilian artist. The sea remains a protagonist, along with the fishermen; but over everything hangs that sense of expectation wavering between fear and hope, which is what makes this photo so great.

206-207 - Russia, 2011 It is the perfect instance of the "less is more" rule. Salgado removes every possible element that might distract and what remains is a distillation of truth, all that there is to say about a world made up only of space, without color, with no forward, backward, over, under. The essence of the North where every detail is crucial, every error fatal. Under a never-ending sky, with the breath of a storm on its way, the man speeds along, pulled by his reindeer, across the nothingness that for him is everything.

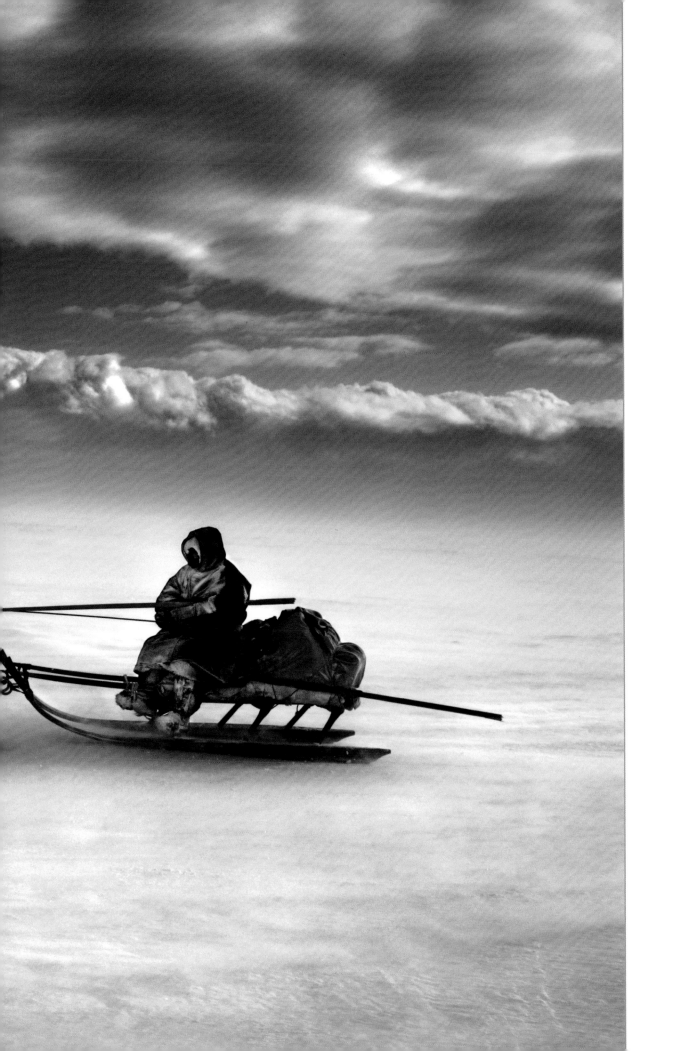

Steve McCurry

February 24th, 1950 - Philadelphia, United States

Transfixed by Afghanistan and its vivid colors, McCurry searched for and found his way among the marginalized tribes on the verge of extinction in Asia. And he photographed them as they stared right back into his eyes.

No jeans, no desert boots, and no t-shirt crossed by the strap of a classic camera bag filled with lenses and films. Rather, a *salwar* tied around the waist with a rope on which lies the long tunic that the Pakistanis call *kameez*. It is in this way that Steve McCurry, not yet 30, suspended his American rural identity and began a long journey in search of the hidden homeland within each of us, regardless of the place where we were born.

Dressed in Pakistani clothing, this was the homeland that the young photographer sought as he crossed the border with Afghanistan, under fire from rebels arrayed against the Kabul government backed by Soviet troops. He found his fatherland 7,000 miles away from the Philadelphia suburb where his mother gave birth to him on February 24th, 1950. He recognized it wholeheartedly, and since then he never stopped chasing it to further understand his emotional roots.

From the journey among the mujahedeen, McCurry was back with his *kameez* burdened by hundreds of rolls of film sewn into the lining, and with his head struck by a fascination for what we might call war reportage engraved directly on the faces of those who suffer. The Afghan girl, photographed in a refugee camp with a flash of fear, frozen in her gaze, was only the most famous of the portraits with which Steve McCurry told the dismay, the inability to tell what can only be told through eyes – the horror of all wars: in India, Cambodia, the Philippines, Beirut or Iraq. Not only this. McCurry chased nomads and underdogs; he captured the ethnic and cultural identities of different groups living along the South Asian steppes, down to the small communities: almost 80 million people at risk of disappearing, like an evanescent hologram by Bill Viola.

The setting in this case is India, but it could just as easily be Pakistan. In any case it is the world where McCurry discovered his vocation. The image, in spite of its blurriness, reveals an extremely natural attitude and a face that seeks to blend in with those of the people around him.

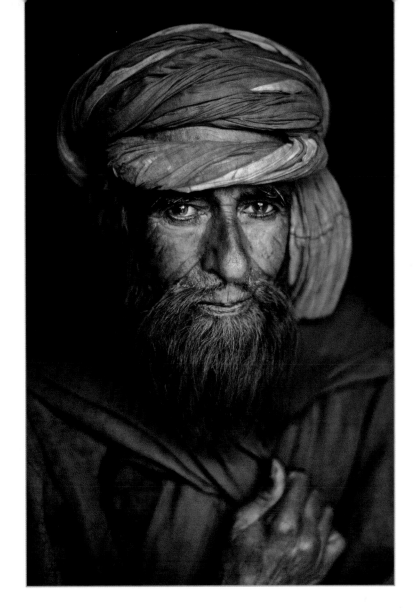

210 - Peshawar, Pakistan, 1984 It is part of a series of photos dedicated to a twelve-year old Afghan refugee, destined to become his most famous subject. One of these photos is chosen as the cover of *National Geographic Magazine* in June 1985 and immediately became an icon and a symbol of a nation ravaged by endless wars. Its strength is all in the gaze: so still and full of pain to suggest a story of madness. The life of Sharbat Gula is bound to know little joy. The girl was back in the newspapers in 2016 when she was arrested in Pakistan for false documents.

211 - Srinagar, India, 1996 Traveling up toward the Himalayas one meets with increasing frequency nomadic peoples, men and women who live in close contact with nature. It is in their faces and especially in their gazes that McCurry first found his passion for photography, then the essence of his photographic language. In the way he photographs this shepherd with his beard dyed with henna, we can see the distinctive style of the American photojournalist.

Steve McCurry

Mumbai, India, 1993 India is the real star of McCurry's most popular story. Its many sensational moments, suspended between the expectation of the monsoon and the difficulty of living, have seduced the collective imagination of a wide audience of young travelers pushing them to the allure of the photojournalist. This photo tells very well the ubiquitous proximity between wealth and poverty, between certainty and uncertainty, between life and death characterizing the daily tragedy of those who live in India.

Jalalabad, Afghanistan, 1983 What is the reporter's job? What is his art? What does it mean? McCurry sums it up in this photo where he combines the realities of the country in a single glance. Pastoralism instead of school takes the lives of young people and children, consuming them. Endless opium plantations in this land do not produce wealth; rather, they put Afghanistan at the center of the immense international interests of the merchants of death.

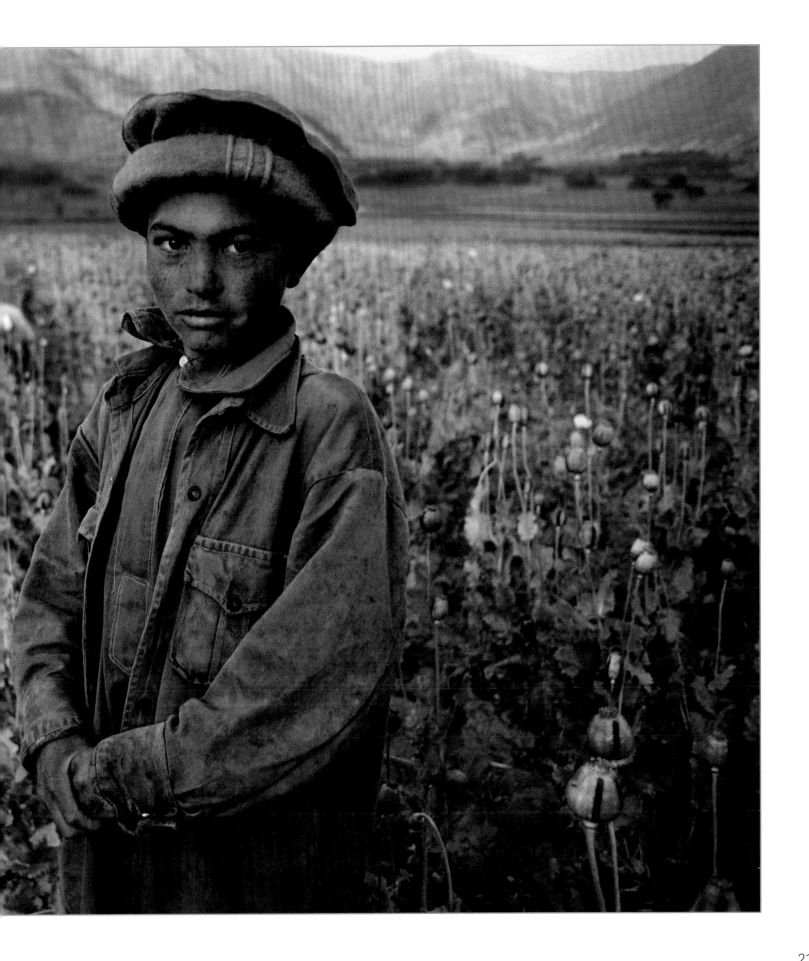

He told all this emphasizing two fundamental expressive features, which make his art recognizable at a glance.

The first: The color is full of energy. We see abundant colors, in high-contrast, which stand out even when the author simply describes a landscape. His ability to balance the consciences of the world and his fascinating way of communicating without betrayal made him a great forerunner of modern travel reportage. His is a referential model, able to speak loud and clear even to the younger generation. Young people will learn from him the fearless use of color and the empathy that his photos convey.

The second: McCurry often favored in his portraits a silent stillness rich in meaning, able to project an image out of time. Faces carved in crimson turbans, long straw hats that protect women hidden behind a *niqab,* guys wearing thick cartridge belts of bullets in place of a stolen adolescence.

Zhengzhou, People's Republic of China, 2004 The twilight zone, between myth and legend; McCurry tells the harsh reality of Shaolin warrior monks. We saw them in various movies, able to fly, but who are they really? We see again the sense of immobility, suspension, so much a part of the American photographer's work. Hence the skillful use of color – which has now entered by force and has established itself in the language of reportage – enhances compositional choice, aided by the unusual gesture. It is impossible not to contemplate this image without a gaze full of surprise.

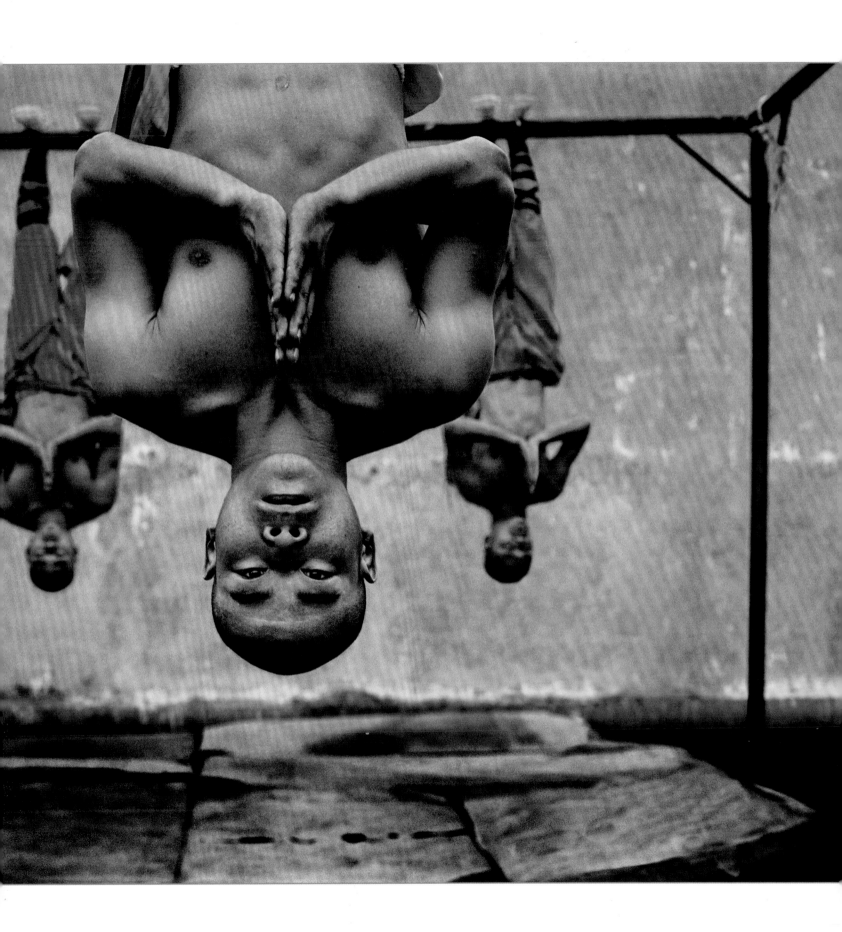

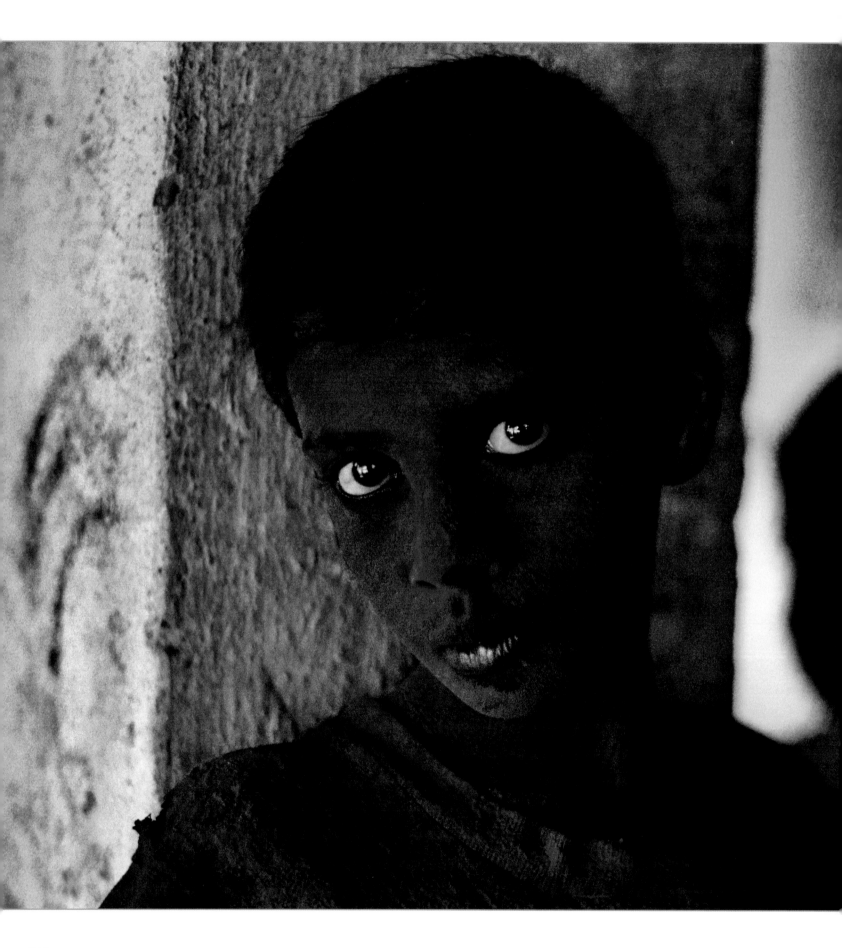

Steve McCurry

The portrait for McCurry was always still, wanted, expected. It was never accidental, never grasped on the fly. We see eyes staring at the lens fixing them in a suspended space, dreamlike, free from soundtrack. This, too, along with the choice of themes and subjects represented, eventually coincides with a love for the extended time that is typical of oriental culture.

"If you wait, people will forget your camera and the soul will drift up into view." His photographs say it forcefully, even more than he does.

218-219 - Mumbai, India, 1996 This photo is dominated by color and by the red boy of Bombai's intense gaze, which catches the eye like a magnet. The deep red highlights the diverted position of the head that makes him look even more contradictory. The figure in the background, also red, is a shadow that refers to the subject's eyes.

220-221 - Jodhpur, India, 2007 In this image the color is crucial to enhance the handprints left on the walls that become protagonists in this escape through the streets of the blue city. The human figure, with a gesture stopped by the shot, is the destination of a gaze that searches for a path; an opening that wants to enter a world full of mysteries and other stories.

The Authors

Laura Magni writes, above all about travel, favoring a point of view that is cultural, social, and interpretative. She publishes articles and news stories in Italian and foreign magazines. She curates creative projects, and writes story treatments and screenplays. She has published guides, been the editorial director and managed the restyling of magazines and book series. She designs and follows the image, including on the web, of private firms and public administration companies. She has taught screenwriting at the IED design institute in Milan.

Marco Santini travels, writes, and takes photographs. He is a journalist specialized in travel writing, in the food and wine sector and interior design photography. He travels with every possible means across oceans, glaciers, and deserts. He has worked with the most important travel and tourism magazines in Italy and abroad. He is the author of books and guides, and has taught photography in the circuit of American Schools and has done various photographic exhibitions in Italy.

Elena Ceratti is a photo consultant for the agencies VU, H&K and Karma Press Photo. She has worked for many years as image researcher for the Italian and foreign press, in particular for French periodicals, and for the Grazia Neri agency. Since 1992 she has also worked as a curator and agent for photography exhibitions. She has been a member of various Italian and international juries, including the World Press Photo Contest. She is the vice president of Grin, the Gruppo Redattori Iconografici Nazionale.

Photo Credits

Page 10 Larry Colwell/Anthony Barboza/Getty Images

Page 13 GraphicaArtis/Getty Images

Pages 14-15 Universal History Archive/UIG/Getty Images

Page 16 Dorothea Lange/Library Of Congress/Getty Images

Page 17 Dorothea Lange/Underwood Archives/Getty Images

Page 18 Philippe Halsman/Magnum Photos/Contrasto

Page 21 Alfred Eisenstaedt/Time &Life Pictures/Getty Images

Page 22 Alfred Eisenstaedt/ullstein bild/Getty Images

Page 23 Alfred Eisenstaedt/ullstein bild/Getty Images

Pages 24-25 Alfred Eisenstaedt/Pix Inc./Time & Life Pictures/ Getty Images

Page 26 Cecil Beaton/Condé Nast/Getty Images

Page 28 Cecil Beaton/Condé Nast/Getty Images

Page 29 Cecil Beaton/Condé Nast/Getty Images

Pages 30-31 Cecil Beaton/Condé Nast/Getty Images

Page 32 Cecil Beaton/Condé Nast/Getty Images

Page 33 Cecil Beaton/Condé Nast/Getty Images

Page 35 Cecil Beaton/Condé Nast/Getty Images

Page 36 Oscar Graubner/The LIFE Images Collection Cecil Beaton/Condé Nast/Getty Images

Pages 38-39 Margaret Bourke-White/Time & Life Pictures/ Getty Images

Page 40 Margaret Bourke-White/Time & Life Pictures/Getty Images

Page 42 Margaret Bourke-White/Time & Life Pictures/Getty Images

Page 43 Margaret Bourke-White/Keystone/Getty Images

Page 44 George Rodger/Magnum Photos/Contrasto

Page 46 George Rodger/Magnum Photos/Contrasto

Pages 48-49 George Rodger/Magnum Photos/Contrasto

Pages 50-51 George Rodger/Magnum Photos/Contrasto

Pages 52-53 George Rodger/Magnum Photos/Contrasto

Page 54 Martine Franck/Magnum Photos/Contrasto

Page 56 Henri Cartier-Bresson/Magnum Photos/Contrasto

Page 57 Henri Cartier-Bresson/Magnum Photos/Contrasto

Pages 58-59 Henri Cartier-Bresson/Magnum Photos/Contrasto

Page 60 Henri Cartier-Bresson/Magnum Photos/Contrasto

Page 61 Henri Cartier-Bresson/Magnum Photos/Contrasto

Pages 62-63 Henri Cartier-Bresson/Magnum Photos/Contrasto

Pages 64-65 Henri Cartier-Bresson/Magnum Photos/Contrasto

Page 66 Elliott Erwitt/Magnum Photos/Contrasto

Pages 68-69 David Seymour/Magnum Photos/Contrasto

Pages 70-71 David Seymour/Magnum Photos/Contrasto

Pages 72-73 David Seymour/Magnum Photos/Contrasto

Page 74 David Seymour/Magnum Photos/Contrasto

Page 76 Peter HAMILTON/Gamma-Rapho/Getty Images

Pages 78-79 Robert DOISNEAU/Gamma-Rapho/Getty Images

Pages 80-81 Robert DOISNEAU/Gamma-Rapho/Getty Images

Page 82 Robert DOISNEAU/Gamma-Rapho/Getty Images

Pages 82-83 Robert DOISNEAU/Gamma-Rapho/Getty Images

Pages 84-85 Robert DOISNEAU/Gamma-Rapho/Getty Images

Page 86 Collection Capa/Magnum Photos/Contrasto

Pages 88-89 Robert Capa ©International Center of Photography/Magnum Photos/Contrasto

WHITE STAR PUBLISHERS

WS White Star Publishers® is a registered trademark
property of White Star s.r.l.

© 2017 White Star s.r.l.
Piazzale Luigi Cadorna, 6 - 20123 Milan, Italy
www.whitestar.it

Translation and Editing: Renata Grilli, Joshua Burkholder, James R. Schwarten,
Paola Paudice (Iceigeo, Milan)

ISBN 978-88-544-1176 -0
1 2 3 4 5 6 21 20 19 18 17

Printed in Italy